Taylor, Kathleen,
Fearless Fair Isle Knitting: 30
Gorgeous Original Sweaters,
Socks, Mittens, and More

fearless
FAIR ISLE KNITTING

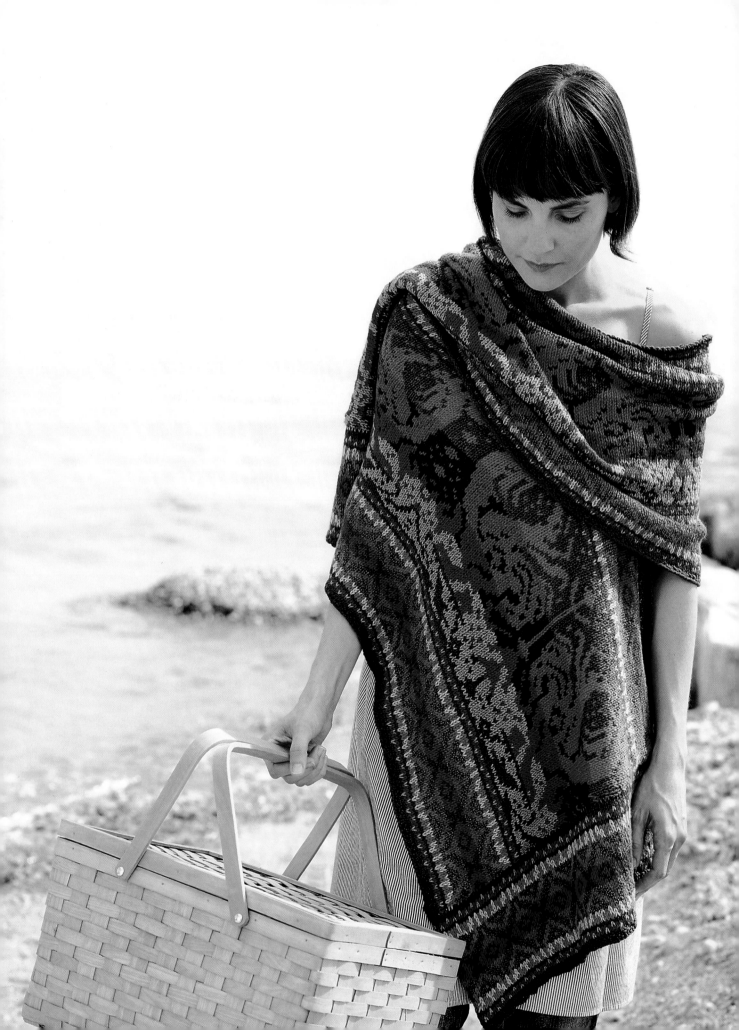

fearless FAIR ISLE KNITTING

30 Gorgeous Original Sweaters, Socks, Mittens, and More

Kathleen Taylor

The Taunton Press

This book is for Genevieve,
my friend, inspiration, and wonderful
daughter-in-law.

Text © 2011 by Kathleen Taylor
Photographs © 2011 by Alexandra Grablewski, except where noted below
Illustrations © 2011 by The Taunton Press, Inc.

The Taunton Press
Inspiration for hands-on living®

The Taunton Press, Inc., 63 South Main Street, PO Box 5506, Newtown, CT 06470-5506
e-mail: tp@taunton.com

Editor: Erica Sanders-Foege
Copy editor: Betty Christiansen
Indexer: Lynne Lipkind
Cover & interior design: Chalkley Calderwood
Layout: Chalkley Calderwood
Illustrator: Christine Erikson
Photographers: Alexandra Grablewski; except pp. 9–15 © Nick Pharris
Stylist: Kin Field
Hair and Makeup: Noelle Marinelli

The following names/manufacturers appearing in *Fearless Fair Isle Knitting* are trademarks: Knit Picks®, Knit Picks Palette™, Knit Picks Swish™, Knit Picks Telemark™, Knit Picks Wool of the Andes™, Shout® Color Catcher®, Soak™

Library of Congress Cataloging-in-Publication Data
Taylor, Kathleen, 1952-
 Fearless Fair Isle knitting : 30 gorgeous original sweaters, socks, mittens, and more / Kathleen Taylor
 p. cm.
 ISBN 978-1-60085-327-2
 1. Knitting--Scotland--Fair Isle--Patterns. I. Title.
 TT819.G72T39 2011
 746.43'2041--dc22

 2010047358

Printed in the United States of America
10 9 8 7 6 5 4 3 2 1

Acknowledgments

Every book is a team effort, and this one would not have come to pass without my agent Stacey Glick, my editor Erica Sanders-Foege (and assistant editor Alex Giannini and copy editor Betty Christiansen), my own personal cheerleaders Ann and Melanie, my friends at Knitters Etc. and from my blog, and the wonderful and amazing knitters who did an impossible amount of work in a very short period of time: Sherri Axcell, Betty Bahl, Karen Irving, Mary Keenan, and Toby Sanders. A special thanks goes to Nick Pharris, who spent an afternoon at my house, taking wonderful process photos.

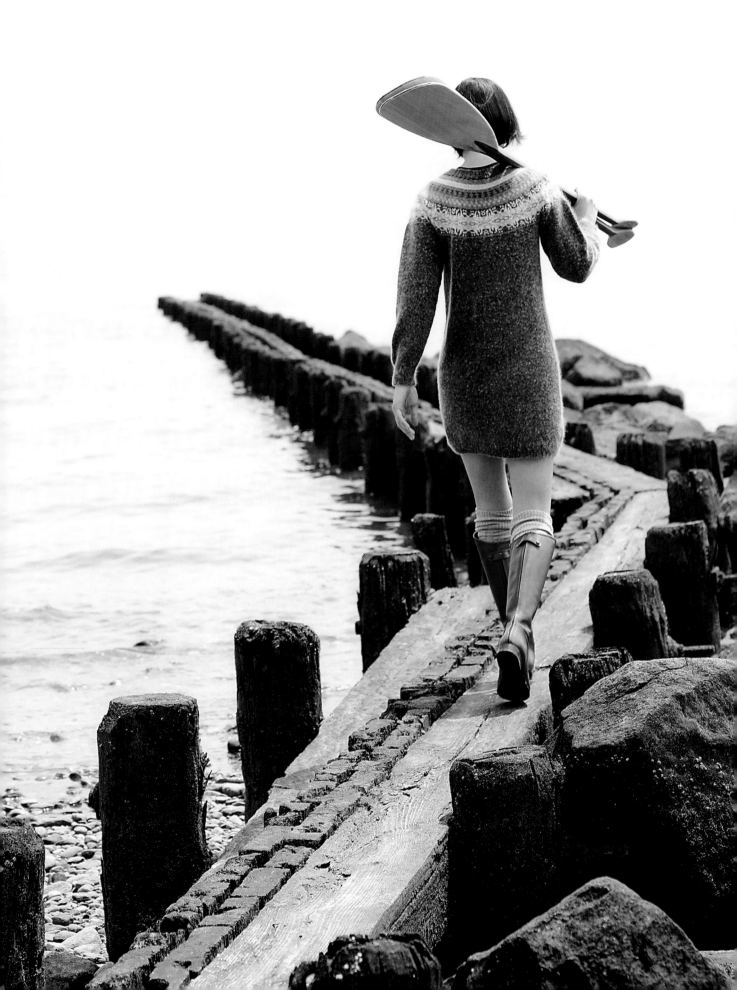

Contents

Taking the Fear Out of Fair Isle

Take a deep breath and repeat after me:

"Fair Isle is fabulous. Fair Isle is fun. Fair Isle is easy. I am not afraid."

Yeah, you heard me: Knitting Fair Isle is easy. It's fun. And it can be fearless, whether you're using just two yarns or going wild with forty.

If you're new to stranded knitting, we'll walk you through the basics: yarn selection, swatching, tension, and the bugaboo of all beginning Fair Islers steeking. You'll learn traditional methods for knitting Fair Isle designs, and you'll learn some not-so-traditional techniques, which will take the mystery, and the fear, out of colorwork.

Newbies can get their Fair Isle feet wet with easy patterns that need no steeking, like mittens and hats. Advanced stranded knitters will love our beautiful patterns and charts. And adventurous knitters will find ways to simplify their Fair Isle knitting even more.

I promise, you will learn to cut your knitting fearlessly.

What Is Fair Isle, Anyway?

Technically, Fair Isle knitting is multicolored stranded work, done in traditional patterns that originated in the Fair Isle, near the Orkneys and Shetland Islands. Most knitters use the term "Fair Isle" to describe any stranded, multicolor knitting.

Whatever you call it, Fair Isle knitting is not as complex as it looks. In any given row or round, you are only working with two colors, and you are only actually knitting with one color at a time, switching colors on individual stitches according to a predetermined pattern, which is usually drawn on a grid or chart.

Choose your yarns carefully. In any Fair Isle or stranded project, it is very important for the two yarn colors that you are using (in any given row) to have a high contrast. If you can't easily see the difference between the colors before you knit them, you won't see the difference afterward.

Of course, the recommended yarns will work just fine for the designs in this book. But if you plan to substitute yarns, a good way to know if your yarns have enough contrast for stranding is to photograph or scan your yarns together, and then turn the picture into a black-and-white image (see the bottom photo on the facing page). If you can still tell which yarn is which, then your color contrast is sufficient.

Choose firm, evenly spun and/or plied yarns, with little or no halo or fuzziness or bumps, so that the pattern in your finished fabric will be crisp and visible. Some tweediness is okay for stranding. If you select self-striping or variegated yarns (either paired together, or with a solid-color yarn) make sure that *all* of the colors in your striping or variegated yarn contrast highly with the color(s) of the other yarn.

If you are substituting yarns for a pattern that uses steeks, or cutting, select yarns with some *grab:* wool or wool blends. Those yarns, even the superwash versions, will hold on to each other and help prevent raveling when the steeks are cut. Some all-wool yarns, such as the Shetland varieties, are known for adhering so well that traditionalists do not reinforce the cut edges at all.

Yarns that are very slippery (such as pure cotton, pure silk, and many man-made fibers) can be used for steeked projects, but the chance of raveling after cutting is much higher. I do not ever recommend cutting slippery yarns without reinforcing the steek edge first.

Swatches? Really?

Okay, there's fearless. And then there's foolish.

It is totally foolish to knit a large Fair Isle project without first knitting a swatch, not only to test your gauge against the listed pattern gauge (recommended needle sizes are just that—recommendations—and you may need to go up or down one or more needle sizes to get the same gauge in your knitting), but also to make sure that the colors look good together and that they have enough contrast to make stranding worth the effort.

And even more important, you want to be absolutely certain that your yarn colors won't bleed. Trust me, you do not want to spend months knitting a red and white Fair Isle sweater only to have it become pink and pinker after washing.

In addition, the gauges listed in this book are measured and calculated *after* the fabric has been wet-blocked. Washing and blocking changes not only the look and texture of the yarn, but it can also change the final gauge and measurements.

Knit a swatch. Wash it. Block it. And dry it. You'll be glad you did.

In the pages that follow, I'll show you the essentials of knitting Fair Isle patterns. You'll read all about changing yarn colors, knitting from a chart, holding the yarn strands for the floats, wet blocking, laundering, steeking, and shaping. It sounds like a lot, but it's simpler than you can imagine.

Happy knitting,
KATHLEEN TAYLOR

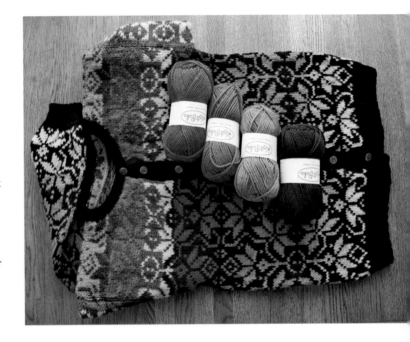

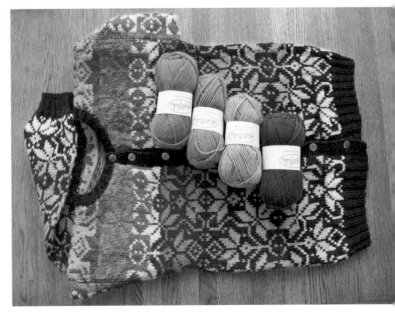

Fair Isle Basics

AS I'VE SAID BEFORE, THERE IS FEARLESS. And then there is foolish. If you've never knitted Fair Isle before but consider yourself a fairly handy knitter, you will want to read this chapter closely because it covers most of what you need to know, with care. Even if you have knitted Fair Isle and you are looking for a new (and, one hopes, more friendly approach), then you might want to review this run through the "fearless" basics as well.

Increases and Decreases

Let's start with knitting increases and decreases, which is something that tends to bedevil beginners. The experienced among you may have your own approach, so do what you know to work best.

Increases

I like to increase stitches by picking up and knitting the side loop from the stitch in the row directly below the row I am working on. This increase does not leave a hole in my knitting. There are other types of increases. Use the one that you prefer, but be consistent. Use the same increase throughout.

Left-Slanting Decreases

Unless otherwise noted, any decrease indicated on the right side of a chart will be a left-slanting decrease. In other words, it's a decrease where the combined stitches lean toward the left.

The slip, slip, knit (SSK), in which you slip the first stitch as if to knit, slip the second stitch as if to knit, then slide the left-hand needle into the front part of both stitches and knit them together, makes a nice left-slanting decrease.

You may use an SSK for any left-slanting decrease in this book. However, I prefer to knit two together through the back loop (K2tog TBL), which produces the same effect with less effort. Simply slip your right needle into the back side of the two stitches, and knit them together. Whether you use an SSK or a K2tog TBL, be consistent. Use the same left-slanting decrease throughout any given project.

Right-Slanting Decreases

Unless otherwise noted, any decrease indicated on the left side of a chart will be a right-slanting decrease. In other words, it's a decrease where the combined stitches lean toward the right. Work all right-slanting decreases by knitting two stitches together in the usual way (K2tog).

Changing Yarn Colors the Fearless Way

There are many "official" ways to change yarn colors at the beginning of a round, which is where you switch colors on most Fair Isle projects. The fearless way is just to cut the former color, leaving at least a 3-in. tail. Then tie the new color to the old color with a plain old square knot, leaving at least a 3-in. tail on the new yarn color, and continue knitting.

That square knot will loosen a bit as your knitting progresses, and sometimes the first and last stitches of those rounds will look a little loose as well. Don't worry about them.

After you finish your project, when it comes time to weave your loose ends in (the ends that aren't trimmed off when the steek is cut open, that is), use a needle to further loosen and untie the knot, pull on the ends a bit to tighten the adjacent stitches, and retie the square knot firmly. Then weave the ends in along the wrong side of the knitted row for an inch or so, and trim the excess tail.

I have never had a knot tied in this manner come undone in wearing or washing. The small knots don't show from the front of the fabric, nor do they make lumps on the wrong side (in socks, for instance).

An added bonus is that tightening the yarn ends often makes that "jog" that happens at the beginning of color-change rounds disappear entirely.

Speaking of that Jog

There are ways to eliminate the jogs that occur at the beginning of a round of striped or Fair Isle knitting. I don't worry about them—I consider them the nature of the beast.

Joining Same-Color Yarns the Fearless Way

If you need to join more yarn to a same-color round (for example, if you're working on a project with large areas of single color, as in the Nordic Snowflake Dress on page 102), you can tie the yarn ends together, as listed above.

But even more fearlessly, if you are using a yarn that can be felted (wool or wool blends that are not superwash), you can *spit-join* your yarn ends together.

I know this sounds a bit ooky, but it works: Put the end of the old yarn and the end of the new yarn in your

mouth (just go with me here), and roll them around for a moment or two. Get them good and wet. Take the yarns out of your mouth, overlap the ends a couple of inches lengthwise, and squeeze them together to form a single strand. Place the strand with the wet portion on one palm. Place the other palm on top and rub your hands together vigorously until the yarn strands felt together (you can feel when that happens).

Then just knit. The join will hold. I promise. In addition, felting reduces the bulk of that short area of double stranding. It won't show from the front (or back) of your work. And once the yarn dries, you'll never be able to find the join again.

If you're really squeamish, you can wet the yarn ends with tap water, but that means getting up and going to the sink. It's easier to do it the totally fearless way.

Yarn Dominance and Ball Placement

It is important in Fair Isle knitting to pick up your strands in the same order throughout your project. I place my main or background color (MC) on the right arm of my chair or beside me, and the contrast color (CC) on the floor or in my lap in front of me, and keep that placement throughout. I am a "thrower." I have learned that some "pickers" prefer to place the CC on the arm of their chair, and the MC in front. Do whatever works for you, but be consistent. Don't change the placement of the balls in the middle of the project.

There are some Fair Isle knitters who twist the yarns around each other on every stitch. I don't recommend that—it not only takes time and uses up a lot more yarn, but the resulting fabric is stiff.

Do not twist the strands around each other unless you are knitting more than five to seven stitches of the same color in a row on the chart, depending on the yarn weight. You can go up to seven stitches with fingering weight yarn without twisting the strands. If you do have to twist the yarns in the middle of long stretches of the same color, untwist them on the next stitch, so that the original ball placement/strand orientation returns. Your finished piece will have uniform stitching and color "dominance" if you maintain the same strand order throughout.

Knitting from a Chart

Each square on a Fair Isle chart represents one stitch. The color of the square represents the color yarn you are supposed to use for that stitch.

Each pattern will specify where to begin on the chart. Some projects begin at the top row, right-hand square of the chart. Others begin at the bottom row, right-hand square of the chart.

Some sizes of some patterns will indicate a different place to begin your first pattern repeat. Individual instructions will specify where to begin working those charts.

One row of squares on the chart equals one repeat of the motif. Each time you finish a repeat of your pattern round, go back to the first stitch and start over for the next pattern repeat on your round.

I find it extremely helpful to place markers between each repeat. That way, if I make a mistake, I only have to go back to the beginning of the repeat to find the error.

Each row of squares on the chart represents one round of knitting. When you finish one complete round of repeats, begin the next round on the far right square in the row up (or down, depending on where you started working) from the one you just completed.

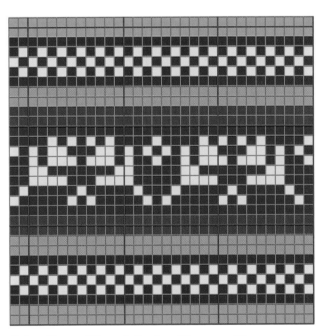

Dakota Dreams Women's Cardigan Chart, page 67

I don't just find it helpful to mark which round I am knitting on a chart, I find it absolutely essential to do so. There is no chart so simple that I cannot lose my place in it, thereby causing angst and anguish, wasted work, and many bad words. I eliminate that possibility by using a metal sheet and strip magnets to highlight the chart row I am working on, with the magnetic strip placed just above my current row. If you don't have a metal sheet and strip magnets, you may use sticky notes in the same way. You can also photocopy the chart and use a highlighter to draw through each completed row.

Charted Decreases

Some project charts have decreases built right into them (the Geometric Dazzle Bag Chart shown below, for example). Those charts look something like a pyramid, with the numbers of squares (and stitches) in a repeat gradually diminishing. The charts will have clearly visible jogs on decrease rounds. Each decrease is represented by a clearly delineated jog in the chart. When you come to a jog, you simply decrease one stitch (with either a K2tog TBL or a K2tog, depending on the side of the chart where the decrease falls), using the yarn color shown in the square.

Each decrease reduces the number of stitches in the repeat (and therefore in the entire project).

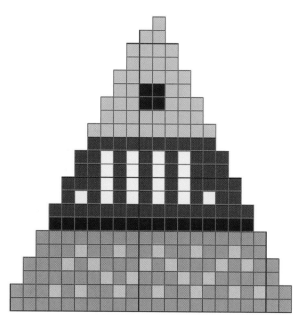

The decreases are built right into the Geometric Dazzle Bag chart.

Changing to Double-Pointed Needles

Unless you are using the Magic Loop method, or are knitting with two long circular needles, as you work on any pattern with decreases, you will have to switch from longer circular needles to shorter ones, and from circular needles to double-pointed needles (DPNs). Or, conversely, if you are working from the cuff up, on sleeves, for example, you'll start with DPNs and then switch to circulars as the stitch count increases. Use whatever circular length feels comfortable to you (changing them as necessary), and switch over to DPNs as needed.

If at all possible, place an entire pattern repeat (or multiple repeats) on separate DPNs. Be aware that your tension and gauge may change a bit in the switch to DPNs. If you find yourself knitting tighter on DPNs, move up a needle size.

Holding the Yarn Strands for the Floats

There are many ways to hold the yarn strands in Fair Isle knitting. The one that is correct is the one that works best for you. I hold both strands of yarn in my right hand. Other knitters hold one strand in their left hand and one in their right. However you hold your yarn, arrange the yarn balls as instructed earlier.

For beginners, I recommend holding only the strand that you are knitting with. When you finish the stitches for that color, drop that strand and pick up the other and knit those stitches without twisting the yarns around each other. After you feel comfortable switching colors, try holding both of the strands in one hand, or one strand in each hand. Experiment until you find the method that feels the most comfortable to you.

Float Tension

It takes practice to achieve even float tension when Fair Isle knitting. As mentioned above, I find it easiest for beginners to hold only the strand they're actually knitting with, then drop that strand and pick up the next color (as indicated on the chart), and loosely pull it up to the needle and continue knitting.

Even the best Fair Isle knitters get some puckering—don't worry if you see some in your work. As long as your

knitting will stretch (test the elasticity occasionally), you should be able to block the puckers out. As you knit and get used to the process, you will find that your float tension relaxes on its own.

Twisting the Yarn Strands in the Float

Unless you are knitting a stretch of more than five to seven stitches of the same color in a motif, it is not necessary to twist the yarn strands around each other as you knit. If you do knit more than five to seven stitches in the same color on a row, at about the middle of that section of stitches, twist the "live" yarn around the "other" strand once and knit a stitch. Then untwist the yarn and continue on. This method produces a nicely elastic fabric, with a good drape.

It is common for a hint of the twisted stitch to show from the front of the fabric. If the chart has large areas of single-color stretches that extend over several rows of squares, stagger your twisted stitches so that they're not directly above or below each other to lessen their visibility on the right side of the work.

Weaving In the Ends

If your project involves steeking, many of your yarn ends will be cut away and discarded when the steek is cut open. (Yay!)

But for sleeves knit one at a time, and for pullover sweaters and vests, as well as hats, mittens, and socks—that is, for any tube that is not cut open—every color change involves yarn ends that will have to be woven in. It's boring, but it has to be done.

After retying the knots, thread one yarn end in a large-eye blunt needle (choose a needle that is only as big as it needs to be to fit the yarn through the eye). Working horizontally along a nearby row of stitches, on the wrong side of the fabric, weave the yarn end over and under several of the purl bumps (or over and under adjacent floats). Do this for about an inch. Trim the yarn end.

Repeat until you are finished with all of the yarn ends, or until you run screaming into the night, whichever happens first.

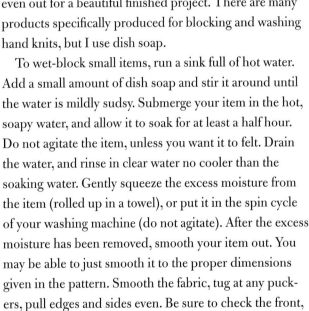
Weaving in ends

Wet Blocking

Wet blocking allows your yarns to bloom, stretch, and even out for a beautiful finished project. There are many products specifically produced for blocking and washing hand knits, but I use dish soap.

To wet-block small items, run a sink full of hot water. Add a small amount of dish soap and stir it around until the water is mildly sudsy. Submerge your item in the hot, soapy water, and allow it to soak for at least a half hour. Do not agitate the item, unless you want it to felt. Drain the water, and rinse in clear water no cooler than the soaking water. Gently squeeze the excess moisture from the item (rolled up in a towel), or put it in the spin cycle of your washing machine (do not agitate). After the excess moisture has been removed, smooth your item out. You may be able to just smooth it to the proper dimensions given in the pattern. Smooth the fabric, tug at any puckers, pull edges and sides even. Be sure to check the front, back, top, and bottom of the item, and smooth and tug as needed.

When it meets your approval, simply lay it flat somewhere and allow it to air-dry (I usually leave everything, from socks to sweaters, on top of my dryer overnight).

If the item will not smooth or unpucker properly, you may stretch the fabric, and then use nonrusting pins. When I pin-block an item, I usually just pin it to my living-room rug (as long as I know that the yarn that will not bleed or run). You may want to invest in a blocking board.

Be careful when pinning your item—any portions pulled out of shape will remain that way after the pins are removed. Allow the item to dry and remove the pins.

To wet-block large items, repeat the above steps, soaking the item in the washing machine or a large bucket or basin, or even in the bathtub. Be very careful not to let the washer go into agitation.

It is possible to add about 10 percent to the height and width of a knitted item by careful blocking, so if your piece is too small, you can widen and lengthen it at this stage.

Blocking only lasts as long as the item remains dry. You will have to reblock your item every time it is washed or gets wet in any way.

Laundering

Even if your item has been knit with superwash wool that is absolutely machine washable and dryable, you'll want to launder it exactly as for the blocking process. Machine washing superwash Fair Isle items leaves them shapeless and lumpy.

Steeks

For knitting purposes, a steek is a built-in seam allowance, which allows knitters to make Fair Isle projects entirely in the round, without having to work back and forth or purl stranded designs. The steek is cut open after the knitting is finished and additional shaping is done (such as curved necklines) or pieces (like sleeves) are added.

The biggest fear a knitter has, when cutting that first steek, is that the fabric will unravel. I won't pretend that can't happen, but as long as you use the right kind of yarn (with some grab) and don't play tug-of-war with your freshly cut knitting, those steek stitches won't go anywhere you don't want them to go.

Yes, it's scary the first time you take scissors to your knitting. I will admit to drinking a glass of wine before I cut my first steek. These days, I don't even think about it (outside of measuring many times before cutting). The ease of working a sweater tube in the round far outweighs any fear of cutting into the knitting, which is a fabric, just like any other.

Steek Construction

Some knitters like to use an uneven number of stitches in their steeks, and then cut down the middle of the center stitch when they open the steek. I prefer to use an even number of stitches and cut between the center two stitches.

Center-front steeks, for cardigans, are built into the original number of cast-on stitches (the first and last five stitches of the round composing the steek). Regardless of any stitch patterning on the body of the sweater, including textured stitches, ribbing, or cables, the steek stitches are always plain knit stitches.

Armhole and V-neck steeks are added to the construction at the right spot in the knitting by casting on a set number of stitches. Those stitches then become the steek, and they are worked the same way a center-front steek is worked.

In all cases, work your steek stitches in alternate colors on two-color rounds, except for the center two stitches, which are worked in the same color to make them easier to identify when it comes time to reinforce the steeks for cutting.

Steek Reinforcement

CROCHETED STEEKS The advantage of a crocheted steek is that you don't need any complicated machinery to do the work for you. You can crochet a steek on the bus or while standing in line at the post office. The disadvantage of a crocheted steek is that the crocheted edge adds bulk to the steek.

To make a crocheted steek, find and mark the center row of stitches along the length of your steek (easy to discover if you have worked those center stitches in the same color, as recommended above). Using a contrasting fine yarn (smaller than the yarn used to knit the project) and a properly sized crochet hook, begin at the top, working a single crochet through the center of the middle stitch. Then work a single crochet from the center stitch, and one through the stitch directly beside it on the steek row. Continue making single crochets down the entire steek side. Cut and tie off the yarn, and repeat on the other side.

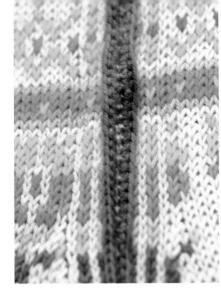

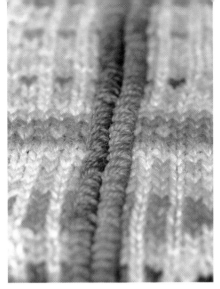

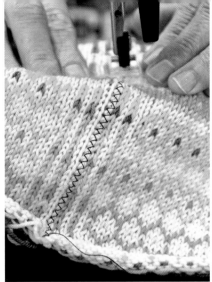

Uncut crocheted steek reinforcement

Uncut hand-sewn steek reinforcement

Machine-sewn steek

HAND-SEWN STEEKS You can reinforce a steek by working hand-sewn cross stitches with fine yarn or thread, catching each loop on either side of the center row of steek stitches, as with the crocheted method.

MACHINE-SEWN STEEKS (MY PREFERRED METHOD) While I have used both the crocheted and hand-sewn steeking methods, when I reinforce a steek (either before or after cutting—more about that later), I use a sewing machine.

Find and mark the center row of the steek stitches, as described earlier. Adjust your sewing machine to the widest zigzag stitch possible and an average stitch length, loosen the pressure on your presser foot, and carefully zigzag-stitch along the center of the steek on both sides. Be careful not to stretch the fabric as you sew.

Steek Cutting

Eeek!

Okay, now that you have that out of your system, calm down and get ready to cut.

If the area being cut is one that is not easily delineated by the steek itself (such as front neckline shaping), measure again. This cannot be emphasized strongly enough: *Be absolutely certain that you are cutting in the right place.*

Then take your scissors and slowly, carefully snip open the steek between your reinforcements (whatever style you use). Trim any excess yarn ends from the edge.

See, it wasn't that hard!

Your newly cut steek should not unravel, especially if you have zigzagged the edges with your sewing machine, but just for safety's sake, don't pull on the steek anyway.

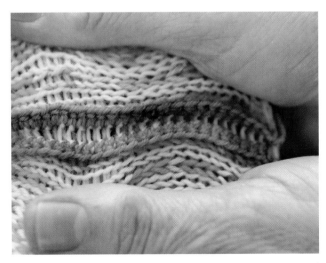
Cut the stitches between the reinforcement of this crocheted steek.

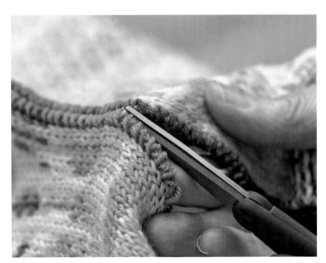
Cutting a hand-sewn steek

If you like, you can zigzag (or hand-stitch) over the new raw edge, but it's not absolutely necessary. You can now fold your steek in, baste it in place (if called for in your pattern), and continue on.

Fearless Steeks

You might want to cut a few steeks in the ways outlined above before trying this, but here is what I do: I just cut the steek open, without reinforcing it in advance.

Yep, you read that right. I just take my scissors and cut the steek open, and then I use my sewing machine to zigzag-stitch along the newly cut edges.

I have never had a steek unravel. Nope, not even once.

However, I will add this caution, which you should take very seriously: *Do not try this method with slippery yarns (cotton, silk, or most man-made fibers).* You can only "cut first, reinforce later" on projects knitted with yarn that adheres well (wool or wool blends).

Also, don't wait around after cutting an unreinforced steek open. Take it directly to the sewing machine (or hand-sew) the raw edges.

If the Unthinkable Happens

It is not likely, but if your cut steek does unravel, don't panic. Stop, take a deep breath, and examine the ravel. Determine where it starts and where it ends.

With a needle and thread (not yarn), anchor as many of the loose loops as you can by hand. Then use your sewing machine to zigzag the area and reinforce the weak spot. If necessary, use leftover project yarns to duplicate-stitch over the raveled area and any weak spots on the right side of the fabric.

Sleeves, the Sort-of-Fearless Way

Traditionally, sleeves are knit into the armhole opening on Fair Isle sweaters by picking up stitches at the opening and working your way down the sleeve, ending with cuff ribbing.

It's a good method, and one that can be adapted to almost any of the sweater patterns in this book, but that's not the method I generally use because flipping the entire sweater over after every round as I knit is a pain. The sweater is heavy (and hot), the weight slows the rest of the knitting down, and manhandling the entire sweater while knitting both sleeves exponentially increases the chance that the fabric will get dirty, stained, or snagged.

I much prefer to knit the sleeves separately, then sew them in place. The time I lose in sewing those two seams is more than made up for in the convenience of not constantly flipping the whole sweater around as I knit the sleeves.

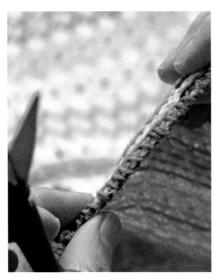

The cut edge of a hand-sewn steek

The cut edge of a crocheted steek, right side

The cut edge of a crocheted steek, wrong side

Tandem Sleeves, the Totally Fearless Way

So you hate knitting two sleeves, you say? What a pain it is to cast on (or pick up) stitches and knit the same thing twice!

I agree. That's why I don't knit sleeves consecutively. I knit them together.

That's right, I knit both sleeves at the same time, and not with the Magic Loop sock method (knitting each tube separately, on the same set of needles).

For tandem sleeves, I knit each cuff separately, then I place them on a single circular needle, casting on 10 stitches between the sleeves as steeks, with markers on either side of both of the new steeks (that's 20 new stitches for the steeks). Then I join them, and, from that point, I work the sleeves in the round, increasing before the markers as though I was working each sleeve separately.

When I finish the sleeves and bind off the large tube (which will likely have more stitches than there were in the body of the sweater), I just cut them apart through the center of the steeks (it's difficult to machine-reinforce the steek before cutting tandem sleeves apart), zigzag along the cut edges, fold the steek edges in, and sew the long sleeve seam.

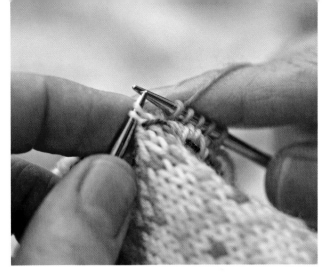

Picking up stitches for the shaped neckline along the basted line

Granted, you will have to sew that seam, which you would not have to do if you knitted each sleeve separately as a tube. On the other hand, if you knitted the sleeves separately, you'd have to weave about a bazillion ends in. With tandem sleeves, the yarn ends are cut away when the sleeves are cut apart!

The patterns in this book are written for more traditional sleeve construction, but you may adapt most of the sleeve instructions in this book to this method (with the exception of the sleeves on the Nordic Snowflake Pullover and the Nordic Snowflake Dress on pages 90 and 102, which must be knit separately and then attached to the body for the yoke knitting).

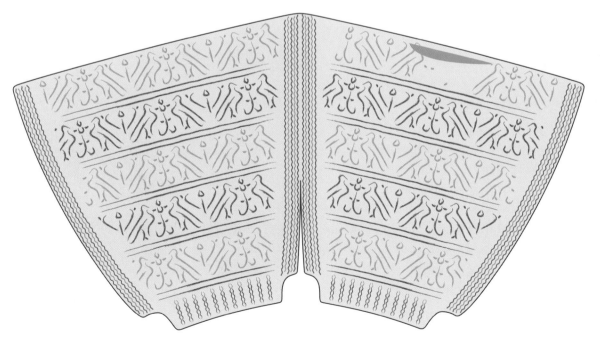

After working tandem sleeves in the round, cut apart the steek.

Picking Up Stitches

Many Fair Isle patterns have front and neck bands that are picked up and knit along folded steek edges. When you pick up a stitch, insert the left needle through both loops of the base stitch, and knit those loops with the right needle. The new stitch goes on the right needle, and is now live.

Pick up and knit the number of stitches instructed in each pattern.

Picking Up Stitches the Fearless Way

Except in a very few cases (buttonhole bands, for example, or bands that have Fair Isle patterning, or need multiples of four stitches for ribbing), it really doesn't matter if you pick up the exact number of stitches listed in the pattern for neck bands, armhole openings, or front bands. A few more or less won't make a difference.

While you can pick up one stitch for each horizontal stitch or vertical row in a piece of knitting, you can often get by with fewer stitches. A rule of thumb if you're not counting the picked-up stitches, is to pick up four stitches for each five rows of vertical knitting. Along horizontal stretches, four stitches for each five stitches works as well. It's a matter of guessing and judging when you pick up stitches along a curved neckline.

Do keep track of how many stitches you pick up on armholes and front bands, so that you pick up the same number on the other opening.

Shaping Necklines

For the most part, the necklines (front and back) of the projects in this book are shaped after the piece has been knit and is off the needles.

Back necklines are shaped by folding the upper edge between the shoulder seams in and down to form a facing.

Round front necklines are shaped by marking the line where stitches will be picked up, then excess fabric is cut away above that line, and the cut edge is reinforced (or that line is reinforced before cutting). The front neckline is then folded in and down.

Neckband stitches are picked up along the basted line (see photo on page 13).

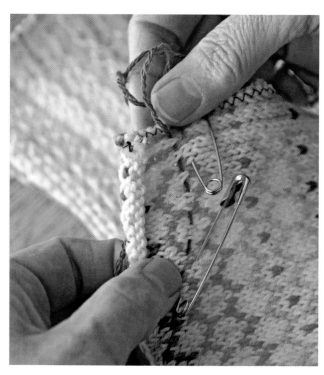
Contrasting thread is used for basting stitches along the neckline.

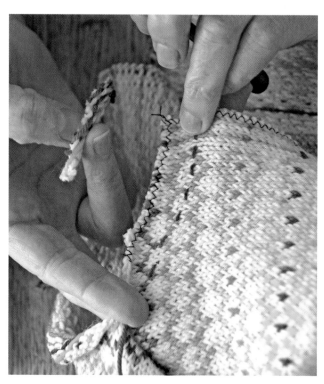
Machine-sewn neckline that has been cut for shaping

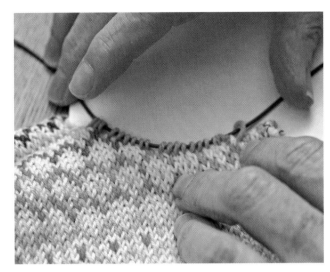

Stitches transferred to circular needle

V-neck shaping can be done by decreasing stitches at the center front, with a new cast-on steek in between the decreases. The steek is cut open and folded in, and the neckband stitches are picked up in the same manner as a round neck band, except that decreases are performed on either side of the V point so the band will lie flat.

Fearless V-neck Shaping

If you've read this far, you probably knew this was coming: You can put in a V-neck after the body tube is knit, just by cutting down the center front of the sweater or vest to the proper depth. You will have to take extra care to reinforce the row of stitches directly below the cut so they don't unravel, but that isn't difficult.

Then just fold your V-neck in at the angle that pleases you best, trim the excess, zigzag along the cut edge, and proceed as for a V-neck that was shaped by steeking and decreases.

Fearless Shaping in General

In fact, you can do all of your shaping after the sweater or vest body tube is knit. Decide where your sleeves should be (location, depth, and so on), shape the front neckline (round or V-neck), make the shoulders more narrow—almost any shaping (except making the piece bigger) can be decided on and performed after the body is knit.

Bear in mind that you will still need to fold under about a half inch of knitted fabric for armholes, front bands, and neckline shaping, so you may need to adjust your sleeve length or front band width to compensate for that loss.

Fearless Fixing

Okay, so you're done with your project, and you spot an error in your Fair Isle patterning.

The first thing you have to decide is whether it's worth addressing—I mean, if you finished the entire sweater and didn't notice until now, then it's not a terrible mistake, right? You may just want to ignore it and resist the urge to point it out to passersby, who will also not notice the mistake if they're not guided directly to it.

But if you can't live with it, and it's too late to rip the knitting out, there are a couple of things you can do to fix small patterning errors.

DUPLICATE STITCH Use the proper yarn color and a large-eye needle and duplicate-stitch over the mistake(s).

PERMANENT MARKERS Yeah, you read that correctly. If the error has been worked with a light yarn, you may just be able to color it with the proper darker shade of permanent marker. I don't recommend doing this for large areas, but trust me, no one will ever know if you fix a stitch here and there this way.

So there you have it.

You now know everything you need to knit Fair Isle, fearlessly and happily. What are you waiting for? Get those needles out and get busy!

2

Geometric Dazzle

IT'S AMAZING HOW DIFFERENT A SIMPLE geometric design looks when worked up in different colorways.

Our cheery children's cardigan is worked in bright summer shades with Knit Picks® Swish™ superwash yarn. The uniquely constructed, fabric-lined companion bag, knit in the same yarn, works well as a purse or a carry-all and is sure to attract attention wherever you take it.

The exact same geometric chart looks totally different when worked in an autumn palette—we used Knit Picks Telemark™ yarn.

The straight-topped floppy hat is warm, yet stylish, pulled low on the forehead. The narrow reversible scarf, worked the long way and closed with a three-needle bind-off, and the fingerless mittens are perfect accessories for a cold fall day.

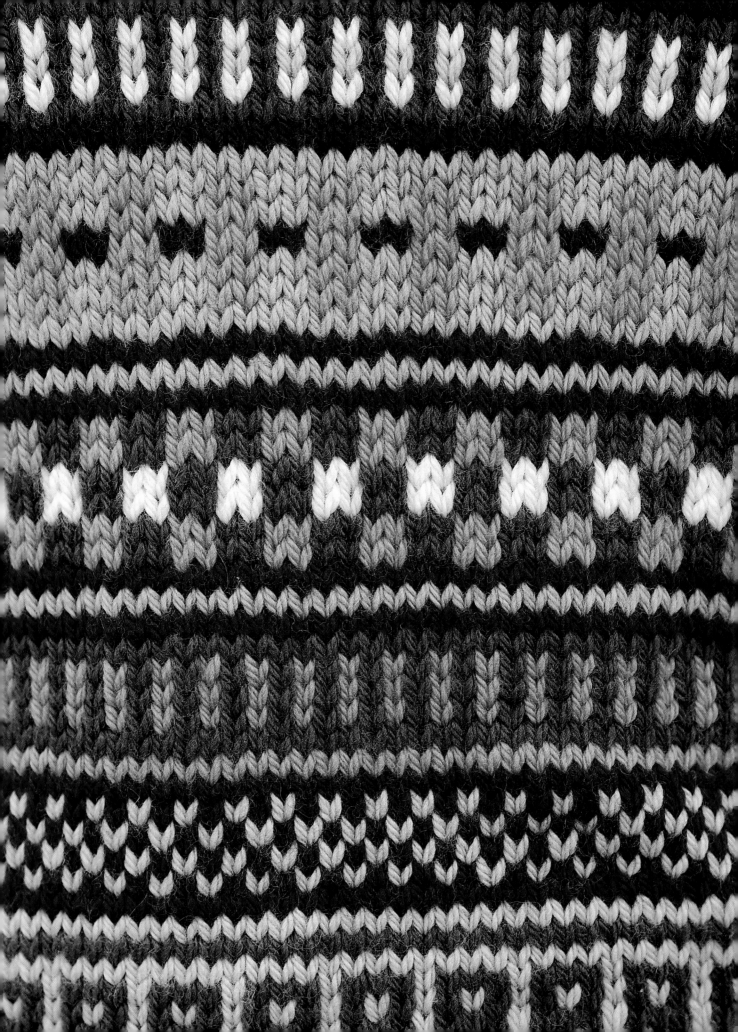

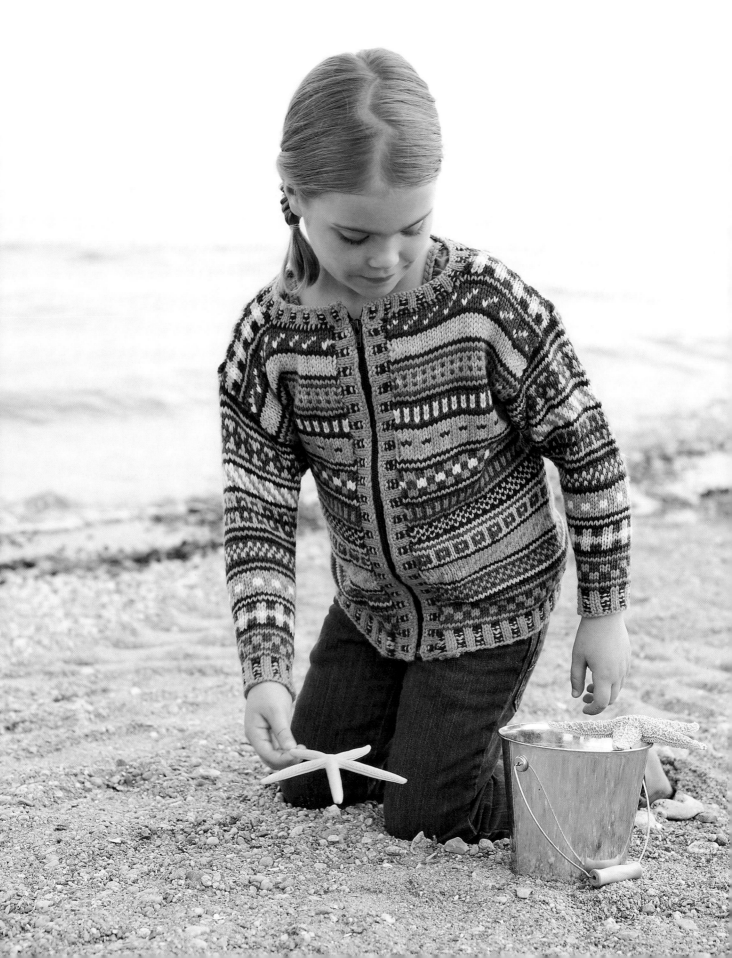

Children's Cardigan

The Geometric Dazzle motif is so versatile that it works in subdued as well as bright colors. Knit this zipper-front children's cardigan in worsted weight, with superwash yarns for ease in laundering.

Yarn Knit Picks Swish Worsted, 100% superwash wool, 50 g, 110 yd., (for all sizes) 2 balls each of #23884 Dublin, #24668 Carnation, #23880 Truffle, #24662 White; 1 (1, 2) balls #24091 Camel Heather; (for all sizes) 1 ball #24300 Bok Choy

Yarn Weight Worsted

Needles Size 7 (U.S.)/4.5 mm 16-in. circular, size 8 (U.S.)/5 mm DPNs, 16-in. and 24-in. circulars, or size needed to obtain gauge

Large-eye blunt needle

2 large stitch markers

4 small stitch markers

Notions 12-in. (14-in., 16-in.) black separating zipper

Sewing thread and needle

Gauge 5.5 sts = 1 in., 6 rows = 1 in. on size 8 needles

Sizes Child Size 2 (4, 6)

Blocked Measurements Chest: 24½ in. (26½ in., 28½ in.); Back Length: 14½ in. (16 in., 17½ in.); Sleeve Length: 10 in. (11 in., 12 in.)

Pattern Difficulty Advanced (uses steeks)

Notes *For more about steek preparation, cutting, and general information, see chapter 1, Fair Isle Basics, page 10.*

The beginning of the round is in the middle of the center front steek. Tie on new colors at the beginning of the round.

Superwash yarn does not felt, so the cut edges on the steeks will look a little more ragged than in projects worked with yarns that felt when washed.

Knitting Instructions

Sweater Ribbing

With a 24-in. size 8 circular needle and Carnation, CO 134 (146, 158) sts. Being careful not to twist the sts, join.

RND 1

Tie on Truffle. Work the first 5 sts alternating Carnation and Truffle, place large marker. Following the **Ribbing Chart**, work K2, P2 corrugated ribbing, working the K sts in Carnation and the P sts in Truffle. Work to within 5 sts of the end of the rnd, place large marker, and work the rem 5 sts alternating Carnation and Truffle. The 10 sts between the markers will be the center front steek.

Work 6 rnds of ribbing as per the **Ribbing Chart**, working all of the Carnation sts in K, and the Truffle and Camel Heather sts in P.

Sweater Body

Beginning where indicated on the **Geometric Dazzle Children's Cardigan Chart**, work the sweater body as shown until it measures 8 in. (9 in., 10 in.).

NEXT RND (ARMHOLE STEEK)

K5, move marker, K28 (31, 34), place small marker, CO 10 sts (alternating colors if it is a 2-color rnd), place small marker, K68 (74, 80), place small marker, CO 10 sts (alternating colors if it is a 2-color rnd), place small marker, K28 (31, 34), move marker, K5. The 10 sts between each new set of markers will be the armhole steeks. (154, 166, 178 sts)

Work even for 4 in. (5 in., 6 in.).

Neckline

RND 1

Work to within 12 (14, 15) sts of the last center steek marker, BO those 12 (14, 15) sts, remove marker, BO rem 5 sts of the rnd.

RND 2

BO the first 5 sts, remove marker, BO the next 12 (14, 15) sts, work to the end of the sts, replace marker, CO 5 sts for the steek, alternating colors if it is a 2-color rnd.

RND 3

Tie on new colors if indicated by the chart border you're working on. CO 5 sts, alternating colors if it is a 2-color rnd, replace marker, work around. (130, 138, 148 sts) Work even until armhole steek measures 6½ in. (7 in., 7½ in.) and sweater body measures 14½ in. (16 in., 17½ in.).

Bind off all sts.

Finish the armhole steeks as desired, and cut them open. Finish the center front steek as desired, and cut it open. Fold the cut steeks in and pin or tack in place if necessary.

Fold the small neckline steek in. Using a yarn color from the last knitted border, sew the sweater back and front together at the shoulders, from the armhole steek to the shoulder neckline edge (as indicated by the folded neckline steek).

Sleeves (make 2)

With Truffle and a 16-in. size 8 circular needle, and beginning at the lower armhole edge, pick up and K 70 (76, 82) sts evenly spaced around the armhole. Place marker at beginning of rnd.

RND 1

K with Truffle.

Begin knitting charted patterns where you left off from the Sweater Body. You may mix and match the border patterns if you like. Do not worry if the pattern reps don't match up at the beginning and end of the rnd.

SLEEVE DECREASE RND 1

K2tog, K, working in established chart motif to within last 2 sts, K2tog.

SLEEVE DECREASE RND 2

K, working in established chart motif.

Rep these 2 rnds until there are 30 (32, 32) sts left. Change to DPNs as necessary. Work even in established chart motif until sleeve measures 8 in. (9 in., 10 in.). Work ribbing as for Sweater Body for 2 in. BO sts loosely in patt. Weave all loose ends in on the inside of the sleeve. Whipstitch the armhole steeks in place on the inside of the sweater.

Continued on page 23

Geometric Dazzle Children's Cardigan Chart

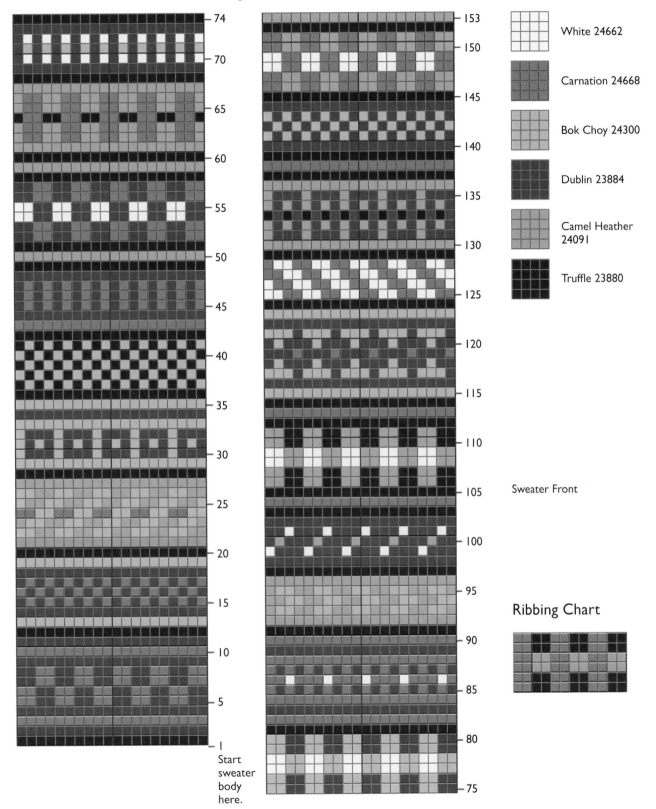

— 74
— 70
— 65
— 60
— 55
— 50
— 45
— 40
— 35
— 30
— 25
— 20
— 15
— 10
— 5
— 1
Start
sweater
body
here.

— 153
— 150
— 145
— 140
— 135
— 130
— 125
— 120
— 115
— 110
— 105
— 100
— 95
— 90
— 85
— 80
— 75

Sweater Front

White 24662

Carnation 24668

Bok Choy 24300

Dublin 23884

Camel Heather
24091

Truffle 23880

Ribbing Chart

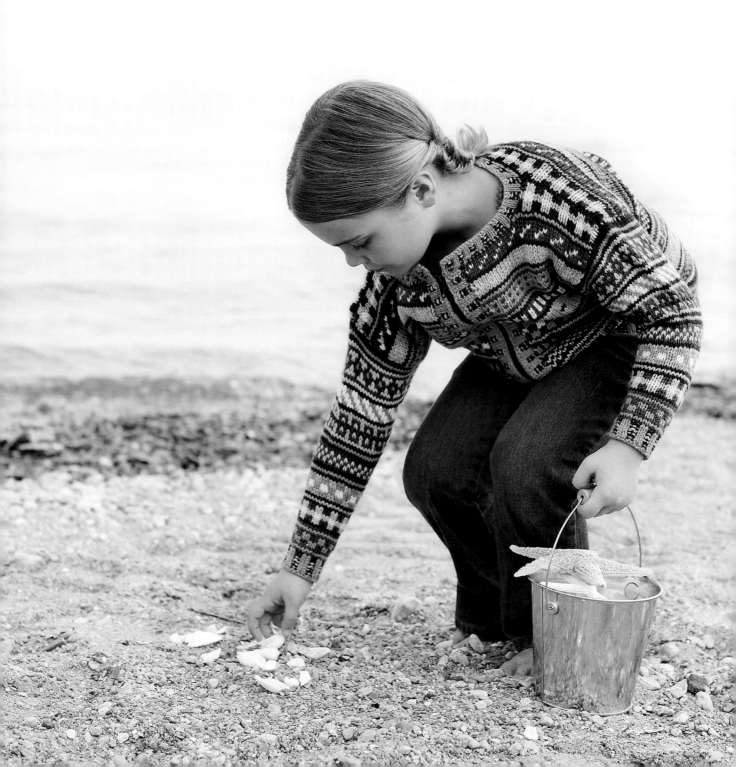

Front Band

With a 16-in. size 8 circular needle and Carnation, pick up and K 74 (78, 86) sts evenly spaced along the right side of one front edge.

BAND ROW 1 (WS)
Work as for Sweater Ribbing, P the Carnation sts, K the Truffle sts. Turn.

BAND ROW 2
(RS) Work as for Sweater Ribbing, K the Carnation sts, P the Truffle sts. Turn.

BAND ROWS 3–4
Rep Band Rows 1–2 with Camel Heather and Carnation.
BO in ribbing with Carnation.
Rep with other front band.
Whipstitch the center front steeks in place on the inside of the sweater. Weave in all loose ends.

Neckband

With a 16-in. size 7 circular needle and Carnation, pick up and K 90 (94, 98) sts evenly spaced around the neckline, including the front bands.
Work ribbing as for Front Bands. BO in ribbing with Carnation.
Whipstitch the front neckline steeks in place on the inside of the sweater. Weave in all loose ends.
Wash and block the sweater to the listed measurements.

Zipper

Pin the zipper in place along the center front openings.
Hand- or machine-stitch the zipper in place.

Bag

This colorful shoulder bag is an easy Fair Isle project for beginners. The ring-top closure makes it fun and funky. The fabric lining gives the bag extra stability and is a nice finishing touch.

Yarn Knit Picks Swish Worsted, 100% superwash wool, 50 g, 110 yd., 2 balls each of #23884 Dublin, #24668 Carnation; 1 ball each of 23880 Truffle, #24091 Camel Heather, #24300 Bok Choy; Knit Picks Bare Superwash Merino Worsted, 100% superwash Merino wool, 100 g, 220 yd., 1 skein #23855 Natural

Yarn Weight Worsted

Needles Size 7 (U.S.)/4.5 mm 16-in. circular, size 8 (U.S.)/5 mm DPNs, 16-in. circular, or size needed to obtain gauge, size G (U.S.)/4.25 mm crochet hook

Large-eye blunt needle

Assorted stitch markers

Notions ¾ yd. coordinating print fabric for lining, matching thread

1 yd. 1-in.-wide grosgrain ribbon (any color)

4-in. metal ring

1⅛-in.-thick wooden circle, 7-in. diameter

Gauge 5.5 sts = 1 in., 6 rows = 1 in. on size 8 needles

Measurements after Assembly 20 in. around, 21 in. tall from sewn opening hem to base

Pattern Difficulty Easy

Note *See chapter1, Fair Isle Basics, page 8 for stranding instructions.*

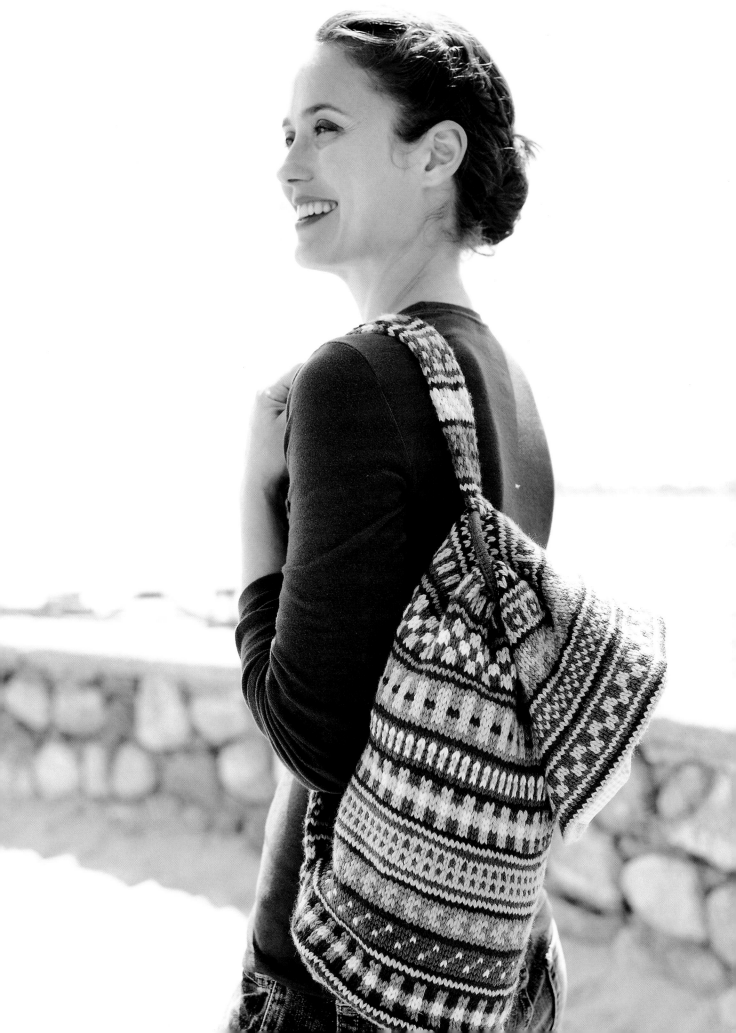

Knitting Instructions

Note Not all border reps will finish fully at the end of the rnd.

Bag Hem

With a 16-in. size 7 circular needle and Carnation, CO 110 sts. Being careful not to twist the sts, join. Beginning of rnd is center back of bag.

RNDS 1–10 (FACING)

K.

RND 11 (FOLD RND)

P.

Bag Body

Change to size 8 circular needle. Work **Geometric Dazzle Children's Cardigan Chart**, beginning at Rnd 1, until bag body measures 20 in. from Fold Rnd.

Bag Bottom

Follow **Geometric Dazzle Bag Chart** beginning at Rnd 1, working decs where shown on chart, using K2tog TBL for decs indicated on the right side of the chart, and K2tog for decs indicated on the left side of the chart. Change to DPNs as necessary.

Cut yarn, leaving a 10-in. tail, thread tail in a large-eye needle, and pull through remaining loops. Tighten and tie off.

Bag Body Finishing

Fold hem facing down and in, and sew in place. Weave all loose ends in on the wrong side of the bag.

Shoulder Handle

With Carnation and size 8 DPNs, CO 20 sts, without twisting sts, join. Beginning of rnd is center back of handle.

Work **Geometric Dazzle Children's Cardigan Chart** until bag handle is 24 in. long. BO.

It is not necessary to weave ends in on the inside of the handle.

Wash and block bag and handle.

Bag Assembly

FABRIC LINING

Cut one bottom lining circle, 7½ in. in diameter. Cut one body lining piece, 21 in. wide by 20 in. long. With right sides together and matching thread, sew the body lining along the 20-in. edge, using a ½-in. seam allowance. With right sides together, sew the bottom circle to the body, using a ½-in. seam allowance, easing excess fabric. Place wooden circle cutout in bottom of bag for base, then arrange lining in bag, wrong side of fabric lining to wrong side of bag. Tack lining to the bag just above the base to hold firmly in place. Fold upper lining edge down and in so that the fold covers the lower edge of the knitted facing, and sew in place.

BAG RING

With size G crochet hook and Dublin, work single crochet around entire ring until covered. Cut yarn, thread tail through the crochet stitches, and trim.

HANDLE

Thread 1-in.-wide grosgrain ribbon through handle and tack at either end. Sew the handle to the bag, through all layers, at the center back base bottom. Place the ring over the top of the bag and slide it down. Sew the upper edge of the handle 7 in. from the top of the bag (making sure that the ring is below the top of the handle), through all layers, at the center back. Slide the ring up to the upper handle seam. Tack the handle in place through all layers just below the ring to secure the ring location.

To Use Bag

Gather the top of the bag and thread it through the ring for closure.

Geometric Dazzle Bag Chart

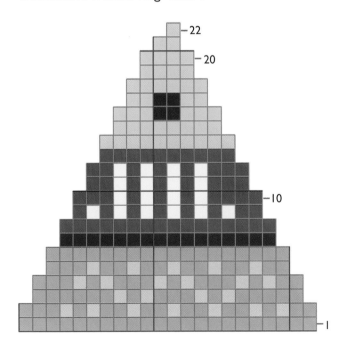

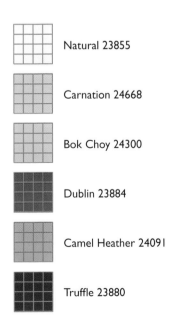

Natural 23855

Carnation 24668

Bok Choy 24300

Dublin 23884

Camel Heather 24091

Truffle 23880

Floppy Hat

An autumn colorway totally changes the look of our Geometric Dazzle motif. This straight-top, floppy hat, sized from toddler to adult, is an easy stranded project that even beginners can complete.

Yarn	Knit Picks Telemark, 100% Peruvian highland wool, 50 g, 103 yd., 1 ball each of #24022 Cilantro Heather, #24024 Flame Heather, #23940 Lichen, #24026 Squirrel Heather, #23926 Black
Yarn Weight	Sport
Needles	Size 5 (U.S.)/3.75 mm 16-in. circular, or size needed to obtain gauge
	Large-eye blunt needle, stitch markers

Pattern Sizes	Toddler (Child, Youth, Adult Small, Adult Large)
Measurements	Hat Length: 6 in. (6 in., 7 in., 8 in., 9 in.); Hat Circumference (unstretched) 15 in. (16¼ in., 17½ in. 18¾ in., 20 in.)
Pattern Difficulty	Easy
Fair Isle Gauge	6.5 sts = 1 in., 8 rnds = 1 in. on size 5 needles
Note	*See chapter 1, Fair Isle Basics, page 8 for stranding instructions.*

Knitting Instructions

With Lichen and 16-in. size 5 circular needle, CO 100 (108, 116, 124, 132) sts. Making sure that the sts are not twisted, join.

RNDS 1-6

Work K1, P1 ribbing.

RND 7

K.

Begin **Geometric Dazzle Floppy Hat and Reversible Scarf Chart** at Rnd 1. Work even, following chart, until hat measures 5⅞ in. (5⅞ in., 6⅞ in., 7⅞ in., 8⅞ in.) long.

NEXT RND

K with Lichen.

BIND-OFF

Divide sts evenly on either side of the circular needle, and work a three-needle bind-off with Lichen.

Weave all ends in on the inside of the hat. Wash and block hat.

Geometric Dazzle Floppy Hat and Reversible Scarf Chart

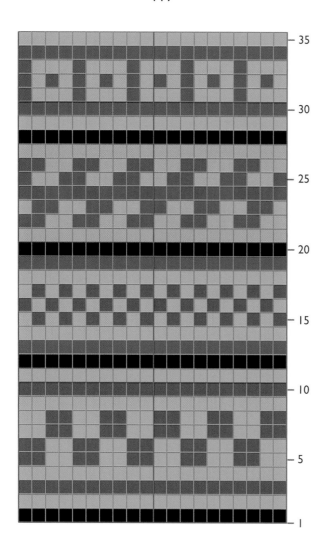

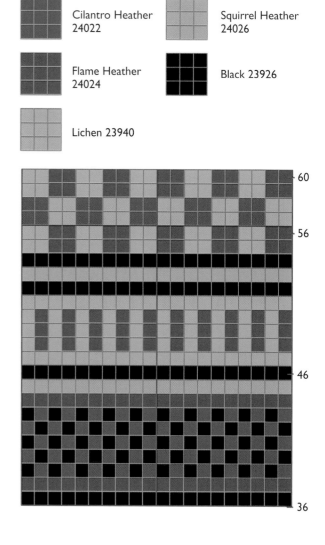

Cilantro Heather 24022

Squirrel Heather 24026

Flame Heather 24024

Black 23926

Lichen 23940

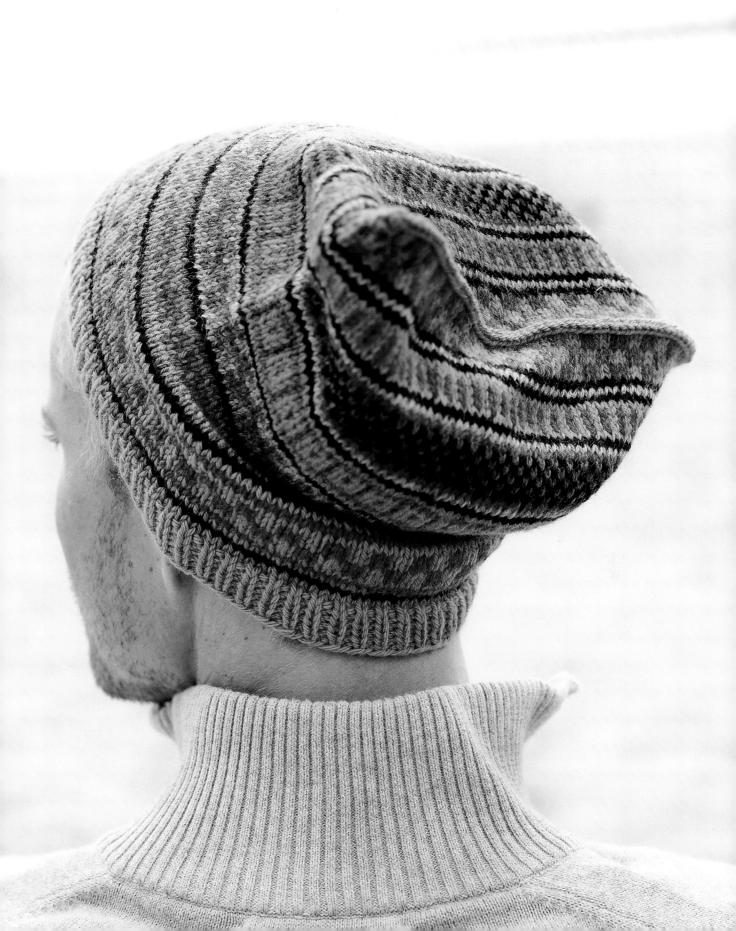

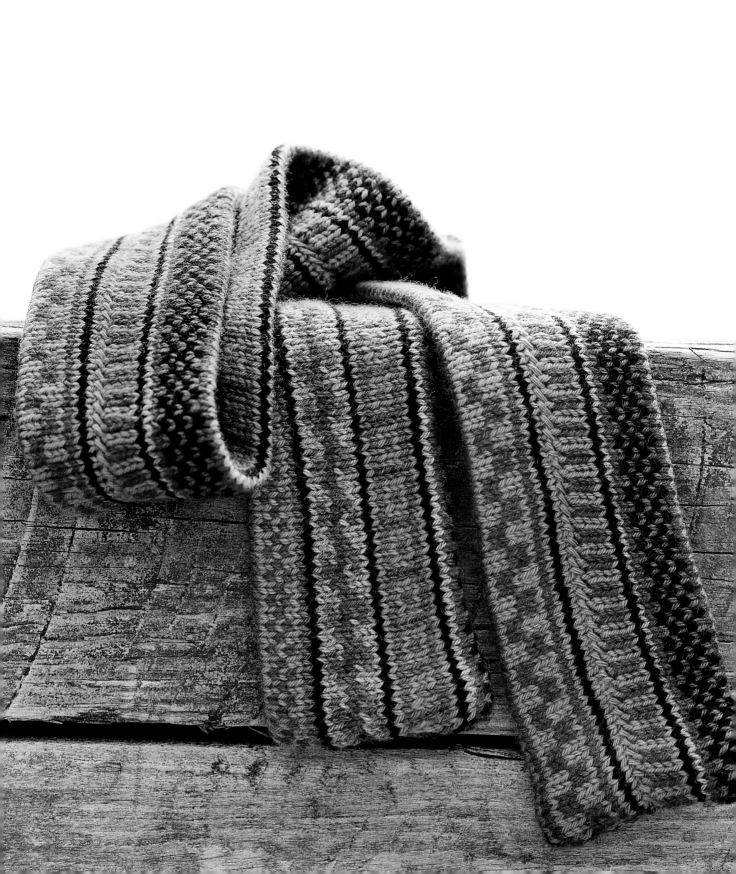

Reversible Scarf

This skinny, reversible scarf, a companion to the *Geometric Dazzle Floppy Hat*, is worked lengthwise in a circle, then cut open and closed with a bind-off that eliminates the need for a long seam.

Yarn Knit Picks Telemark, 100% Peruvian highland wool, 50 g, 103 yd., 1 ball each of #24022 Cilantro Heather, #24024 Flame Heather, #24026 Squirrel Heather, #23926 Black; 2 balls #23940 Lichen

Yarn Weight Sport

Needles Size 6 (U.S.)/4 mm 29-in. circular, or size needed to obtain gauge Large-eye blunt needle, stitch markers

Pattern Size One size fits all

Measurements 3¾ in. wide, 52 in. long

Pattern Difficulty Easy

Fair Isle Gauge 5.75 sts = 1 in., 7 rnds = 1 in. on size 6 needles

Note *See chapter 1, Fair Isle Basics, page 8 for stranding instructions.*

Knitting Instructions

With Lichen and 29-in. size 6 circular needle, CO
300 sts. Making sure that the sts are not twisted, place
marker, join.

RND 1 K.

Begin **Geometric Dazzle Floppy Hat and Reversible
Scarf Chart** at Rnd 1. Work even, following chart, for
the first 2 motif borders. Skip the next border, and then
work the chart for the next 3 borders.

NEXT RND K with Lichen.

Following instructions for reinforcing steeks (chapter
1, Fair Isle Basics, page 10), reinforce the scarf at the
beginning of the rnd, and cut the scarf open between
the reinforcement stitching.

BIND-OFF Folding the scarf so that the WS is out, pick
up a loop from the first cast-on st and place it on the left
needle. K the loop and the st together. Pick up a loop
from the next cast-on st and place it on the left needle.
K the loop and that st together, then pass the st from the
left needle over the most recent st.

Rep around the scarf.

Turn the scarf right side out, fold the cut edges in, and
sew the bottom seams.

Wash and block the scarf.

Fingerless Mittens

Knit a pair of coordinating fingerless mittens with leftover yarn from the *Geometric Dazzle Floppy Hat* and *Reversible Scarf*. Wear them alone or over store-bought black wool gloves.

Yarn Knit Picks Telemark, 100% Peruvian highland wool, 50 g, 103 yd., 1 ball each of #24022 Cilantro Heather, #24024 Flame Heather, #23940 Lichen, #24026 Squirrel Heather, #23926 Black, or use leftover yarns from the **Geometric Dazzle Floppy Hat** or **Geometric Dazzle Reversible Scarf**.

Yarn Weight Sport

Needles Size 5 (U.S.)/3.75 mm DPNs, or size needed to obtain gauge

Large-eye blunt needle

Stitch markers

2 safety pins

Pattern Sizes Child (Women's, Men's)

Measurements Width at Hand (not including thumb): 3⅛ in. (3¾ in., 4⅛ in.); Length: 6½ in. (7¾ in., 8¼ in.)

Pattern Difficulty Easy

Fair Isle Gauge 6.5 sts = 1 in., 8 rnds = 1 in. on size 5 needles

Note *See chapter 1, Fair Isle Basics, page 8 for stranding instructions.*

Note *Choose any Fair Isle borders from the **Geometric Dazzle Floppy Hat and Scarf Chart**, in any order, for the Fingerless Mittens. If you are using leftover yarns, substitute ribbing colors as needed if you don't have enough of the suggested color.*

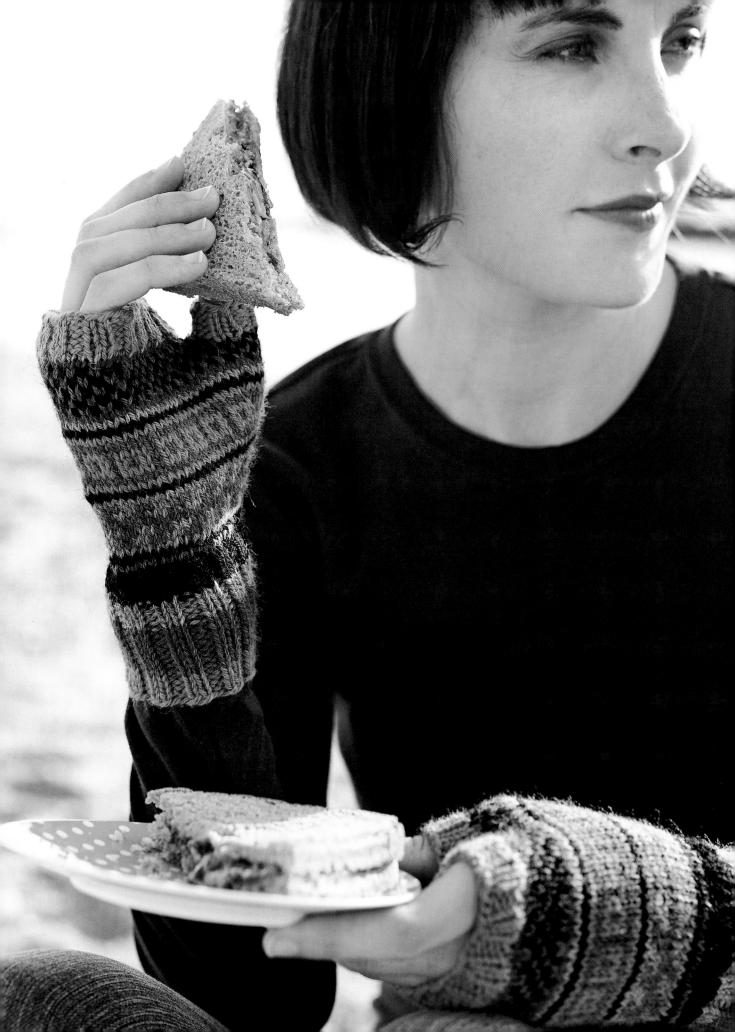

Knitting Instructions (make 2)

With Lichen and size 5 DPNs, CO 40 (48, 56) sts. Without twisting the sts, join.

Cuff

Work 4 rnds each in K2, P2 ribbing in the following colors: Lichen, Cilantro Heather, Flame Heather, Squirrel Heather, Black, or in the colors you desire.

PALM RND 1

K 1 rnd Black.

PALM RNDS 2–5

Select any border from the **Geometric Dazzle Floppy Hat and Reversible Scarf Chart**. Work the first 4 rnds of that chart.

THUMB GUSSET RND 1

With the background color, if it is a 2-color rnd, pick up and K 1 st, place marker, work rem of rnd according to the established border chart.

THUMB GUSSET RND 2

With the opposite color if it is a 2-color rnd, K 1, move marker, work rem of rnd according to the established border chart.

THUMB GUSSET RND 3

With the background color, if it is a 2-color rnd, pick up and K 1 st, work rem st in alternate color, pick up and K 1 st with background color, move marker, work rem of rnd according to the established border chart.

THUMB GUSSET RND 4

Work the sts before the marker in alternating colors if it is a 2-color rnd, move marker, work rem of rnd according to the established border chart.

Rep Thumb Gusset Rnds 3–4, alternating the st color of the gusset sts on 2-color rnds, until there are 13 (15, 17) sts before the marker.

Work 2 (4, 6) rnds even in the established border chart motif.

Hand

Place the 13 (15, 17) thumb sts divided on 2 safety pins, work rem of rnd according to the established border chart.

Work 2 (4, 6) rnds even in the established border chart motif.

Upper Ribbing

Work 4 rnds K2, P2 ribbing in Lichen, or desired leftover yarn color. BO loosely.

Thumb

Place the 13 (15, 17) sts divided as evenly as possible on 3 DPNs.

THUMB RND 1

With Lichen, or desired leftover yarn color, pick up and K 1, K rem of rnd. (14, 16, 18 sts)

THUMB RIBBING, CHILD'S AND MEN'S SIZES

Work 4 rnds K1, P1 ribbing. BO loosely.

THUMB RIBBING, WOMEN'S SIZE

Work 4 rnds K2, P2 ribbing. BO loosely.

Weave all ends in on the inside of the mittens. Wash and block mittens.

3

Stripes, Checks, and Curlicues

IT'S BEEN MORE THAN 10 YEARS SINCE I BOUGHT my first self-patterning yarns, and I am still enchanted as the colors magically change.

The magic is even more powerful when those yarns are used for stranded knitting. I get all of the visual interest of continually changing colors without the fuss of cutting, tying, and weaving in ends, not to mention buying and keeping track of many balls of yarn.

This trio of deceptively simple patterns uses only two yarns per project. The gradual color changes in Crystal Palace's Mini Mochi sock yarn, which is used for the Stripes, Checks, and Curlicues Hoodie Vest and for the companion socks, blend and contrast in beautifully random combinations. The Felted Bag uses two colorways of Crystal Palace's Kaya, a beautiful bulky self-striping yarn that felts almost instantly. The random color changes make this wonderful bag quick to knit and beautiful to own.

Hoodie Vest

Knit this wonderful zipper-front hoodie vest using only two colors of yarn. The long repeats in Crystal Palace's soft and beautiful Mini Mochi yarn result in gorgeous, random Fair Isle color combinations.

Yarn	Crystal Palace Yarns Mini Mochi, 80% Merino wool/20% nylon, 50 g, 195 yd., 4 (5, 5, 6, 6) balls #120 Fireworks; 4 (5, 5, 6, 6) balls #116 Feldspar
Yarn Weight	Fingering
Needles	Size 2 (U.S)/2.75 mm 16-in. and 32-in. circular needles, size 2.5 (U.S.)/3.0 mm 16-in. and 32-in. circular needles, or size needed to obtain gauge
	Large-eye blunt needle
	Stitch markers
Notions	20-in. gray separating zipper (Small to X-Large); 22-in. gray separating zipper (XX-Large)
	Matching sewing thread

Pattern Sizes	Small (Medium, Large, X-Large, XX-Large)
Measurements	Chest: 36 in. (40 in., 44 in., 48 in., 52 in.); Back Length: 23 in. (23½ in., 24 in., 24½ in., 25 in.); Length to Armhole (all sizes): 14 in.; Armhole Length: 9 in. (9½ in., 10 in., 10½ in., 11 in.); Shoulder Width: 5½ in. (6 in., 6½ in., 7 in., 7½ in.); Hood Length (all sizes): 12 in.
Pattern Difficulty	Advanced (uses steeks)
Fair Isle Gauge	9 sts = 1 in., 9 rnds = 1 in. on size 2.5 needles
Note	*For more on the stranding, steek preparation, knitting, and cutting techniques used in this pattern, see chapter 1, Fair Isle Basics, page 5.*

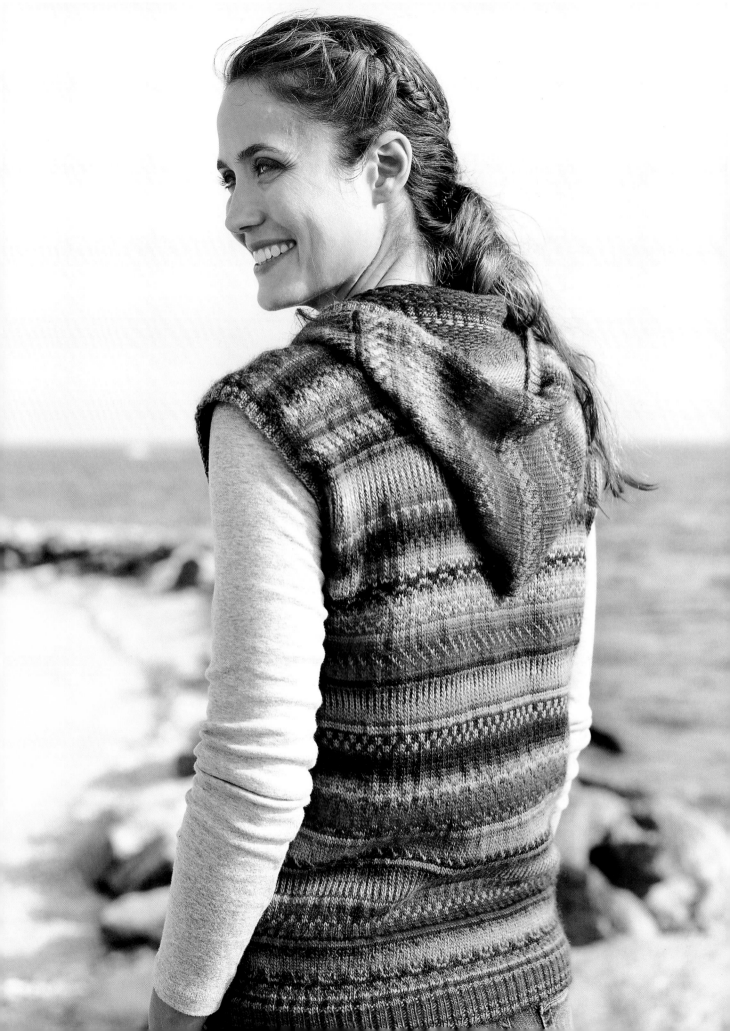

Knitting Instructions

Vest Body

With 32-in. size 2 circular needle and Feldspar, CO 298 (330, 362, 394, 426) sts. Without twisting the sts, join.

RIBBING RND 1

K5, place marker, work K2, P2 ribbing to within 5 sts of the end, place marker, K5. The 10 sts between the markers are the center front opening steek. New rnds begin in the middle of the center front steek.

RIBBING RND 2

K5, move marker, work K2, P2 ribbing to marker, move marker, K5.

Continue ribbing in this manner, working 2 rnds Feldspar, 2 rnds Fireworks, for 14 rnds total.

BODY RND 1

Change to 32-in. size 2.5 needle and, with Fireworks, begin **Checks, Stripes, and Curlicues Hoodie Vest Chart 1** at Rnd 1.

Follow **Chart 1** and **Chart 2** (repeating as necessary throughout) for the body of the vest, working the steek sts in alternating colors on 2-color rnds, until the body measures 14 in.

ARMHOLE STEEK RND 1

K5 steek sts, alternating colors if it is a 2-color rnd, move marker, K 67 (75, 83, 91, 99) sts according to the chart, place marker, K1, CO 8, alternating colors if it is a 2-color rnd, K1, place marker (these 10 sts are the first armhole steek), K 150 (166, 182, 198, 214) sts across the vest back, place marker, K1, CO 8, alternating colors if it is a 2-color rnd, K1, place marker (these 10 sts are the second armhole steek), K 67 (75, 83, 91, 99) sts, move marker, K5. (314, 346, 378, 410, 442 sts)

ARMHOLE STEEK RND 2

Work according to chart, working the steek sts in alternating colors on 2-color rnds.

Armhole Shaping

Work according to chart, working the steek sts in alternating colors on 2-color rnds, dec 1 st on either side of both armhole steeks, every other rnd, 4 times (16 sts dec). (298, 330, 362, 394, 426 sts)

Work even until body of sweater measures 23 in. (23½ in., 24 in., 24½ in., 25 in.).

NEXT RND

K with background color of current chart border.

BO all sts with background color of current chart border.

Steeks

Prepare armhole steeks as directed on page 10. Cut the armhole steeks open. Fold in the cut armhole steeks and stitch them down.

Armhole Band

With a 16-in. size 2 needle and Feldspar, beginning at the shoulder, on the RS at the folded edge, pick up and K 1 st for each row around the armhole opening, adjusting the st number to have an even number of sts if needed. Turn.

ARMHOLE BAND ROW 1 (WS)

Work K2, P2 ribbing. Turn.

ARMHOLE BAND ROW 2 (RS)

Tie on Fireworks. Work K2, P2 ribbing. Turn.

ARMHOLE BAND ROW 3 (WS)

Work K2, P2 ribbing. Turn.

ARMHOLE BAND ROW 4 (RS)

With Feldspar, work K2, P2 ribbing. Turn.

BO in patt with Feldspar.

Rep with other Armhole Band.

Shoulder Seams

Measure in 5½ in. (6 in., 6½ in., 7 in., 7½ in.) from outside edge of the Armhole Band, and sew shoulder seams.

Front Neckline Shaping

Measure and mark 2 in. down from the upper BO edge on either side of the center front steek. Measure and mark matching curves angling up from the center mark to the sewn shoulder seam on either side of the center front steek. Sew a line of contrasting basting thread or yarn along that marked line. Measure ¾ in. above the basted line, and reinforce that line in your desired manner for a new steek. If you are crocheting or hand-sewing your new steek line, stop at the center of the

Checks, Stripes, and Curlicues Hoodie Vest Chart

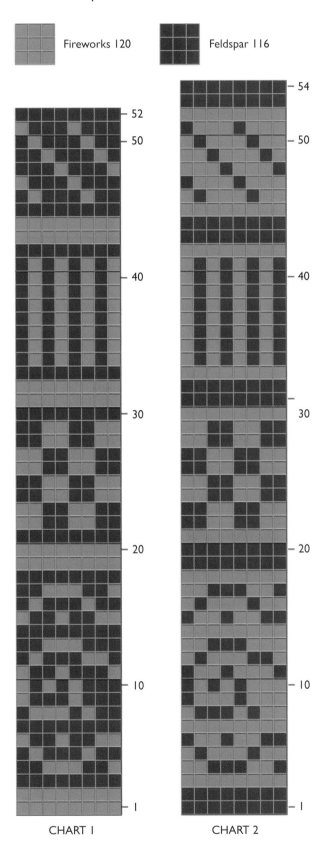

Fireworks 120

Feldspar 116

CHART 1

CHART 2

front steek, cut the yarn/thread, and begin again for the other side of the new steek. If you are machine-sewing your new steek line, you may sew across the center front steek without interruption. Trim the excess fabric along the newly sewn steek line. **Do not cut the center front steek open.**

Note No shaping is necessary on the back neckline.

Hood

HOOD RND 1

With 16-in. size 2.5 circular needle and Fireworks, pick up and K 5 sts beginning at the right side center front of the center front steek, place marker, pick up and K 112 (120, 128, 136, 144) sts around the neckline, K to the other edge of the center front steek, place marker, pick up and K 5 sts along the steek edge. The 10 sts between the markers are the center front hood steek. Begin new rnd in the center of the center front hood steek. (122, 130, 138, 146, 154 sts)

HOOD RND 2

K5, move marker, inc 20 sts evenly spaced to marker, move marker, K5. (142, 150, 158, 166, 174 sts)
Work even, beginning with Rnd 1 of **Chart 2**, following with **Chart 1**, repeating as necessary until Hood measures 12 in.

Note You might not end each rnd with a full rep.

NEXT RND

K with the background color of the current chart border.
BO with the background color of the current chart border.

Center Front Steek

Work steek reinforcement in your desired manner, from the top of the hood to the bottom of the vest, along the center front steek. Cut the center front steek open from the bottom to the top of the hood. Fold the steek edges in and baste in place.

Hood Seam

Fold the hood in half and sew the top seam.

Front Band

With 32-in. size 2 circular needle and Feldspar, beginning at the lower ribbing edge on the RS of the steek fold, pick up and K 1 st for each row up the front opening, around the hood, and back down the other front opening, along the folded steek edges. Adjust st number so that your st count is a multiple of 4 + 2, if necessary. Turn.

ROW 1 (WS)

Work K2, P2 ribbing. Turn.

Work K2, P2 ribbing, alternating 2 rows Feldspar and 2 rows Fireworks, twice (8 ribbing rows total). BO in patt with Feldspar.

Weave all loose ends in on the inside of the vest. Wash and block vest. Pin zipper in place along center front opening and machine- or hand-sew with matching sewing thread.

Women's Socks

The long repeats in Crystal Palace's wonderful Mini Mochi yarn mean that you likely won't get identical socks, but fraternal socks are beautiful, too.

Yarn Crystal Palace Yarns Mini Mochi, 80% Merino wool/20% nylon, 50 g, 195 yd., Women's Average Shoe Size 5–8: 1 ball #120 Fireworks, 1 ball #116 Feldspar; Women's Average Shoe Size 9–10, Women's Wide Shoe Size 5–8: 1 ball #120 Fireworks, 2 balls #116 Feldspar; Women's Wide Shoe Size 9–10: 2 balls #120 Fireworks, 2 balls #116 Feldspar

Note *You may be able to use some leftover yarn from the **Stripes, Checks, and Curlicues Hoodie Vest** to complete these socks. Or you can work the toe in solid Fireworks, to save yarn.*

Yarn Weight Fingering

Needles Size 2 (U.S.)/2.75 mm, 4 or 5 DPNs or 1 or 2 circular needles, or size needed to obtain gauge; size 3 (U.S.)/3.25 mm DPN for casting on

Large-eye blunt needle

Stitch markers

Pattern Sizes Women's Average (Women's Wide) Shoe Size 5–6 (7–8, 9–10)

Measurements Cuff Length (all sizes): 6 in.; Cuff Width Women's Average: approx 3⅝ in. wide, Women's Wide: approx 4¼ in. wide; Foot Length: Shoe Size 5–6: 8¼ in., Shoe Size 7–8: 9¼ in., Shoe Size 9–10: 10¼ in.

Pattern Difficulty Advanced (uses short-row heel technique)

Fair Isle Gauge 10 sts = 1 in., 9 rnds = 1 in. on size 2 needles

Note *For more about stranding, see chapter 1, Fair Isle Basics, page 10.*

Note *When following charts, work only 1 rnd of solid color (the current background color) between the border motifs. Omit the other solid color rnds on the chart. Note that not all pattern reps will complete fully at the end of the rnd.*

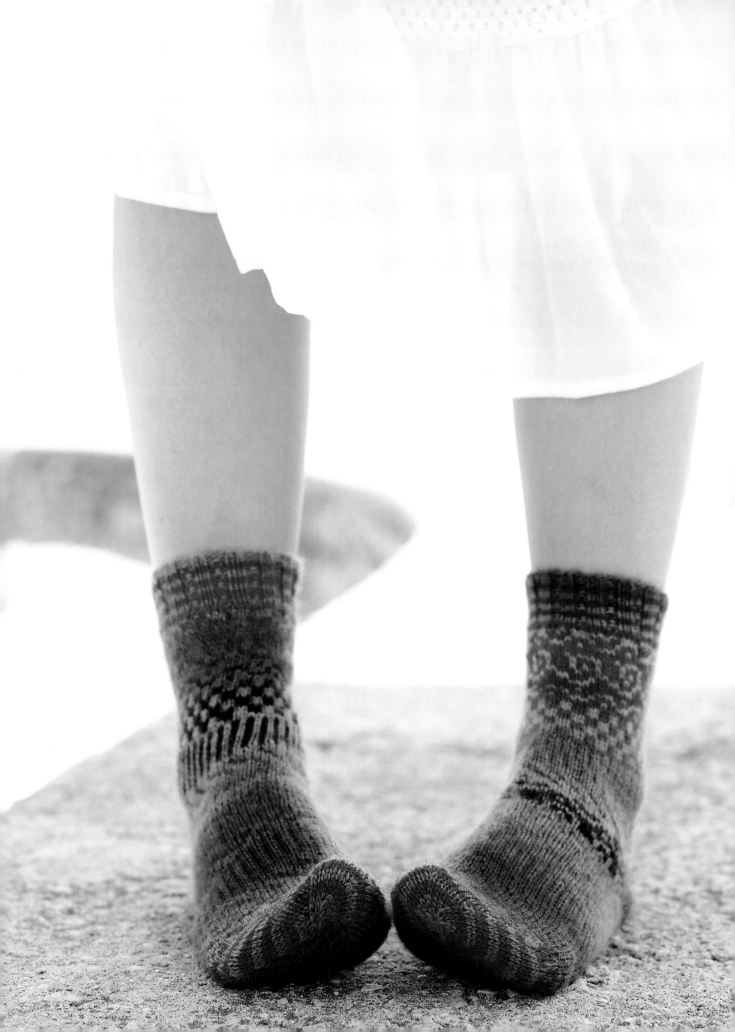

Knitting Instructions (make 2)

With size 3 DPN and Feldspar, CO 60 (64) sts. Distribute sts on 3 or 4 size 2 DPNs or 1 or 2 size 2 circulars as desired. Without twisting the sts, join. Beg of rnd is center back of sock.

RIBBING RND 1

Work K2, P2 ribbing.

Work 16 rnds total of K2, P2 ribbing, alternating 2 rnds each Feldspar and Fireworks.

Cuff

With Feldspar, inc 12 (20) sts evenly spaced in rnd. (72, 84 sts)

Beginning with Row 4 of **Stripes, Checks, and Curlicues Hoodie Vest Chart 2**, work chart, following with **Stripes, Checks, and Curlicues Hoodie Vest Chart 1** (beginning with Row 4), working only 1 solid color rnd in the current background color between the borders (omit the other solid color rnds) until the cuff measures 6 in.

Heel Setup

Cut Fireworks. With Feldspar, K 15 (16) sts. Place the next 42 (52) sts on a separate needle or holder for the instep, place the remaining 15 (16) sts with the first for the heel. (30, 32 heel sts)

HEEL ROW 1

Turn. Working with Feldspar only, Sl 1, P28 (30), turn.

HEEL ROW 2

Sl 1, K27 (29), turn.

Continue in this manner, working 1 less st before the turn on each row, until 9 (11) K sts rem after the slipped st.

HEEL TURN ROW 1 (HTR 1)

Sl 1, P8 (10), Sl 1, pick up loop in the gap before the next st, P the Sl st and the loop together, turn.

HEEL TURN ROW 2 (HTR 2)

Sl 1, K8 (10), Sl 1, pick up and K 1 st in the gap before the next st, PSSO, turn.

Continue to work HTR 1 and HTR 2, working 1 more K or P st before the turn on each row, until you have worked across all of the sts. On the final row, pick up the st or the loop in the gap between the heel sts and the instep sts. End with a P row.

Foot Setup

Sl 1, K14 (15). Begin new rnd in center of heel. Redistribute sts on needles as desired.

WOMEN'S AVERAGE FOOT

Knit the foot, following the charts as before, until the foot measures: for Shoe Size 5–6: 4¼ in. (Shoe Size 7–8: 5¼ in., Shoe Size 9–10: 5½ in.).

WOMEN'S WIDE FOOT

Knit the foot, following the charts as before, until the foot measures: for Shoe Size 5–6: 4 in. (Shoe Size 7–8: 5 in., Shoe Size 9–10: 5¼ in.).

TOE DECREASE RND 1

With Feldspar, K.

TOE DECREASE RND 2

With Feldspar, *K10 (12), K2 tog*, rep around. (6 sts dec)

TOE DECREASE RND 3

With Fireworks, K.

TOE DECREASE RND 4

With Fireworks, *K9 (11), K2 tog*, rep around. (6 sts dec)

Continue in this manner, alternating 2 rnds Feldspar with 2 rnds Fireworks, working 1 less st before the decs on the even number rnds, until 12 sts rem.

Cut yarn, leaving an 8-in. tail. Thread tail in a large-eye needle and pull the tail through the remaining sts. Tighten and tie off. Weave all loose ends in on the inside of the sock. Wash and block sock.

Felted Bag

Fair Isle designs can be subtle, too, as this bag proves. Worked in Crystal Palace Kaya yarn, it's the perfect companion to the *Stripes, Checks, and Curlicues Hoodie Vest.* The braided I-cord handles, folded cuff, and bead detailing add interest to this simply constructed bag.

Yarn Crystal Palace Yarns Kaya, 100% wool, 50 g, 65 yd., 3 balls each of #0125 Borealis, #0114 Cobblestones

Yarn Weight Bulky

Needles Size 11 (U.S.)/8 mm 16-in. circular, or size needed to obtain gauge; 2 size 13 (U.S.)/9 mm DPNs

Large-eye blunt needle

Mesh zippered lingerie bag

Top-loading washing machine

Notions Coordinating beads, strung on a wire

Sewing thread

Measurements
Before Felting Approx 13 in. across, 16½ in. long

Measurements
After Felting with
Top Folded Down 9 in. across, 10½ in. long

Pattern Difficulty Easy

Fair Isle Gauge Approx 3.5 sts = 1 in., approx 3.5 rows = 1 in. on size 11 needles

Note *For more about stranding, see chapter 1, Fair Isle Basics, page 8.*

Note *This yarn felts very quickly. Check your washer frequently during the felting process and remove items when they are felted to your satisfaction.*

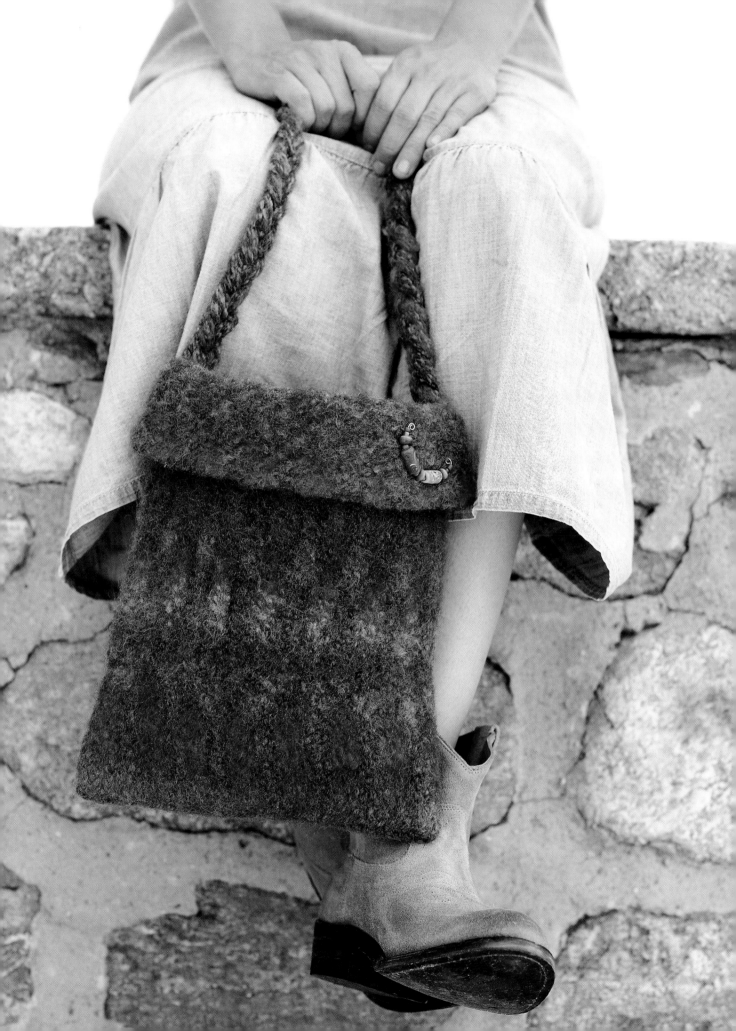

Knitting Instructions

Bag Body

With Cobblestones and size 11 circular needle, CO 90 sts. Without twisting the sts, join.

Work **Stripes, Checks, and Curlicues Felted Bag Chart 1** three times for top of bag.

Work **Stripes, Checks, and Curlicues Felted Bag Chart 2** four times.

Work **Stripes, Checks, and Curlicues Felted Bag Chart 3** once.

Bag should measure 16½ in. long.

With Cobblestones, BO all sts.

With Cobblestones, sew bottom seam.

I-Cord Handles (Make 1 Cobblestones and 2 Borealis)

With size 13 DPN, CO 4 sts. Do not turn.

ROW 1

Slide sts to right side of needle, bring yarn around behind needle, K across. Do not turn.

Rep Row 2 until handle is 24 in. long.

FINISH ROW 1

Slide sts to the right side of the needle, bring yarn around behind the needle, K2 tog twice. Do not turn.

FINISH ROW 2

Slide the sts to the right side of the needle, bring yarn around behind the needle, K2 tog.

Cut yarn and pull through remaining loop and tighten. Using large-eye blunt needle, weave the ends inside the I-cord.

Felting Instructions

Place bag body and the I-cords in a mesh zippered lingerie bag. Set your washer on a small load setting with hot wash and cold rinse cycles. Add a small amount of laundry soap to the water, and allow the items to agitate. Check the felting progress frequently, as this yarn felts almost immediately. When the bag and handles are felted to your satisfaction, remove them from the hot water (using gloves if needed), and rinse them in cold water. You may do this in a sink, under running water. Spin the excess moisture from the items. Straighten the I-cords. Even out the edges of the bag body, pulling if needed in order to get the edges straight. Fold the upper edge down approx 2½ in. Lay on a flat surface, and allow the pieces to air-dry.

BAG ASSEMBLY

Braid the handles together, tacking the ends. With matching sewing thread, sew the braided handles inside the upper edge of the bag, at the sides. String assorted glass beads on a wire. Bend each end of the wire into a little spiral. Bend the wired beads in a curve. Sew to upper bag cuff with sewing thread.

Stripes, Checks, and Curlicues Felted Bag Chart

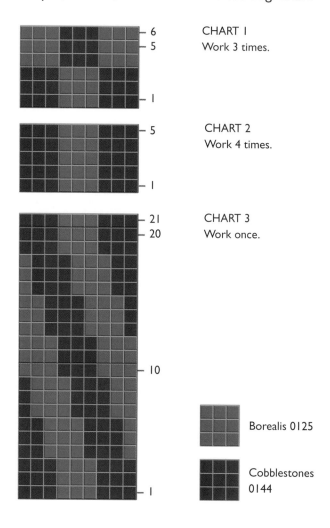

CHART 1
Work 3 times.
— 6
— 5
— 1

CHART 2
Work 4 times.
— 5
— 1

CHART 3
Work once.
— 21
— 20
— 10
— 1

Borealis 0125

Cobblestones 0144

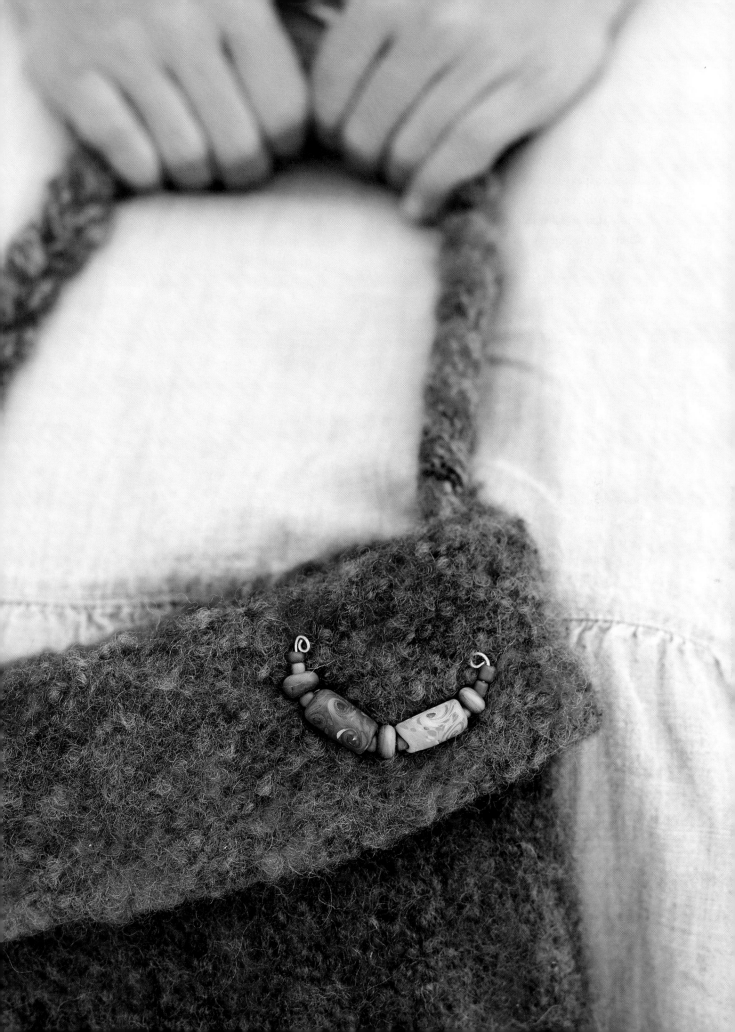

4

Holiday Fun

OUR MODERN TAKE ON HOLIDAY DÉCOR includes an oversized stocking with jolly borders of wrapped packages, golden stars, jaunty Santa hats, and romping reindeer, knit from versatile Knit Picks Palette™ yarns. With its picot hem and I-cord loop, this stocking is ready to hang on the mantel and fill with wonderful surprises.

The adorable little companion drawstring bags, knit using the stars and the wrapped packages borders, are perfect for small gifts under the tree. They're quick to knit, fun to give, and pretty enough to become treasured heirlooms.

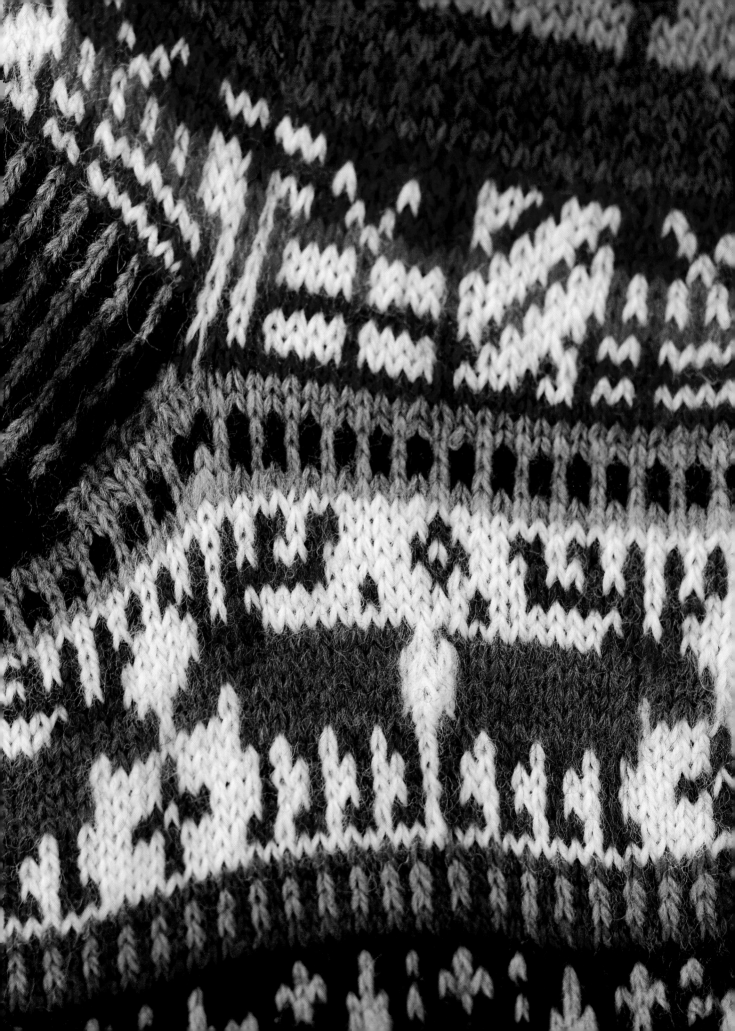

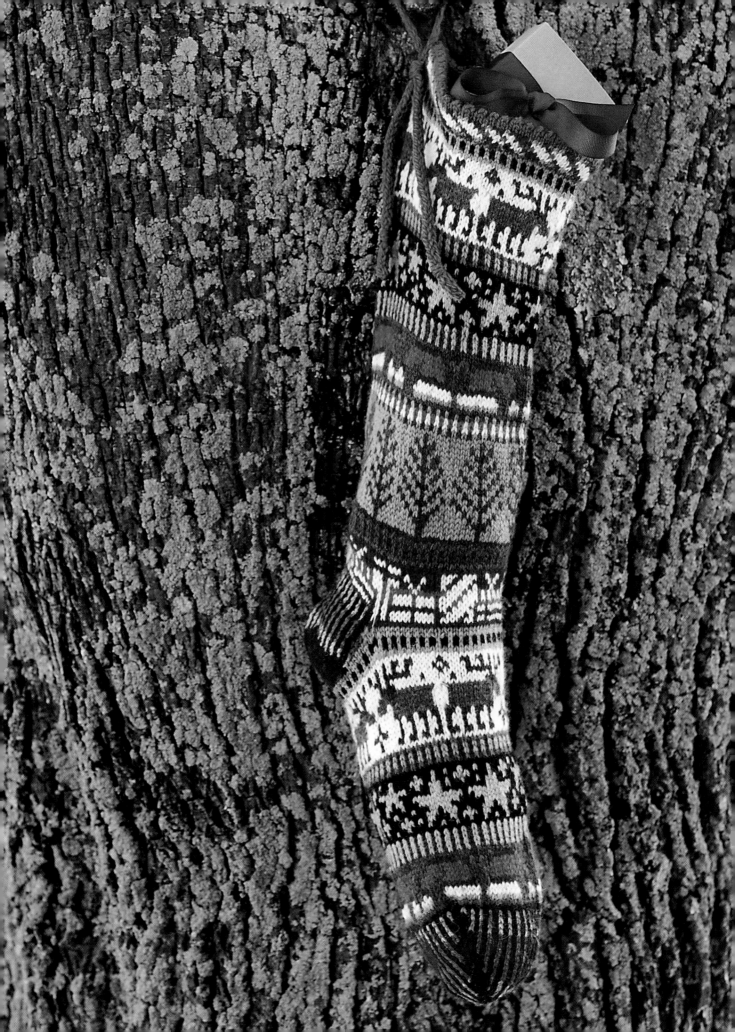

Christmas Stocking

Use traditional stranding techniques to knit our decidedly untraditional Christmas stocking. The picot hem and I-cord hanger add charm to this adorable design.

Yarn Knit Picks Palette, 100% Peruvian highland wool, 50 g, 231 yd., 1 ball each of #23729 Black, #23728 White, #23737 Bark, #24004 Brindle Heather, #24580 Delta, #23723 Pool, #24015 Garnet Heather, #24003 Salsa Heather, #24005 Golden Heather, #24012 Iris Heather, #24008 Rainforest Heather, #24000 Teal

Note *There will be enough yarn left over from the* Reindeer Romp Christmas Stocking *to knit both the* Shining Stars Drawstring Gift Bag *and the* Pretty Presents Drawstring Gift Bag*.*

Yarn Weight Fingering

Needles Size 3 (U.S.)/3.25 mm, 1 or 2 circulars or 4 or 5 DPNs as desired, or size needed to obtain gauge; 2 size 3 DPNs for knitting the I-cord

Large-eye blunt needle

Stitch markers

Pattern Sizes One size

Measurements Cuff (with picot hem sewn): 11 in.; Heel to Toe: 10½ in.; Width: 5¼ in.

Pattern Difficulty Intermediate (uses flap/gusset heel)

Fair Isle Gauge Approx 9 sts = 1 in., 8 rnds = 1 in. on size 3 needles

Knitting Instructions

With a size 3 circular needle or DPN and Delta, CO 96 sts. Divide on 1 or 2 circulars or 3 or 4 DPNs as desired, and without twisting the sts, join. K 8 rnds.

PICOT RND 1

YO, K2tog, rep around.

PICOT RND 2

K, working each YO as a st.

Work **Reindeer Romp Christmas Stocking Chart** beginning at the upper right corner, working the entire chart once.

Heel Setup

Slip the first 20 sts on the heel needle. Place the next 56 sts on a separate needle or holder for the instep. Place the remaining 20 sts on the heel needle. (40 heel sts)

HEEL FLAP ROW 1

Turn. With Black and Iris Heather, Sl 1, P across, alternating Black and Iris Heather, turn.

HEEL FLAP ROW 2

Sl 1, K across, alternating Black and Iris Heather, turn.
Rep Heel Flap Rows 1–2 once more.
Work Heel Flap Rows 1–2 four times, alternating Black and Delta.
Work Heel Flap Rows 1–2 twice, alternating Black and Iris Heather.

LAST HEEL FLAP ROW

With Black only, Sl 1, P across, turn.

HEEL TURN ROW 1

Sl 1, K24, K2tog, K1, turn.

HEEL TURN ROW 2

Sl 1, P11, P2tog, P1, turn.

HEEL TURN ROW 3

Sl 1, K12, K2tog, K1, turn.

HEEL TURN ROW 4

Sl 1, P13, P2tog, P1, turn.

HEEL TURN ROW 5

Sl 1, K14, K2tog, K1, turn.

HEEL TURN ROW 6

Sl 1, P15, P2tog, P1, turn.

HEEL TURN ROW 7

Sl 1, K16, K2tog, K1, turn.

HEEL TURN ROW 8

Sl 1, P17, P2tog, P1, turn.

HEEL TURN ROW 9

Sl 1, K18, K2tog, K1, turn.

HEEL TURN ROW 10

Sl 1, P19, P2tog, P1, turn.

HEEL TURN ROW 11

Sl 1, K20, K2tog, K1, turn.

HEEL TURN ROW 12

Sl 1, P21, P2tog, P1, turn.

HEEL TURN ROW 13

Sl 1, K22, K2tog, K1, turn.

HEEL TURN ROW 14

Sl 1, P23, P2tog, P1, turn.

HEEL TURN ROW 15

Sl 1, K23, K2tog, turn.

HEEL TURN ROW 16

Sl 1, P22, P2tog, turn. (24 sts)

Gusset Setup

Sl 1, K11. Begin new rnd at the center of the heel. Redistribute sts on needles as desired.

GUSSET RND 1

With Iris Heather, K12, pick up, twist, and K 11 sts along the heel flap edge, place marker or otherwise mark the spot, work across instep, place marker or otherwise mark the spot, pick up, twist, and K 11 sts down the other heel flap edge, K12.

GUSSET RND 2 (AND ALL EVEN GUSSET RNDS)

Following the chart, beginning at the border indicated on the chart, work to within 2 sts of the marker, SSK, move marker, work across instep in charted patt, move marker, K2tog, work to the end of the rnd in the charted patt.

GUSSET RND 3

K, working chart.
Rep Gusset Rnds 2–3 until 96 sts rem.
Work foot even, following chart through the Hat Border.

LAST ROW OF HAT BORDER CHART

K24, place marker, K48, place marker, K24. Work toe

Reindeer Romp Christmas Stocking Chart

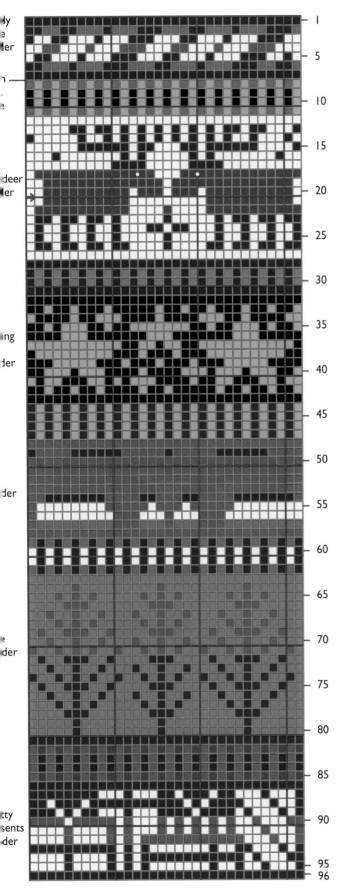

stripe progression as for heel flap, decreasing before and after the markers, every other rnd, until 28 sts rem. If necessary, K to one marker. Cut the yarn, leaving an 18-in. tail. Close the toe with Kitchener st. Weave the loose end in on the inside of the stocking. Weave all of the loose ends in on the inside of the stocking. With Delta threaded in a large-eye needle, stitch the hem down inside the stocking, folding along the Picot Rnd.

I-Cord Hanger

With Delta and a size 3 DPN, CO 4 sts.

I-CORD ROW 1

K across. Do not turn.

I-CORD ROW 2

Slide sts to right side of needle, bring yarn around behind work, and K across.

Rep I-Cord Row 2 until the I-cord is 15 in. long. Cut a 6-in. tail. Thread the tail in a large-eye needle and pull through the rem loops. Tighten and tie off inside the I-cord. Rep with the other tail. Fold the I-cord in half and tie a loop approx 2 in. from the fold. Knot both hanging ends. Sew firmly to the upper center back of the stocking.

Wash and block the stocking.

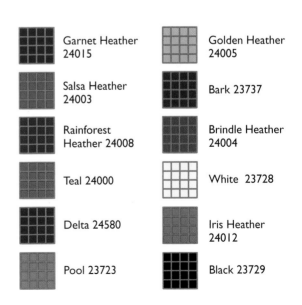

Garnet Heather 24015

Salsa Heather 24003

Rainforest Heather 24008

Teal 24000

Delta 24580

Pool 23723

Golden Heather 24005

Bark 23737

Brindle Heather 24004

White 23728

Iris Heather 24012

Black 23729

Drawstring Gift Bag

The picot hem and candy cane borders surrounding festive gift motifs make this an especially adorable gift bag. Knit it with yarns left over from the *Reindeer Romp Christmas Stocking*.

Yarn	Knit Picks Palette, 100% Peruvian highland wool, 50 g, 231 yd., 1 ball each of #23729 Black, #24015 Garnet Heather, #24003 Salsa Heather, #23728 White, #24012 Iris Heather
Note	*There will be enough yarn left over from the Reindeer Romp Christmas Stocking to knit both the Shining Stars Drawstring Gift Bag and the Pretty Presents Drawstring Gift Bag*
Yarn Weight	Fingering
Needles	Size 3 (U.S.)/3.25 mm, 1 or 2 circulars or 4 or 5 DPNs as desired, or size needed to obtain gauge; size 0 (U.S.)/2.55 mm steel crochet hook Large-eye blunt needle Stitch markers

Pattern Sizes	One size
Measurements	Length: 8 in.; Width: 5¼ in.
Pattern Difficulty	Easy
Fair Isle Gauge	Approx 9 sts = 1 in., 8 rnds = 1 in. on size 3 needles

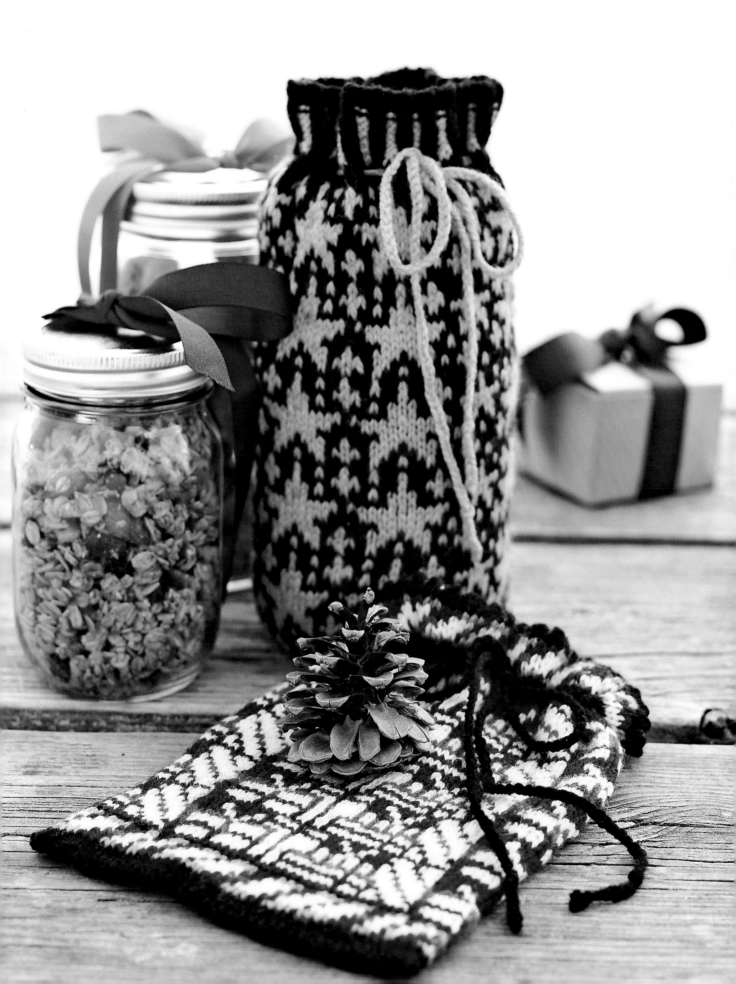

Knitting Instructions

With size 3 circular needle or DPN and White, CO 96 sts. Divide as desired on 1 or 2 circular needles or 3 or 4 DPNs as desired, and without twisting the sts, join.

RNDS 1-6

K.

RND 7

Change to Black, K.

RND 8 (PICOT HEM RND)

K2tog, YO, rep around.

Work Candy Cane Border from **Reindeer Romp Christmas Stocking Chart**, beginning and ending with a Black rnd.

NEXT RND (EYELET RND)

With Black, *K2tog, YO, K2*, rep around.

NEXT RND

With Black, K.

Work Pretty Presents Border from **Reindeer Romp Christmas Stocking Chart** 5 times.

Work Candy Cane Border.

With Black, work 3 rnds even.

Bind off, and weave all loose ends in on the inside of the gift bag.

Finishing

With the beginning of the rnd as the center back, and the bag flat, sew the bottom seam. Fold the upper facing in at the Picot Hem Rnd and tack down.

Drawstring

With size 0 steel crochet hook and Black, ch 30 in., and tie off. Weave the loose ends back inside the drawstring, and tie a knot in the drawstring, 1 in. from either end. Using a large-eye needle, beginning at the center front of the bag, thread the drawstring through the eyelet holes. Tighten drawstring as desired and tie in a bow. Wash and block bag.

Drawstring Gift Bag

Knit this versatile drawstring gift bag with yarns left over from the *Reindeer Romp Christmas Stocking.*

Yarn	Knit Picks Palette, 100% Peruvian highland wool, 50 g, 231 yd., 1 ball each of #23729 Black, #24005 Golden Heather
Note	*There will be enough yarn left over from the Reindeer Romp Christmas Stocking to knit both the Shining Stars Drawstring Gift Bag and the Pretty Presents Drawstring Gift Bag*
Yarn Weight	Fingering
Needles	Size 3 (U.S.)/3.25 mm, 1 or 2 circulars or 4 or 5 DPNs as desired, or size needed to obtain gauge; size 0 (U.S.)/2.55 mm steel crochet hook Large-eye blunt needle Stitch markers
Pattern Size	One size
Measurements	Length: 9½ in.; Width: 5¼ in.
Pattern Difficulty	Easy
Fair Isle Gauge	Approx 9 sts = 1 in., 8 rnds = 1 in. on size 3 needles

Knitting Instructions

With a size 3 circular needle or DPN and Black, CO 96 sts. Divide as desired on 1 or 2 circular needles or 3 or 4 DPNs as desired, and without twisting the sts, join.

RNDS 1–2
Work K2, P2 ribbing.

RNDS 3–10 (CORRUGATED RIBBING)
K2 Black, P2 Golden Heather, rep around.

RND 11
With Black, K.

RND 12 (EYELET RND)
With Black, *K2 tog, YO, K2*, rep around.

RND 13
With Black, K. Work Shining Star Border from **Reindeer Romp Christmas Stocking Chart** 6 times.
Work 3 rnds even with Black.
Bind off, and weave all loose ends in on the inside of the gift bag.

Finishing

With the beginning of the rnd as the center back, tack the center front to the center back on the BO edge. Bring the center of the sides to the tacked center and tack in place. The bottom will look like an X. Sew the bottom seams.

Drawstring

With size 0 steel crochet hook and Golden Heather, ch 30 in., and tie off. Weave the loose ends back inside the drawstring, and tie a knot in the drawstring, 1 in. from either end. Using a large-eye needle, beginning at the center front of the bag, thread the drawstring through the eyelet holes. Tighten drawstring as desired and tie in a bow.
Wash and block bag.

5

Dakota Dreams

THIS DESIGN IS DEAR TO MY HEART, COMPOSED with motifs that represent eastern South Dakota, where I've lived happily for the last 40 years. The large wheat motif reminds me of the miles and miles of wheat fields that cover the open prairie. The ring-necked pheasant is South Dakota's state bird, and the pastures and fields behind my house are a perfect habitat for them. While no one actually treasures the Canada thistle, it certainly thrives in my neck of the woods, and its flowers are always pretty, despite being considered a noxious weed.

The Dakota Dreams Women's Cardigan and Mittens, worked in greens, blues, and reds, symbolize the renewal of spring here on the plains.

The Dakota Dreams Men's V-neck Vest and Hat are worked in golds, browns, and rusts. They beautifully represent this land at harvest, with fall on the way and winter following closely behind.

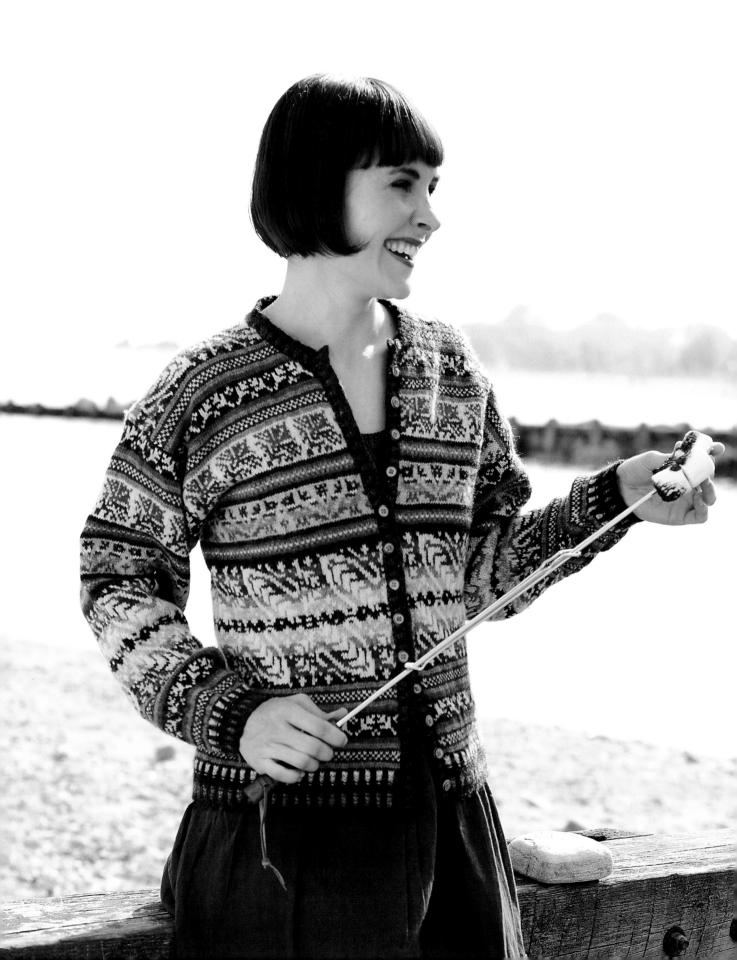

Women's Cardigan

With motifs that represent life on the prairie, the *Dakota Dreams Women's Cardigan* beautifully recalls wheat fields, pheasants, and ever-present thistles.

Yarn Knit Picks Palette, 100% Peruvian highland wool, 50 g, 231 yd., 3 (3, 4, 4, 4) balls #24559 Oyster Heather; 2 (2, 2, 3, 3) balls #24004 Brindle Heather; 2 (2, 2, 3, 3) balls #24241 Camel Heather; 2 (2, 2, 2, 3) balls #24254 Celadon Heather; (for all sizes) 1 ball each of #24015 Garnet Heather, #24010 Marine Heather, #24243 Asphalt Heather

Yarn Weight Fingering

Needles Size 2 (U.S.)/3 mm DPNs, 29-in. circular; size 3 (U.S.)/3.25 mm DPNs, 16-in. and 29-in. circulars (or length desired for body of sweater), or size needed to obtain gauge

Large-eye blunt needle

Assorted stitch markers

14 (14, 15, 15, 16) ⅜-in. buttons

Pattern Sizes Small (Medium, Large, X-Large, XX-Large)

Measurements Chest: 36 in. (40 in., 44 in., 48 in., 52 in.); Back Length: 23 in. (23½ in., 24 in., 24½ in., 25 in.); Length to Armhole (all sizes): 14 in.; Armhole Length: 9 in. (9½ in., 10 in., 10½ in., 11 in.); Sleeve Length: 19 in. (19 in., 19 in., 19¾ in., 19¾ in.); Shoulder Width: 6½ in. (6½ in., 7 in., 7½ in., 8 in.)

Pattern Difficulty Advanced (uses steeks)

Fair Isle Gauge 8 sts = 1 in., 9 rnds = 1 in. on size 3 needles

Note *For more about stranding, steek knitting, and steek preparation, see chapter 1, Fair Isle Basics, page 5.*

Knitting Instructions

Body

With 29-in. size 2 circular needle and Asphalt Heather, CO 298 (330, 362, 394, 426) sts. Without twisting the sts, join. Beginning of rnd will be the center of the cardigan front opening steek. Knit the steek sts in alternating colors on 2-color rnds.

RNDS 1-2

K5, place marker, work K2, P2 ribbing to within 5 sts of end of rnd, place marker, K5. The first and last 5 sts (10 total) will be the front opening steek.

CORRUGATED RIBBING RNDS 3-16

Working in established patt, with the first and last 5 sts for the steek, work all ribbing K2 with Asphalt Heather, alternating colors for the P2 sts in this order: 2 rnds each Brindle Heather, Camel Heather, Garnet Heather, Marine Heather, Celadon Heather, Oyster Heather.

NEXT RND

Change to 29-in. size 3 circular needle, K with Asphalt Heather.

Work **Dakota Dreams Women's Cardigan Charts 1, 2,** and **3** in order, repeating as necessary throughout the sweater, until body of the sweater measures 14 in.

ARMHOLE STEEK RND

K 5 steek sts, alternating colors if it is a 2-color rnd, move marker, K67 (75, 83, 91, 99) according to the chart, place marker, K1, CO 8 (alternating colors if it is a 2-color rnd), K1, place marker (these 10 sts are the first armhole steek), K150 (166, 182, 198, 214), place marker, K1, CO 8 (alternating colors if it is a 2-color rnd), K1, place marker (these 10 sts are the second armhole steek), K67 (75, 83, 91, 99), move marker, K5. (314, 346, 378, 410, 442 sts)

Work even until body of sweater measures 23 in. (23½ in., 24 in., 24½ in., 25 in.).

Work 1 rnd in the background color of the current chart border.

BO all sts.

Sleeves (make 2)

With size 2 DPNs and Asphalt Heather, CO 72 (72, 72, 80, 80) sts. Without twisting sts, join.

Work Corrugated Ribbing as for Sweater Body.

NEXT RND

Change to size 3 DPNs. K with Asphalt Heather, inc 16 (18) sts evenly spaced in rnd. (88, 88, 88, 98, 98 sts)

Work **Dakota Dreams Women's Cardigan Charts** as for Sweater Body, inc 1 st at the beginning and end of every third rnd in the established charted patt until there are 148 (158, 166, 176, 184) sts.

Work even until sleeve measures 19 in. (19 in., 19 in., 19¾ in., 19¾ in.).

Work 1 rnd in the background color of the current chart border.

BO all sts.

Steeks

Prepare armhole and center front steeks as described in chapter 1, Fair Isle Basics, page 10. Cut the steeks open.

Shoulder Seams

Fold the armhole steeks in and baste in place. Measure 6½ in. (6½ in., 7 in., 7½ in., 8 in.) from folded steek edge and mark at neckline. Sew shoulder seam from steek edge to mark. Rep with other shoulder.

Sleeve Assembly

Pin the sleeve in place at the armhole opening, along the folded steek edge, and sew sleeve in place. Rep with other sleeve.

Back Neck Shaping

Measure and mark the center of the back neck opening. Fold the back neck area (between the shoulder seams) in and down 1 in. at the center back neck for a facing, making a gradual curve from the center back to the shoulder seam. Baste the facing in place.

Front Neck Shaping

Do not fold the center front opening steek in. Measure 4 in. from upper edge on both sides of the front opening. Fold the front neckline down at that point, making a gradual curve from the center front to the shoulder

Continued on page 69

Dakota Dreams Women's Cardigan Chart 1

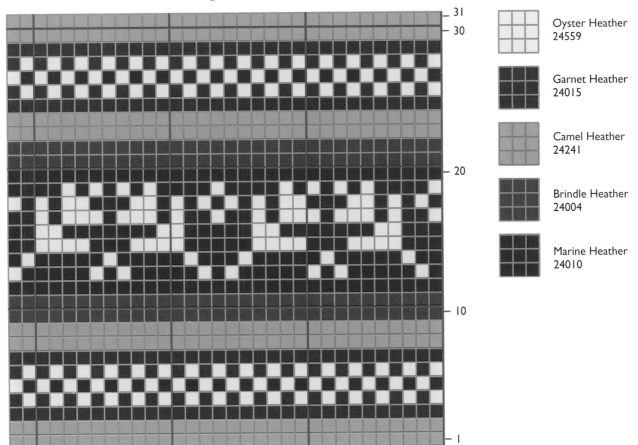

Oyster Heather
24559

Garnet Heather
24015

Camel Heather
24241

Brindle Heather
24004

Marine Heather
24010

Dakota Dreams Women's Cardigan Chart 2

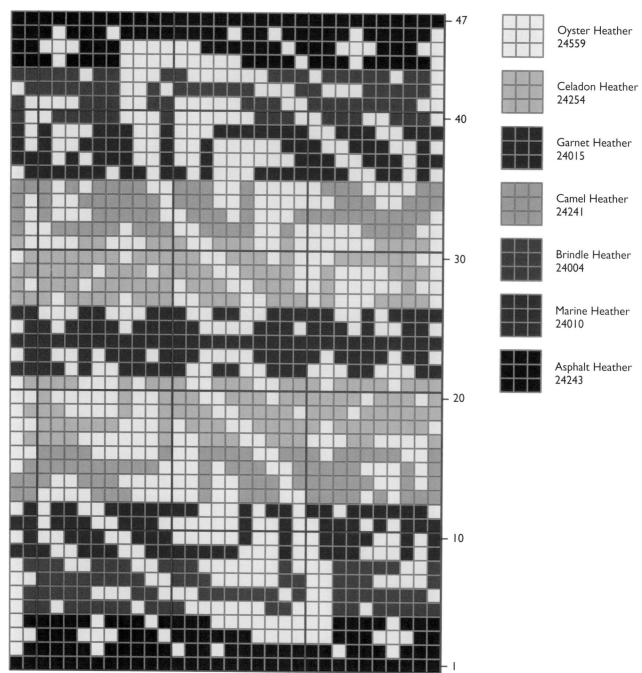

Oyster Heather
24559

Celadon Heather
24254

Garnet Heather
24015

Camel Heather
24241

Brindle Heather
24004

Marine Heather
24010

Asphalt Heather
24243

seam. Rep with the other side, measuring to make sure that the curves match. With a highly contrasting yarn, sew a line of basting sts along the curve lines on both front necklines. By hand or machine, following the instructions on page 10, sew a steek reinforcement seam 1 in. up from the basted line and trim the excess knitted fabric from the front openings. Fold the new edge down, along the sewn contrast stitching to form a facing. Baste the facing in place. Remove the contrasting line of basting sts.

Center Front Openings

Fold the steeks in along the center front openings, and baste in place.

Neckband

With 16-in. size 2 circular needle and Asphalt Heather, beginning at the right front neck curved edge on the right side, pick up and K 34 (36, 38, 40, 42) sts to shoulder seam, pick up and K 68 (72, 76, 80, 84) sts across the folded back neckline, pick up and K 34 (36, 38, 40, 42) sts along the left front neck curved edge, turn. (136, 144, 152, 160, 168 sts)

NECKBAND ROW 1 (WS)
Work K2, P2 ribbing, turn.
Work 4 rows of Corrugated Ribbing, 2 rows of Brindle Heather, 2 rows of Garnet Heather (working the P sts on the right side, the K sts on the wrong side with either Brindle Heather or Garnet Heather).
Work 2 more rows of K2, P2 ribbing in Asphalt Heather.
BO loosely.

Left Front Band

Beginning at the upper left front neck edge on the right side, with Asphalt Heather and 29-in. size 2 circular needle, pick up and K 166 (166, 178, 178, 190) sts along the folded steek edge.
Work ribbing as for Neckband.

Right Front Buttonhole Band

Starting at lower right front edge on the right side, pick up and K sts as for the Left Front Band. Work 3 rows as for the Left Front Band.

BUTTONHOLE ROW
Working as for the Left Front Band, work 4 sts in patt, *YO, K2 tog* (for buttonhole), work 10 sts in patt, and rep buttonhole. Continue along the band, working 10 sts in patt between each buttonhole.
Finish as for Left Front Band.

Finishing

Weave in all loose ends. Sew the steeks more firmly in place, if desired. Wash and block sweater. Sew buttons in place.

Dakota Dreams Women's Cardigan Chart 3

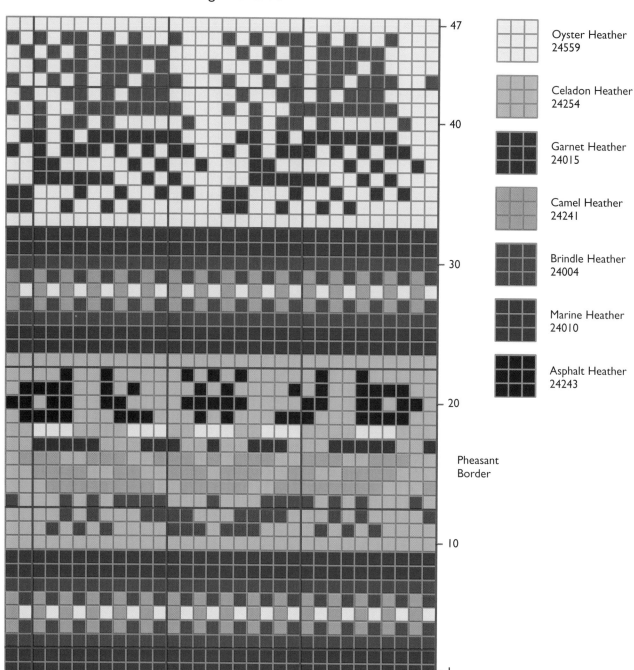

Oyster Heather
24559

Celadon Heather
24254

Garnet Heather
24015

Camel Heather
24241

Brindle Heather
24004

Marine Heather
24010

Asphalt Heather
24243

Pheasant
Border

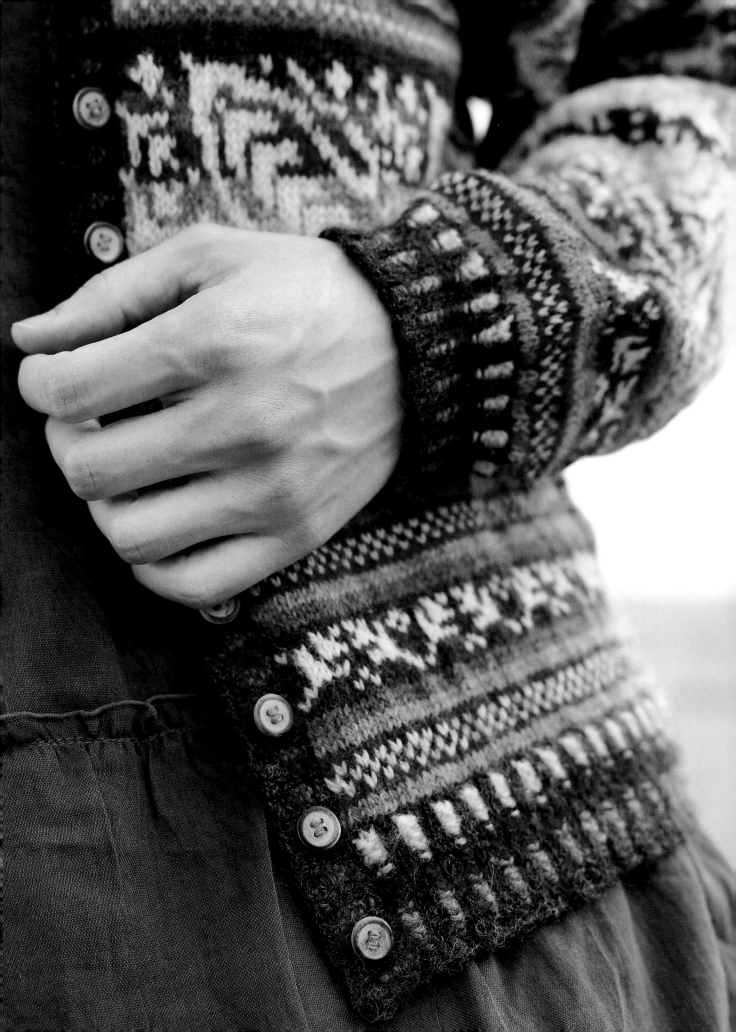

Women's Mittens

Knit these wonderful matching mittens with yarn left over from the *Dakota Dreams Women's Cardigan.*

Yarn Knit Picks Palette, 100% Peruvian highland wool, 50 g, 231 yd., 1 ball each of #24559 Oyster Heather, #24004 Brindle Heather, #24241 Camel Heather, #24254 Celadon Heather, #24015 Garnet Heather, #24010 Marine Heather, #24243 Asphalt Heather

Note *There should be enough yarn left from most sizes of the **Dakota Dreams Women's Cardigan** to knit these mittens.*

Yarn Weight Fingering

Needles Size 2 (U.S.)/3 mm DPNs or 1 or 2 long circulars, as desired

Large-eye blunt needle

Stitch markers

2 safety pins

Pattern Sizes Women's Average (Women's Large)

Note *Women's Average will fit most youth sizes. Shorten cuff and hand as needed for proper fit.*

Measurements Width: 3½ in. (4 in.); Length: 11 in. (11½ in.)

Pattern Difficulty Intermediate

Fair Isle Gauge 9 sts = 1 in., 10 rnds = 1 in.

Note *For more on stranding, see chapter 1, Fair Isle Basics, page 8.*

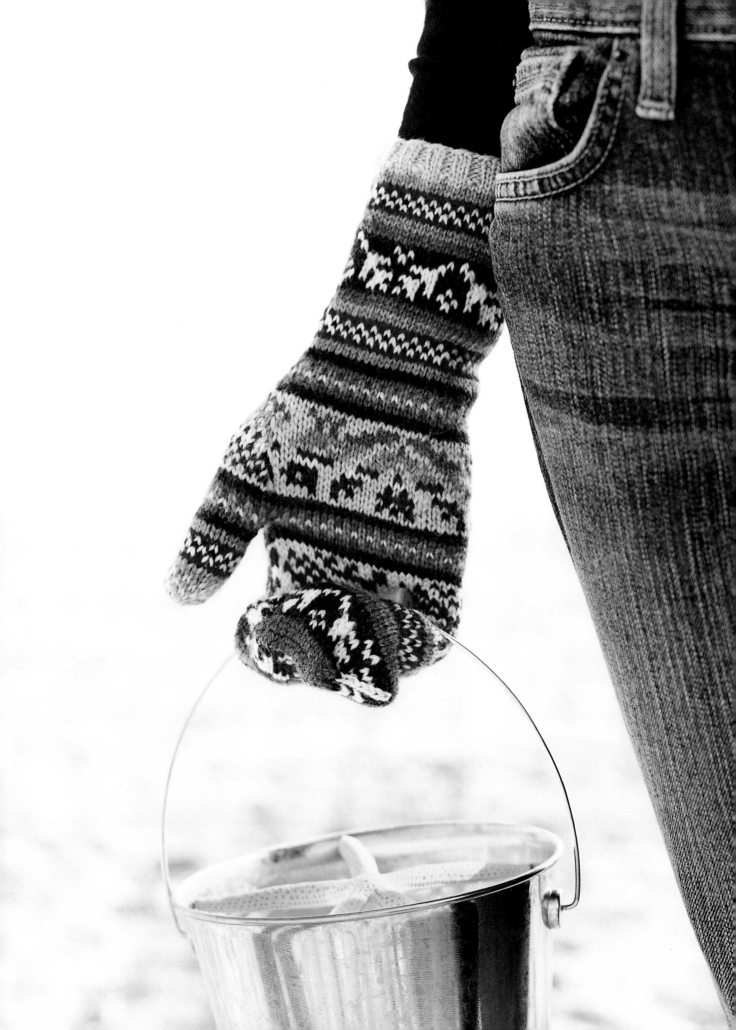

Knitting Instructions (make 2)

With size 2 DPNs and Celadon Heather, CO 64 (72 sts). Divide sts on 3 or 4 DPNs or 1 or 2 circular needles as desired. Without twisting sts, place marker, and join.

RIBBING

Work 6 rnds K2, P2 ribbing.

NEXT RND

K32 (36), place marker, K to end of rnd.

Note

For Women's Average, work **Dakota Dreams Women's Cardigan Charts** as shown for each rep throughout (32 sts). For Women's Large, work 2 sts in background color (on 2-color rnds), work **Dakota Dreams Women's Cardigan Charts** as shown, work 2 sts in background color (on 2-color rnds), for each rep throughout (36 sts). For both sizes, work **Dakota Dreams Women's Cardigan Chart 1**, followed by **Dakota Dreams Women's Cardigan Chart 3**, then work **Chart 1** again. Following charts in the order instructed above, work until cuff measures 4½ in. for all sizes.

THUMB GUSSET RND 1

Following chart as instructed, pick up and K 1 st in the background color (if a 2-color rnd), place marker, finish rnd in established manner following chart.

THUMB GUSSET RND 2

Following chart as instructed, K1 in the alternate color (if a 2-color rnd), move marker, finish rnd in established manner following chart.

THUMB GUSSET RND 3

Alternating colors throughout the gusset on 2-color rnds (until you get to the border above the Pheasant Border on **Chart 3**, which is worked as shown on the chart), pick up and K 1 st, work thumb gusset to marker, pick up and K 1 st, move marker, finish rnd in established manner following chart.

THUMB GUSSET RND 4

Alternating colors throughout the gusset on 2-color rnds (except as noted), work sts to marker, move marker, finish rnd in established manner, following chart.
Rep Thumb Gusset Rnds 3–4 until there are 19 (21) sts before the marker.

Work 5 (7) rnds even in the established manner, following chart.

HAND RND 1

Place the thumb gusset sts on 2 safety pins, work rnd in established manner, following chart. (64, 72 sts)
Work hand in established manner, following chart until hand measures 3¼ in. (3½ in.) or to the end of the little finger.

Note Work all decs in background color on 2-color rnds.

DECREASE RND

K2tog TBL, work in established manner until there are 2 sts before the marker, K2tog, move marker, rep around.
Rep Decrease Rnd until there are 24 (28) sts left, working last 4 rnds in a solid color.
Divide sts evenly on 2 needles, front and back, and turn mitten inside out. Work a three-needle bind-off to close the end of the mitten.
Cut yarn, and tie off. Turn mitten right side out.

Thumb

Divide the 19 (21) sts evenly on DPNs or circular needles as desired. Following established chart, pick up and K 1 st in the gap with the background color on a 2-color rnd. (20, 22 sts)
Continue working **Chart 1** in established manner, and then alternate Celadon Heather and Camel Heather sts, until thumb measures 2 in. (2¼ in.).

THUMB DECREASE RND 1

With Camel Heather, *K2tog*, rep around. (10, 11 sts rem).

THUMB DECREASE RND 2

K2tog, rep around, ending with K1 for Women's Large.
Cut yarn, leaving a 10-in. tail. Thread tail in a large-eye blunt needle, and weave through remaining sts. Tighten and tie off on the inside of the mitten. Weave all loose ends in on the inside of the mitten. Wash and block mitten.

Women's Socks

You may be able to knit these beautiful Dakota Dreams socks with yarn left over from the cardigan.

Yarn	Knit Picks Palette, 100% Peruvian highland wool, 50 g, 231 yd., 1 ball each of #24559 Oyster Heather, #24004 Brindle Heather, #24241 Camel Heather, #24254 Celadon Heather, #24015 Garnet Heather, #24010 Marine Heather, #24243 Asphalt Heather
Yarn Weight	Fingering
Needles	Size 2 (U.S.)/2.75 mm DPNs or 1 or 2 circular needles, as desired, or size needed to obtain gauge; size 3 (U.S.)/3.25 mm DPN for casting on
	Large-eye blunt needle
	Assorted stitch markers

Pattern Sizes	Women's Average (Women's Wide), Shoe Size 5–6 (7–8, 9–10)
Measurements	Cuff Length: 6¾ in. all sizes; Cuff Width: 3¾ in. (4¼ in.); Foot Length: Shoe Size 5–6: 8¼ in. (Shoe Size 7–8: 9¼ in., Shoe Size 9–10: 10¼ in.)
Pattern Difficulty	Intermediate (uses flap/gusset heel technique)
Fair Isle Gauge	10 sts = 1 in., 9 rnds = 1 in. on size 2 needles
Note	*For stranding instructions, see chapter 1, Fair Isle Basics, page 8.*

Knitting Instructions (make 2)

With size 3 needle and Asphalt Heather, CO 72 (84) sts. Distribute sts on 3 or 4 size 2 DPNs or 1 or 2 circular needles as desired. Without twisting the sts, join. The beginning of the rnd is the center back of the sock.

RIBBING RNDS 1–2

Work K2, P2 ribbing.

CORRUGATED RIBBING RNDS 3–12

Work Corrugated Ribbing as for **Dakota Dreams Women's Cardigan**, 2 rnds of each color in this order: Oyster Heather, Celadon Heather, Garnet Heather, Marine Heather, Camel Heather.

RIBBING RNDS 13–14

K2, P2 with Asphalt Heather.

Cuff

Work Rnd 1 of **Dakota Dreams Women's Cardigan Chart 2**.

Work the rest of **Chart 2**, working the first and last 4 (10) sts of each rnd in alternating colors as vertical stripes on 2-color rnds.

Heel Setup

Work the first 18 (20) sts in Asphalt Heather, place the next 36 (44) sts on a separate needle or holder for the instep. Place the rem 18 (20) sts with the first, for the heel. The heel flap will be centered on the back of the sock. (36, 40 heel sts)

HEEL FLAP ROW 1

Turn. Sl 1, P across, alternating Asphalt Heather and Camel Heather. Turn.

HEEL FLAP ROW 2

Sl 1, K across, alternating Asphalt Heather and Camel Heather (working the sts in vertical stripes). Turn. Rep Heel Flap Rows 1–2: 14 (16) times more. End with a P row.

HEEL TURN ROW 1 (RS)

With Asphalt Heather, Sl 1, K21 (24), K2tog, K1, turn.

HEEL TURN ROW 2 (WS)

Sl 1, P9 (11), P2tog, P1, turn.

HEEL TURN ROW 3

Sl 1, K10 (12), K2tog, K1 turn.

Continue in this manner, working one more st before the K2 tog (or P2 tog), until all of the sts have been worked. End with a P row.

Gusset Setup

Sl 1, K9 (11). Begin new rnd at the center of the heel (bottom of foot).

GUSSET RND 1

With Asphalt Heather, K10 (12), pick up, twist, and K 14 (16) sts along the heel flap edge, place marker, work across the instep sts, place marker, pick up, twist, and K 14 (15) sts along the other heel flap edge. Distribute sts on needles as desired.

GUSSET RND 2

K, alternating colors on 2-color rnds in vertical stripes, to within 2 sts of marker, K2tog, move marker, using **Dakota Dreams Women's Cardigan Chart 3**, beginning at the top of the chart (not the bottom, as for the cardigan), work across instep sts, working the first and last 2 (6) instep sts in alternating colors on 2-color rnds, move marker, K2tog TBL, K to end of rnd, alternating colors on 2-color rnds in vertical stripes. (2 sts dec)

GUSSET RND 3

Work rnd according to chart. Make sure to follow chart on the instep with the proper number of alternate sts before and after the instep rep and work alternate color vertical stripes on the sole and gusset.

Rep Gusset Rnds 2–3, following chart as directed, with the charted pattern on the instep and vertical stripes on the sole (on 2-color rnds), until 72 (84) sts rem.

Foot

Work **Chart 3**, and then follow with **Chart 1** (working from the top of the chart down) if needed, continuing in the established patt of knitting stripes on the sole, and following the chart on the instep sts as before, until the foot measures 4 in (5 in., 5½ in.).

Note Shoe Size 5–6 may not complete all of **Chart 3** before working the toe.

Toe Setup

On last charted rnd with background color only, when you have reached the desired length, K 18 (21) sts, place marker, K 36 (42) sts, place marker, K rem 18 (21) sts.

TOE DECREASE RND 1

K, alternating Asphalt Heather and Camel Heather, to within 2 sts of the first marker, K2tog with Asphalt Heather, move marker, K2tog TBL with Asphalt Heather, K, alternating Asphalt Heather and Camel Heather, to within 2 sts of marker, K2tog with Asphalt Heather, move marker, K2tog TBL with Asphalt Heather, K to end, alternating Asphalt Heather and Camel Heather.

TOE DECREASE RND 2

K, alternating Asphalt Heather and Camel Heather in vertical stripes, working the sts on either side of each marker with Asphalt Heather.

Rep Toe Decrease Rnds 1–2 until 36 (40) sts rem, using only Asphalt Heather on the last rnd. Divide the sts evenly on 2 needles with the decs at either end of each needle, close the toe with Kitchener st. Weave all ends in on the inside of the sock. Wash and block sock.

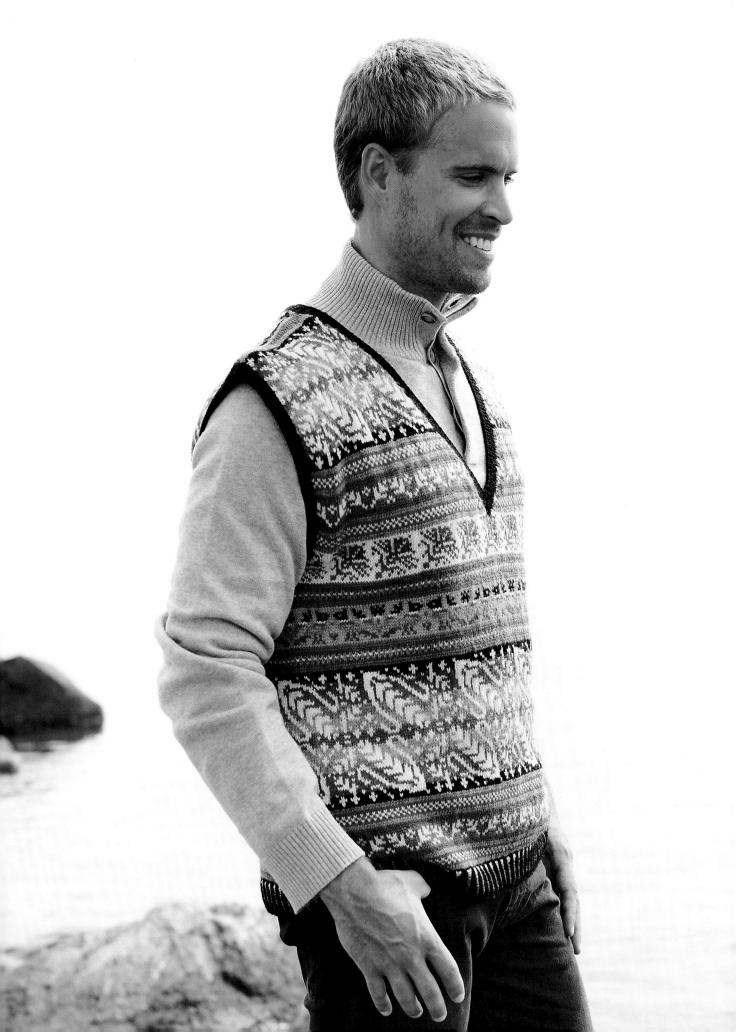

Men's V-neck Vest

Our Dakota Dreams pattern looks good in this masculine colorway as well as the softer palette used for the *Dakota Dreams Women's Cardigan*. Make this companion V-neck pullover vest for the favorite man in your knitting life.

Yarn Knit Picks Palette, 100% Peruvian highland wool, 50 g, 231 yd., 2 (2, 3, 3, 3) balls #24559 Oyster Heather; 1 (1, 1, 2, 2) balls #24004 Brindle Heather; 1 (1, 1, 2, 2) balls #24241 Camel Heather; 1 (1, 1, 1, 2) balls #24251 Turmeric; for all sizes, 1 ball each of #24248 Masala, #24561 Wallaby, #23729 Black

Yarn Weight Fingering

Needles Size 2 (U.S.)/3 mm 29-in. circular; size 3 (U.S.)/3.25 mm 16-in. and 29-in. circulars, or size needed to obtain gauge

Large-eye blunt needle

Assorted stitch markers

Pattern Sizes Men's Small (Medium, Large, X-Large, XX-Large)

Measurements Chest: 36 in. (40 in., 44 in., 48 in., 52 in.); Back Length (all sizes): 26½ in.; Length to Armhole (all sizes): 15½ in.; Armhole Length (all sizes): 11 in.

Pattern Difficulty Advanced (uses steeks)

Fair Isle Gauge 8 sts = 1 in., 10 rnds = 1 in. on size 3 needles

Note *For more on stranding, steek knitting, and steek preparation, see chapter 1, Fair Isle Basics, page 5.*

Knitting Instructions

With 29-in. size 2 circular needle and Black, CO 288 (320, 352, 384, 416) sts. Place a marker, and without twisting the sts, join. Beginning of rnd will be left side in seam.

RNDS 1-2

Work K2, P2 ribbing.

CORRUGATED RIBBING RNDS 3-14

Work all K2 sts with Black, alternating colors for the P2 sts in this order, 2 rnds each: Wallaby, Brindle Heather, Camel Heather, Masala, Turmeric, Oyster Heather.

NEXT RND

Change to 29-in. size 3 circular needle, K with Black. Work **Charts 1, 2,** and **3** in order (rep as necessary throughout the vest), until body of vest measures 15½ in.

ARMHOLE STEEK RND 1

Working in charted patt, BO 4, place marker after st left from the BO, K134 (150, 166, 182, 198), place marker, K1, BO 8, K1, place marker, K134 (150, 166, 182, 198), place marker, K1, BO 4. Break yarn.

ARMHOLE STEEK RND 2

Continuing charted patt, CO 4 (alternating colors if it is a 2-color rnd), K1, move marker, K to next marker, move marker, K1, CO 8 (alternating colors if it is a 2-color rnd), K1, move marker, K to marker, K1, CO 4. The beginning of the rnd will now be in the center of this armhole steek.

ARMHOLE SHAPING (ALL SIZES)

Continuing in charted patt, every other rnd, 3 times: K2tog before and after the armhole steeks (4 sts dec every other rnd).

V-NECK STEEK RND

K5, move marker, continuing in charted patt, K63 (71, 79, 87, 95), place marker, K1, CO 8 (alternating colors if it is a 2-color rnd), K1, place marker, finish rnd.

EVERY OTHER RND

Continuing in charted patt, K2tog on either side of the V-neck steek until 34 (36, 38, 40, 42) sts rem for each front shoulder (the sts between the V-neck and Armhole steeks on the front). Change to 16-in. circular needle as needed.

Work even until piece measures 26½ in. long.

LAST RND

K in the background color.

BO with the background color.

Prepare armhole and V-neck steeks as desired, and as instructed on page 10, then cut them open.

Armhole Band

Fold the steeks in and tack in place. With a size 2 circular needle and Black, pick up and K 4 sts for each 5 rows of knitted fabric around armhole opening along the folded steek edge. Do not join. Turn.

ARMHOLE RIBBING

Work ¾ in. of K2, P2 ribbing. BO loosely.

Rep with other armhole.

Sew right shoulder seam.

Back Neck Shaping

Measure and mark the inside location of the other shoulder seam. Fold the back neck area (between the shoulder seams) in and down 1 in. at the center back neck for a facing. Tack the facing in place.

Neckband

Fold the steeks in and tack in place. Starting on the RS at the neck edge at the left front V opening, with Black, pick up and K 4 sts for each 5 rows of knitted fabric along the folded steek edge, place a marker just before the center of the V, pick up and K1, place marker, pick up and K 4 sts for each 5 rows of knitted fabric along the other side of the V opening, pick up and K 1 st for each st along the back facing upper edge. Do not join. Turn.

NECKBAND ROW 1 (WS)

Work K2, P2 ribbing to marker, move marker, P center st, move marker, work K2, P2 ribbing to end of row. Turn.

NECKBAND ROW 2 (RS)

Work K2, P2 ribbing to within 2 sts of marker. Work 2 sts tog in established patt, move marker, K center st, move marker, work 2 sts tog in patt, complete row in established patt.

Rep Neckband Rows 1–2 until neckband is 1 in. BO loosely.

Sew left shoulder seam. Weave all loose ends in on the inside of the vest. Wash and block vest.

Dakota Dreams Men's V-neck Vest Chart 1

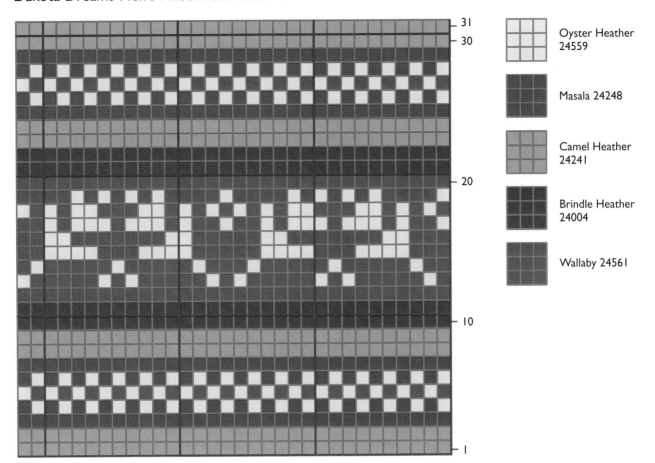

Oyster Heather
24559

Masala 24248

Camel Heather
24241

Brindle Heather
24004

Wallaby 24561

Dakota Dreams Men's V-neck Vest Chart 2

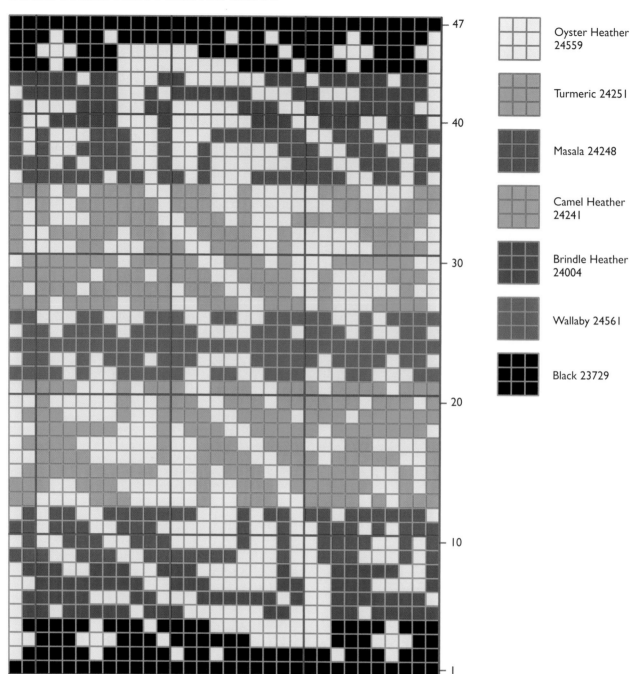

Oyster Heather
24559

Turmeric 24251

Masala 24248

Camel Heather
24241

Brindle Heather
24004

Wallaby 24561

Black 23729

Dakota Dreams Men's V-neck Vest Chart 3

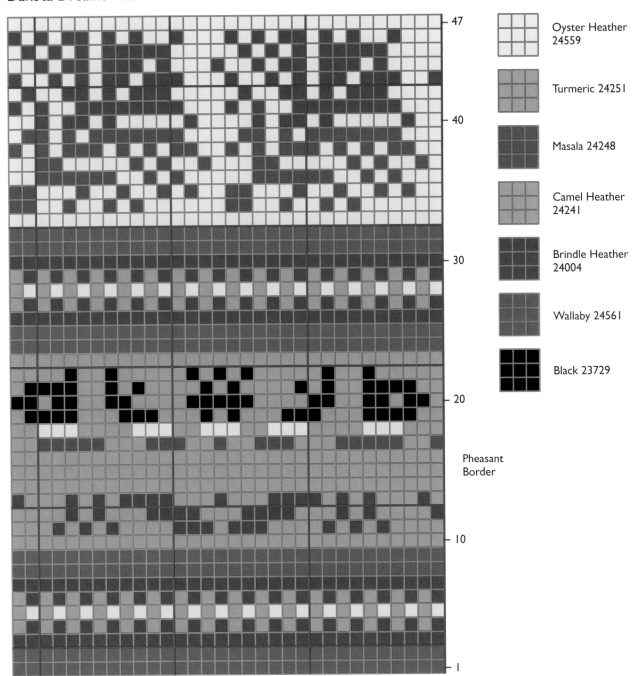

— 47

— 40

— 30

— 20

Pheasant
Border

— 10

— 1

Oyster Heather
24559

Turmeric 24251

Masala 24248

Camel Heather
24241

Brindle Heather
24004

Wallaby 24561

Black 23729

Men's Hat

Knit this companion hat to the *Dakota Dreams Men's V-neck Pullover Vest.*

Needles Size 2 (U.S.)/3 mm 16-in. circulars; size 3 (U.S.)/3.25 mm DPNs, 16-in. circulars

Large-eye blunt needle

Assorted stitch markers

Pattern Size One size fits all

Measurements Hat Circumference: 20 in.; Hat Length: 8 in.

Pattern Difficulty Easy

Fair Isle Gauge 8 sts = 1 in., 10 rnds = 1 in. on size 3 needles

Note *For more on stranding, see chapter 1, Fair Isle Basics, page 8.*

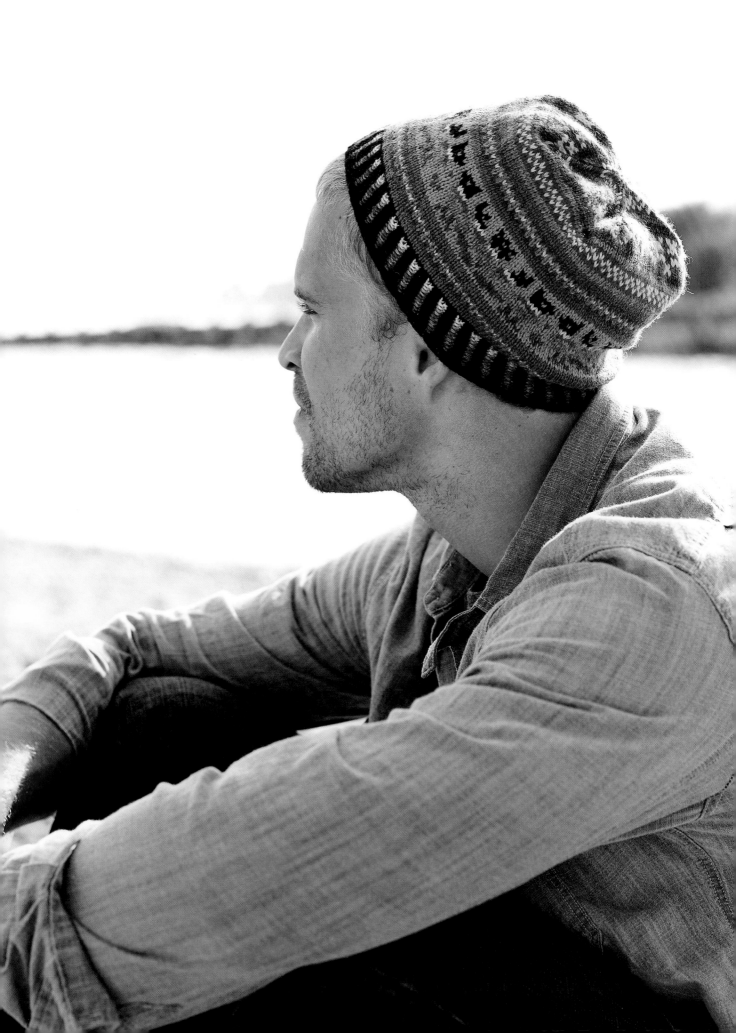

Knitting Instructions

With 16-in. size 2 circular needle and Black, CO 160 sts. Place a marker and without twisting the sts, join.

RNDS 1–2

Work K2, P2 ribbing.

Corrugated Ribbing Rnds 3–12

Work all K2 sts with black, alternating colors for the P2 sts in this order, 2 rnds each: Brindle Heather, Camel Heather, Masala, Turmeric, Oyster Heather.

NEXT RND

Change to size 3 circular needle, K with Black.

Work **Dakota Dreams Men's V-neck Vest Chart 3**, followed by **Chart 1**, placing a marker between each rep. When hat measures 6½ in., begin decs.

DECREASE RND

Continuing in charted patt, *K2tog, work to within 2 sts of marker, K2tog TBL, move marker*, rep around. On 2-color rnds, work the decs in the background color regardless of which color is indicated on the chart for that st. Change to DPNs as desired.

Work the decs every rnd until 10 sts rem. Cut yarn, leaving a 10-in. tail. Thread the tail in a large-eye needle, and pull through the remaining loops. Tighten and tie off on the inside of the hat. Weave all loose ends in. Wash and block hat.

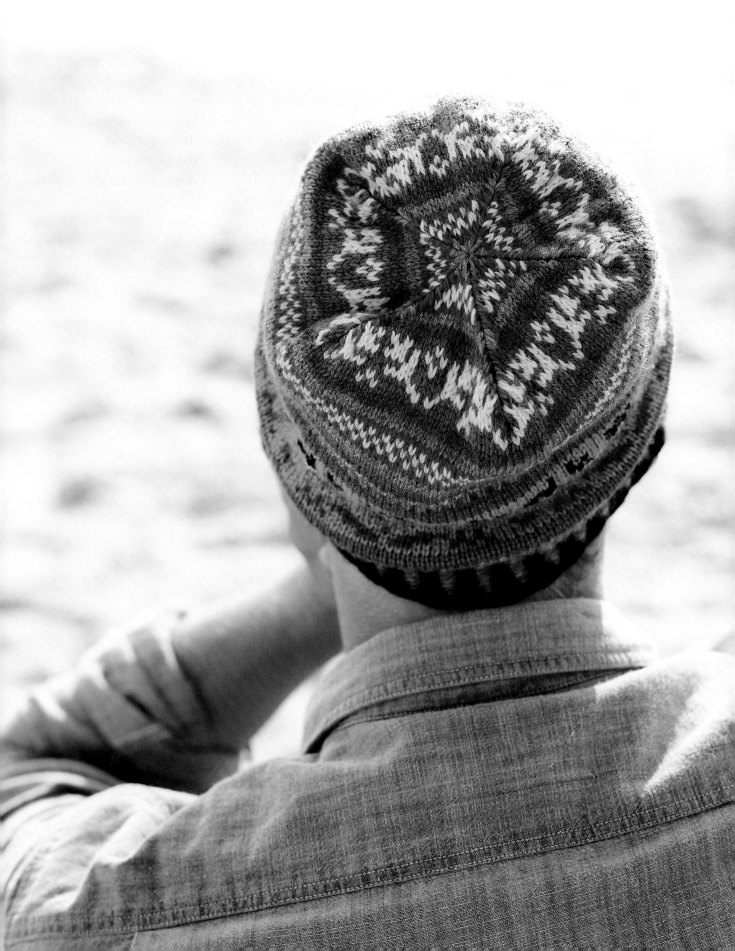

6

Nordic Snowflake

YOKED SWEATERS ARE A STAPLE OF STRANDED knitting. Not only are they lovely, but there are no steeks, and they involve only very small underarm seams. They're a good project for new Fair Isle knitters who are transitioning from small items to wearable clothing.

We updated the traditional Nordic snowflake motif for a more modern look and used some spectacularly soft and beautiful hand-dyed alpaca and wool yarn from Pat and Chris at Decadent Fibers for our basic pullover. Once you've completed the sweater, you'll discover that there's probably enough yarn left to knit the companion hat and gloves, too.

For the ladies, we took the Nordic detailing that you expect from a yoked pattern and gave it a twist by turning our new design into a lovely dress using luscious Classic Elite Fresco, a wool, alpaca, and angora yarn.

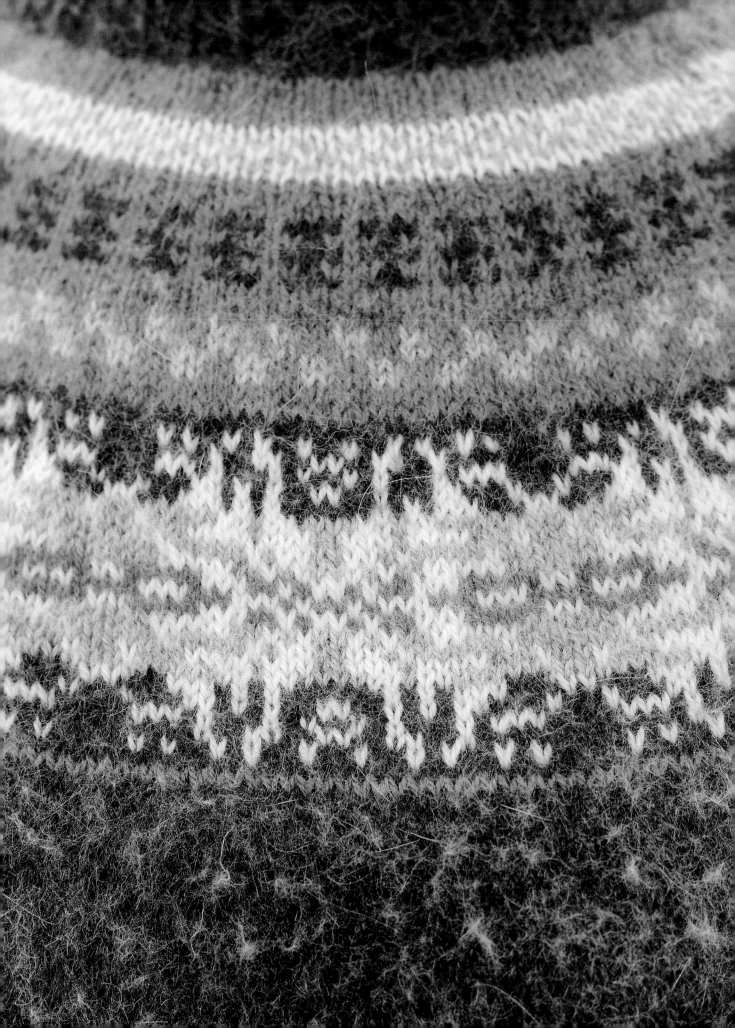

Pullover

Knit this wonderful traditional snowflake pullover—sized for men, but just as easily unisex—in the absolutely perfectly named Marshmallow alpaca/Merino yarn from Decadent Fibers.

Yarn Decadent Fibers Marshmallow, 80% alpaca/20% Merino wool, 113 g, approx 315 yd., 3 (4, 4, 5, 5) skeins Chestnut; (for all sizes) 1 skein each of Natural, Light Gold, Dark Gold, Light Gray, Dark Gray

Yarn Weight Sport Weight

Needles Size 3 (U.S.)/3.25 mm DPNs, 16-in. and 29-in. circulars; size 4 (U.S.)/ 3.5 mm DPNs, 16-in. and 29-in. circulars, or size needed to obtain gauge

Note You may use whatever length circular needle is most comfortable for you.

Large and small stitch markers

Large-eye blunt needle

Pattern Sizes X-Small (Small, Medium, Large, X-Large)

Measurements Chest: 35 in. (39 in., 43 in., 46 in., 51 in.); Body Length to Sleeve: 14 in. (15 in., 15½ in., 16 in., 16½ in.); Yoke Depth: 7 in. (7 in., 8 in., 8 in., 8 in.); Sleeve Length to Yoke: 17½ in. (18 in., 18½ in., 19 in., 19½ in.)

Pattern Difficulty Intermediate

Stockinette Gauge 6 sts = 1 in., 8 rnds = 1 in. on size 4 needles

Fair Isle Gauge 7 sts = 1 in., 7 rnds = 1 in. on size 4 needles

Note For more about stranding, see chapter 1, Fair Isle Basics, page 8.

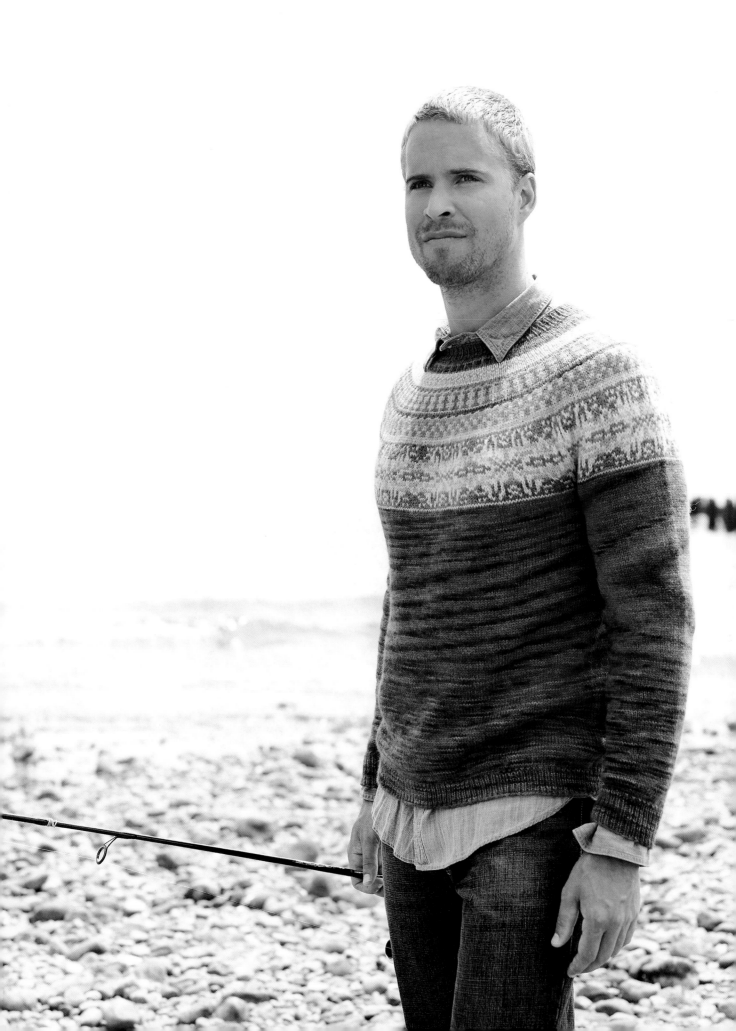

Knitting Instructions

Body

With 29-in. size 3 circular needle and Chestnut, CO 212 (236, 260, 284, 308) sts. Without twisting sts, place marker and join.

ALL SIZES

Work 14 rnds K1, P1 ribbing.

NEXT RND

Change to 29-in. size 4 circular needle. K 106 (118, 130, 142, 154) sts, place small marker, K to end.

Work even in Stockinette st until body measures 14½ in. (15 in., 15½ in., 16 in., 16½ in.).

ARMHOLE RND

BO 6 sts, K to within 6 sts of small marker, BO 12 sts, removing small marker, K to within 6 sts of end, BO 6 sts. (24 sts BO for all sizes)

Break yarn and place body sts on a holder or waste yarn. (188, 212, 236, 260, 284 sts rem)

Sleeves (make 2)

With size 3 DPNs, CO 60 (60, 60, 64, 64) sts. Without twisting sts, join.

ALL SIZES

Work 20 rnds K1, P1 ribbing.

Change to size 4 DPNs. Work in Stockinette st, inc 1 st at the beginning and end of the rnd, every 6 rnds until there are 86 (88, 90, 92, 94) sts. Change to 16-in. circular needle as desired.

Work even in Stockinette st until sleeve measures 17½ in. (18 in., 18½ in., 19 in., 19½ in.).

ARMHOLE RND (ALL SIZES)

BO 6 sts, work to within 6 sts of end of rnd, BO 6 sts. (12 sts BO; 74, 76, 78, 80, 82 sts rem)

Break yarn, place sleeve on holder or waste yarn.

Yoke

Transfer all sts of one sleeve to 29-in. size 4 circular needle. Transfer the body front sts to the needle, transfer the other sleeve sts to the needle, and transfer the body back sts to the needle. Place marker at beginning of rnd. (336, 364, 392, 420, 448 sts)

RND 1

With Chestnut, K 1 rnd. Sts will be very tight at the armholes for a few rnds.

ALL SIZES

Work **Nordic Snowflake Pullover Chart 1**, placing markers between the reps if desired. (12, 13, 14, 15, 16 reps)

Following **Nordic Snowflake Pullover Chart 2** or **Chart 3** for your desired size, with Dark Gold, work Rnd 1, dec 1 (4, 2, 0, 3) sts evenly spaced in rnd. (335, 360, 390, 420, 445 sts rem)

YOKE DECREASE RND

Following **Chart 2** or **Chart 3** for your desired size, work next rnd, *K3, K2tog*, rep around. (67, 72, 78, 84, 89 sts dec; 268, 288, 312, 336, 356 sts rem)

Following **Chart 2** or **Chart 3** for your desired size, work Light Gray/Dark Gold checkerboard border.

NEXT RND (ALL SIZES)

K with Chestnut following **Chart**.

YOKE DECREASE RND

Following **Chart 2** or **Chart 3** for your desired size, work next rnd, *K2, K2tog*, rep around. (201, 216, 234, 252, 267 sts rem)

Following **Chart 2** or **Chart 3** for your desired size, work Light Gold/Dark Gray border.

NEXT RND (ALL SIZES)

K with Dark Gold following **Chart**.

YOKE DECREASE RND

Following **Chart 2** or **Chart 3** for your desired size, work next rnd, *K1, K2tog*, rep around. (134, 144, 156, 168, 178 sts rem)

Change to 16-in. circular needle or DPNs as desired.

Following **Chart 2** or **Chart 3** for your desired size, work Natural/Light Gray and Dark Gold/Chestnut borders.

Change to Chestnut, K 1 rnd, dec 2 (0, 0, 0, 1) sts in rnd. (132, 144, 156, 168, 177 sts rem)

YOKE DECREASE RND

K1, K2tog, rep around. (88, 96, 104, 112, 118 sts rem)

ALL SIZES

Change to size 3 needles, and work 10 rnds K1, P1 ribbing. BO loosely in patt.

Finishing

Sew armhole openings. Weave all ends in on the inside of the sweater. Wash and block sweater.

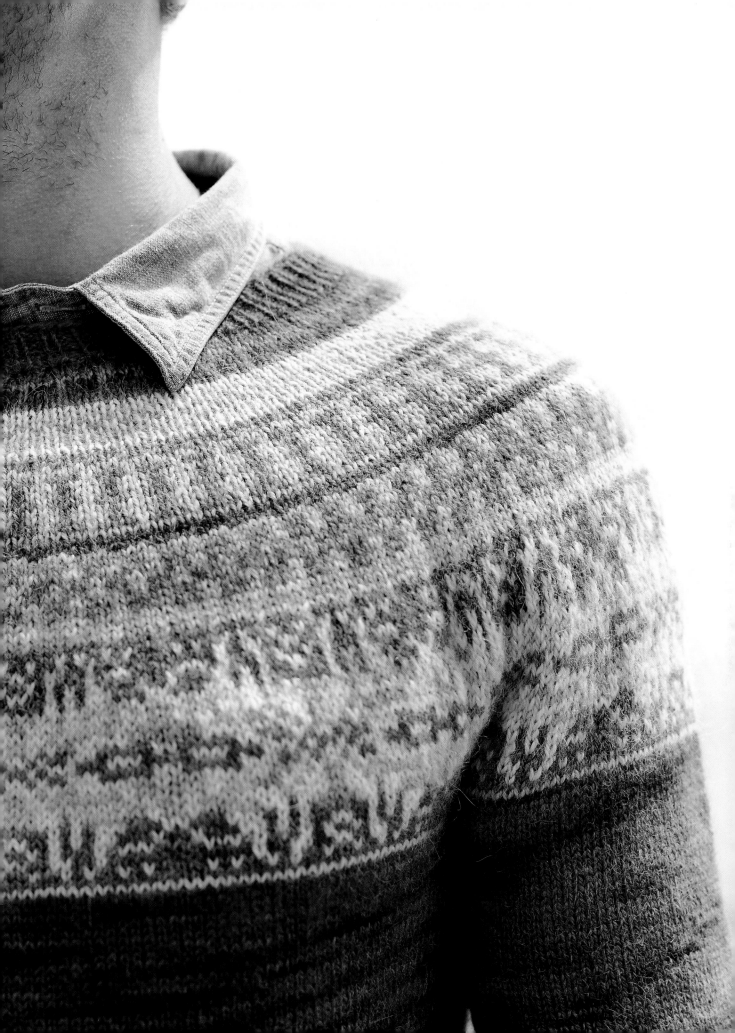

Nordic Snowflake Pullover Chart 1 All Sizes

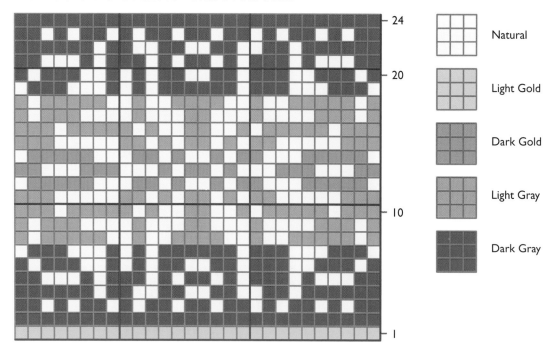

	Natural
	Light Gold
	Dark Gold
	Light Gray
	Dark Gray

Nordic Snowflake Pullover Chart 2, XS and S Sizes

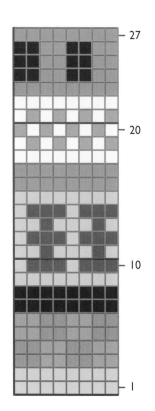

Nordic Snowflake Pullover Chart 3, M, L, and XL Sizes

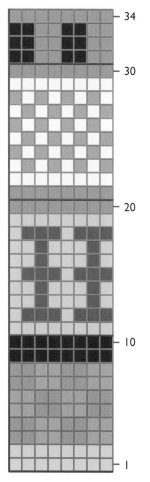

	Natural
	Light Gold
	Dark Gold
	Chestnut
	Light Gray
	Dark Gray

Gloves

Use leftover Decadent Fibers Marshmallow yarn for these yummy, soft, coordinating gloves. Though designed for men, the smaller size should fit most women.

Yarn Decadent Fibers Marshmallow, 80% alpaca/20% Merino wool, 113 g, approx 315 yd., 1 skein each of Natural, Light Gold, Dark Gold, Light Gray, Dark Gray

Note *There should be enough yarn left over from most sizes of the **Nordic Snowflake Pullover** to knit these companion gloves.*

Yarn Weight Sport Weight

Needles Size 3 (U.S.)/3.25 mm and size 4 (U.S.)/3.5 mm DPNs, or size needed to obtain gauge

Large stitch markers

Small stitch markers

8 safety pins

Large-eye blunt needle

Pattern Sizes Women's (Men's)

Measurements All Sizes: Cuff: 3¾ in. long; Hand Width: 3⅜ in. (4 in.)

Pattern Difficulty Intermediate

Fair Isle Gauge 7.5 sts = 1 in., 8 rnds = 1 in. on size 4 needles

Note *For more about stranding, see chapter 1, Fair Isle Basics, page 8.*

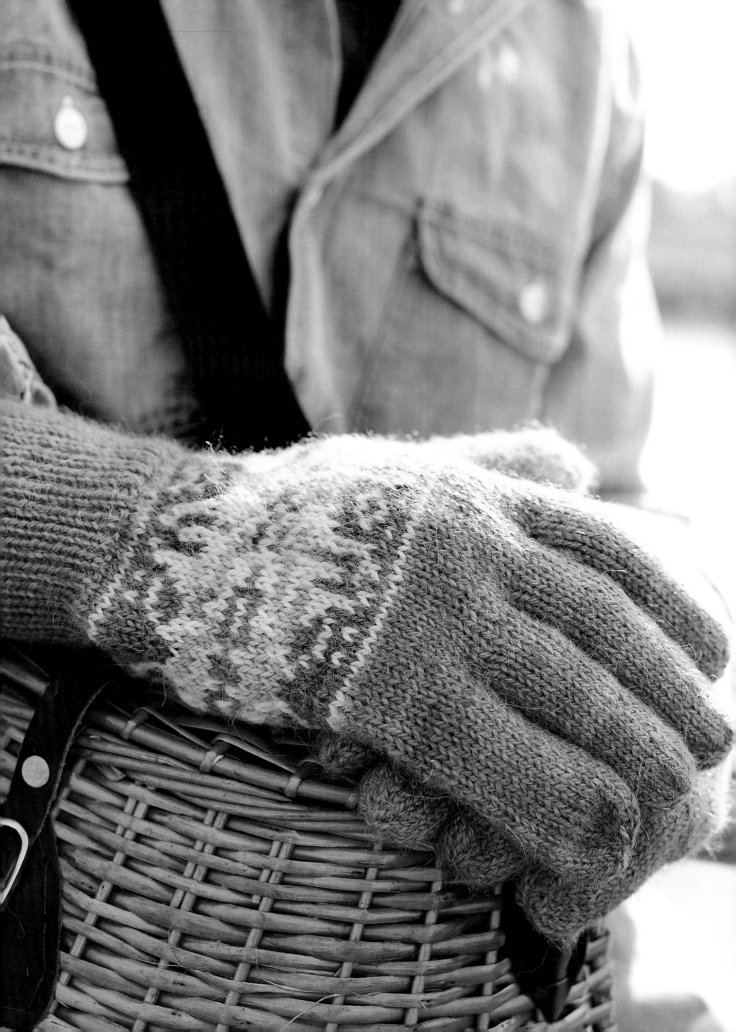

Knitting Instructions (make 2)

Note *Regardless of size, when you complete the **Nordic Snowflake** **Pullover Chart 1**, work 1 rnd of Light Gold, and then change to Dark Gold for the remainder of the glove.*

With size 3 DPNs and Dark Gold, CO 50 (60) sts. Without twisting sts, join.

ALL SIZES

Work 30 rnds K1, P1 ribbing.

NEXT RND (ALL SIZES)

Change to size 4 DPNs, K around, placing a marker after st 25 (30).

WOMEN'S HAND RND 1

Beginning at square 3 of Rnd 1 of **Nordic Snowflake Pullover Chart 1**, work chart to marker (3 squares will be left unworked), move marker, rep.

For rem of **Chart 1**, work as above, beginning each rnd of the chart at square 3, ending with 3 squares unworked (25-st rep), on both sides of the glove.

MEN'S HAND RND 1

K1 in the background color, work Rnd 1 of **Nordic Snowflake Pullover Chart 1**, K1 in the background color, move marker, rep.

For rem of chart, work as above, beginning each rnd with a st in the background color, move marker, work each rnd of the chart, K1 in the background color, move marker, rep.

ALL SIZES

Work 3 more rnds even.

THUMB GUSSET RND 1 (ALL SIZES)

Pick up and K 1 in the background color, place marker, work rnd in established patt, following chart for your size.

THUMB GUSSET RND 2 (ALL SIZES)

Work st before marker in alternate color (if a 2-color rnd), move marker, work rnd in established patt, following chart for your size.

THUMB GUSSET RND 3 (ALL SIZES)

Pick up and K 1 st, K to marker, pick up and K 1 st, alternating colors on 2-color rnds, move marker, work rnd in established patt, following chart for your size.

THUMB GUSSET RND 4 (ALL SIZES)

Work sts before marker in alternate colors if a 2-color rnd, move marker, work rnd in established patt following chart for your size.

Rep Thumb Gusset Rnds 3–4 until there are 17 (21) sts before the marker in the thumb gusset.

ALL SIZES

Work 4 rnds even in established patt, following chart for your size.

HAND RND 1

Place the thumb gusset sts on 2 safety pins, and work the remainder of the rnd in the established patt (continuing with the chart if necessary, or with solid Dark Gold). (50, 60 sts)

Work 5 (7) more rnds even.

Note *Work Fingers and Thumb with Dark Gold.*

Divide for Fingers

K25 (30). Divide the sts on 2 needles. Beginning at the thumb side on the front needle, place the first 7 (8) sts on a safety pin for the front of the index finger. Place the next 6 (7) sts on a safety pin for the front of the middle finger. Place the next 6 (7) sts on a safety pin for the front of the ring finger. Rep with the sts on the back needle, beginning at the thumb side with the index finger.

Little Finger

Divide the rem 14 (16) sts on 3 needles. CO 2 sts in the gap between the front and the back. (16, 18 sts)

Work even until finger measures 1¾ in. (2¼ in.) long, or until the finger is ¼ in. shorter than desired length for each finger instruction.

LITTLE FINGER DECREASE RND

K2tog, rep around.

Cut yarn, leaving a 10-in. tail, and thread in a large-eye needle. Weave tail through remaining loops. Tighten and tie off on the inside of the glove.

Ring Finger

Place the 6 (7) front sts on a needle, place the 6 (7) back sts on a needle. Beginning at the little finger, pick up

2 sts along the edge of the little finger, K sts on needle, CO 2 sts in the gap. Redistribute sts on 3 needles. (16, 18 sts)

Work even until finger measures 2½ in. (3 in.) long. Dec and tie off as for Little Finger.

Middle Finger

Work as for Ring Finger until finger measures 3 in. (3½ in.) long. Dec and tie off as for Little Finger. (16, 18 sts)

Index Finger

Divide the sts on 3 needles. Beginning at the Middle Finger edge, pick up 2 sts along the edge. (14, 18 sts) Work as for Little Finger until finger measures 2¾ in. (3¼ in.) long. Dec and tie off as for Little Finger.

Thumb

Divide the 17 (21) sts on 3 needles. Pick up and K 1 st in the gap between the thumb and the hand. (18, 22 sts) Work even until Thumb measures 1½ in. (2⅛ in.) long.

THUMB DECREASE RND 1

K2tog, rep around. (9, 11 sts)

THUMB DECREASE RND 2

K.

THUMB DECREASE RND 3

K2tog, rep around, end with K1.

Tighten and tie off as for Little Finger.

Weave all ends in on the inside of the gloves. Use the tails to close any gaps between the fingers. Wash and block gloves.

Hat

Use leftover Light Gray Decadent Fibers Marshmallow yarn as the main color of this coordinating hat.

Yarn	Decadent Fibers Marshmallow, 80% alpaca/20% Merino wool, 113 g, approx 315 yd., 1 skein each of Natural, Light Gold, Dark Gold, Light Gray, Dark Gray
Note	*There should be enough yarn left over from most sizes of the **Nordic Snowflake Pullover** to knit this companion hat.*
Yarn Weight	Sport Weight
Needles	Size 3 (U.S.)/3.25 mm 16-in. circular, size 3 (U.S.)/3.25 mm DPNs, or size needed to obtain gauge Large stitch markers Small stitch markers Large-eye blunt needle

Pattern Sizes	Child (Adult Small, Adult Large)
Note	*Adult Small and Adult Large are knit with the same number of stitches. The difference in sizes is in the length of the hat. Work both sizes as for Adult until noted in pattern.*
Measurements	Circumference: 15⅛ in. (19 in.); Length: 7¼ in. (8 in., 8¾ in.)
Pattern Difficulty	Easy
Fair Isle Gauge	7.5 sts = 1 in., 8 rnds = 1 in. on size 3 needles
Note	*For more about stranding, see chapter 1, Fair Isle Basics, page 8.*

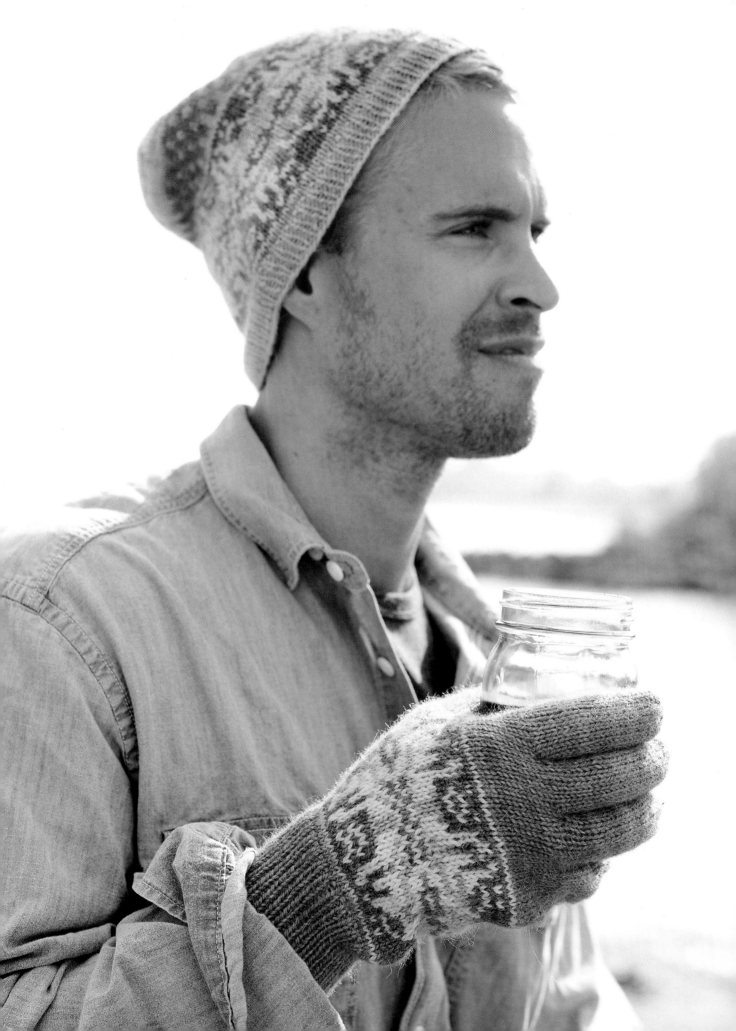

Knitting Instructions

With size 3 circular needle and Light Gray, CO 112 (140) sts. Without twisting sts, place marker, and join.

ALL SIZES

Work 8 rnds K1, P1 ribbing.

ALL SIZES

Work **Nordic Snowflake Pullover Chart 1**, placing markers between reps if desired.

CHILD AND ADULT SMALL SIZE

Work Light Gray/Dark Gold border from **Nordic Snowflake Pullover Chart 2**.

ADULT LARGE SIZE

Work Light Gray/Dark Gold border from **Nordic Snowflake Pullover Chart 3**.

CHILD SIZE ONLY

With Light Gray, K next rnd, dec 2 sts evenly spaced in rnd. (110 sts rem)

CHILD DECREASE RND 1

K9, K2tog, rep around. (100 sts rem)

CHILD DECREASE RND 2, AND ALL EVEN RNDS

K.

CHILD DECREASE RND 3

K8, K2tog, rep around. (90 sts rem)

CHILD DECREASE RND 5

K7, K2tog, rep around. (80 sts rem)

CHILD DECREASE RND 7

K6, K2tog, rep around. (70 sts rem)

CHILD DECREASE RND 9

K5, K2tog, rep around. (60 sts rem)

CHILD DECREASE RND 11

K4, K2tog, rep around. (50 sts rem)

CHILD DECREASE RND 13

K3, K2tog, rep around. (40 sts rem)

CHILD DECREASE RND 15

K2, K2tog*, rep around. (30 sts rem)

CHILD DECREASE RND 17

K1, K2tog, rep around. (20 sts rem)

CHILD DECREASE RND 19

K2tog, rep around. (10 sts rem)

ADULT SMALL SIZE ONLY

With Light Gray, K 2 rnds even.

ADULT LARGE SIZE ONLY

With Light Gray, K 6 rnds even.

ADULT DECREASE RND 1

K12, K2tog, rep around. (130 sts rem)

ADULT DECREASE RND 2, AND ALL EVEN DECREASE RNDS

K.

ADULT DECREASE RND 3

K11, K2tog, rep around. (120 sts rem)

ADULT DECREASE RND 5

K10, K2tog, rep around. (110 sts rem)

Continue dec as for Child Size, beginning at Child Decrease Rnd 1.

Cut yarn, leaving a 10-in. tail. Thread the tail in a large-eye needle, and weave it through the remaining loops. Tighten and tie off. Weave all loose ends in on the inside of the hat. Wash and block hat.

Dress

Knit this gorgeous traditional snowflake dress in Classic Elite's amazing Fresco—
a luscious blend of wool, baby alpaca, and angora.

Yarn	Classic Elite Fresco, 60% wool/30% baby alpaca/10% angora, 50 g, 164 yd., 8 (9, 10, 11, 12) skeins #5375 Graystone; 1 (1, 1, 2, 2) skeins each of #5377 Charcoal Black, #5303 Cinder, #5301 Parchment, #5331 Periwinkle, #5315 Pea Pod
Yarn Weight	DK
Needles Size	3 (U.S.)/3.25 mm DPNs, 16-in. and 29-in. circulars; size 4 (U.S.)/3.5 mm DPNs, 16-in. and 29-in. circulars, or size needed to obtain gauge
Note	*You may use whatever length circular needle is most comfortable for you.*
	Large stitch markers
	Small stitch markers
	Large-eye blunt needle

Pattern Sizes	X-Small (Small, Medium, Large, X-Large)
Measurements	Chest: 35 in. (39 in., 43 in., 46 in., 51 in.); Body Length to Sleeve: 24 in. (25 in., 26 in., 27 in., 28 in. or desired length to armhole); Yoke Depth: 7 in. (7 in., 8 in., 8 in., 8 in.); Sleeve Length to Yoke: 17½ in. (18 in., 18½ in., 19 in., 19½ in.)
Pattern Difficulty	Intermediate
Stockinette Gauge	6 sts = 1 in., 8 rnds = 1 in. on size 4 needles
Fair Isle Gauge	7 sts = 1 in., 7 rnds = 1 in. on size 4 needles
Note	*For more about stranding, see chapter 1, Fair Isle Basics, page 8.*

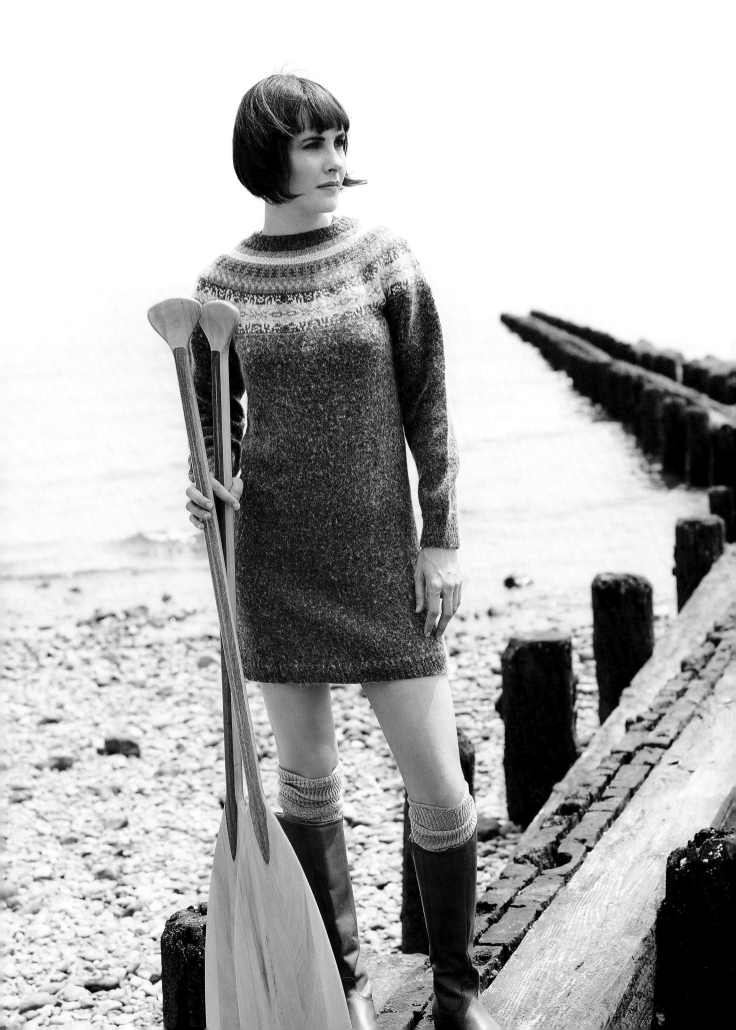

Knitting Instructions

Body

With 29-in. size 3 circular needle and Charcoal Black, CO 212 (236, 260, 284, 308) sts. Without twisting sts, place marker and join.

ALL SIZES

Work 14 rnds K1, P1 ribbing.

NEXT RND

Change to 29-in. size 4 circular needle. K 106 (118, 130, 142, 154) sts, place small marker, K to end.

Work even in Stockinette st until body measures 24 in. (25 in., 26 in., 27 in., 28 in.).

ARMHOLE RND

BO 6 sts, K to within 6 sts of small marker, BO 12 sts, remove small marker, K to within 6 sts of end, BO 6 sts. (24 sts BO for all sizes)

Break yarn and place body sts on a holder or waste yarn. (188, 212, 236, 260, 284 sts rem)

Sleeves (make 2)

With size 3 DPNs and Charcoal Black, CO 60 (60, 60, 64, 64) sts. Without twisting sts, join.

ALL SIZES

Work 20 rnds K1, P1 ribbing.

ALL SIZES

Change to size 4 DPNs. Working in Stockinette st, inc 1 st at the beginning and end of the rnd, every 6 rnds, until there are 86 (88, 90, 92, 94) sts. Change to 16-in. circular needle as desired.

Work even in Stockinette st until sleeve measures 17½ in. (18 in., 18½ in., 19 in., 19½ in.).

ARMHOLE RND (ALL SIZES)

BO 6 sts, work to within 6 sts of end of rnd, BO 6 sts. (12 sts BO; 74, 76, 78, 80, 82 sts rem)

Break yarn, place sleeve on holder or waste yarn.

Yoke

Transfer all sts of one sleeve to 29-in. size 4 circular needle, transfer the body front sts to the needle, transfer the other sleeve sts to the needle, and transfer the body back sts to the needle. Place marker at beginning of rnd. (336, 364, 392, 420, 448 sts)

RND 1

With Charcoal Black, K 1 rnd.

Note Sts will be very tight at the armholes for a few rnds.

ALL SIZES

Work **Nordic Snowflake Dress Chart 1**, placing markers between the reps if desired. (12, 13, 14, 15, 16 reps)

Following **Nordic Snowflake Dress Chart 2** or **Chart 3** for your desired size, with Periwinkle, work Rnd 1, dec 1 (4, 2, 0, 3) sts evenly spaced in rnd. (335, 360, 390, 420, 445 sts rem)

YOKE DECREASE RND

Following **Chart 2** or **Chart 3** for your desired size, work next rnd, *K3, K2tog*, rep around. (67, 72, 78, 84, 89 sts dec; 268, 288, 312, 336, 356 sts rem)

Following **Chart 2** or **Chart 3** for your desired size, work Cinder/Pea Pod checkerboard border.

NEXT RND (ALL SIZES)

K with Graystone following **Chart**.

YOKE DECREASE RND

Following **Chart 2** or **Chart 3** for your desired size, work next rnd, *K2, K2tog*, rep around. (201, 216, 234, 252, 267 sts rem)

Following **Chart 2** or **Chart 3** for your desired size, work Periwinkle/Charcoal Black border.

NEXT RND (ALL SIZES)

K with Pea Pod, following **Chart**.

YOKE DECREASE RND

Following **Chart 2** or **Chart 3** for your desired size, work next rnd, *K1, K2tog*, rep around. (134, 144, 156, 168, 178 sts rem)

Following **Chart 2** or **Chart 3** for your desired size, work Parchment/Cinder and Pea Pod/Graystone borders.

Change to Charcoal Black, K 1 rnd, dec 2 (0, 0, 0, 1) sts in rnd. (132, 144, 156, 168, 177 sts rem)

YOKE DECREASE RND

K1, K2tog, rep around. (88, 96, 104, 112, 118 sts rem)

ALL SIZES

Change to 16-in. size 3 circular needles or DPNs, and work 10 rnds K1, P1 ribbing. BO loosely in patt.

Finishing

Sew armhole openings. Weave all ends in on the inside of the dress. Wash and block dress.

Nordic Snowflake Dress Chart 1, All Sizes

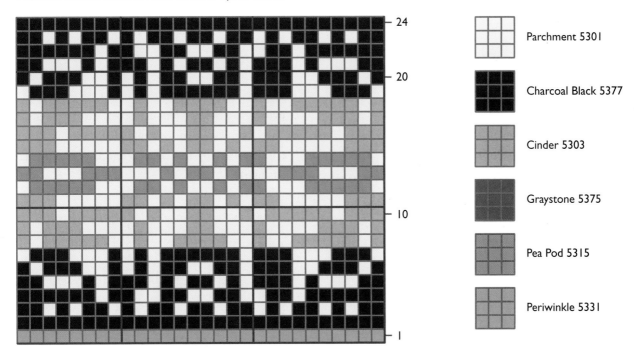

	Parchment 5301
	Charcoal Black 5377
	Cinder 5303
	Graystone 5375
	Pea Pod 5315
	Periwinkle 5331

Nordic Snowflake Dress Chart 2, XS and S Sizes

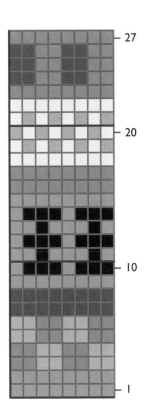

Nordic Snowflake Dress Chart 3, M, L, and XL Sizes

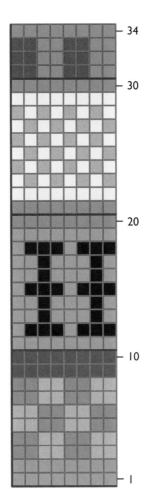

Genevieve's Graduation

THE ONLY THING MY WONDERFUL DAUGHTER-in-law Genevieve ever puts on her Christmas list is "something hand-knit by Kathi." I am always happy to oblige, especially since a certain son, whom I will not name, is not particularly interested in receiving or wearing hand-knit socks.

I don't always wait for special occasions for gifting hand knits, but I do like to commemorate the really important ones with needles and yarn. Gen's graduation from the University of South Dakota with a doctorate in education certainly qualified.

I designed this sweater and the accompanying pieces with her in mind, knowing how much she loves bold patterns and sharp contrasts. For me, I threw in some design elements that I thought would be fun to knit and gorgeous in the final piece. She was delighted when I told her that I wanted to share the pattern for her special sweater in this book. I know that she loves it, and so do I.

I hope you will, too.

Cardigan

When my daughter-in-law, Genevieve, received her doctorate from the University of South Dakota, I wanted to commemorate the occasion with something really special, so I designed this gold, red, and green banded cardigan for her. The scrollwork picot-edge bands add much to the finish of this elegant design.

Yarn Decadent Fibers Savory Socks, 90% superfine superwash Merino/10% nylon, 100 g, approx 400 yd., 4 skeins each of Prince of Wales (red), Highland Green, Scottish Gold; 3 skeins Natural undyed

Note *Hand-dyed yarns can sometimes bleed in the wash. Before knitting with them, wash hand-dyed yarns in separate batches (one for each color) with cold water and Soak™, or other products made especially for washing wool fabrics, and use a Shout® Color Catcher® dye-catching sheet to absorb any excess color that may leach into the wash water. Wash the natural skeins separately in the same way (without the sheet) to allow the yarn to bloom.*

Yarn Weight Fingering

Needles Size 2 (U.S.)/3 mm DPNs, 16-in. and 29-in. circulars; size 3 (U.S.)/3.25 mm DPNs, 16-in. and 29-in. circulars (or length desired for body of sweater), or size needed to obtain gauge

Large-eye blunt needle

Assorted stitch markers

Six 1¼-in. clasps (I used silver JHB963 Classic Clasps; see Resources on page 165)

Pattern Sizes Small (Medium, Large, X-Large, XX-Large)

Measurements Chest: 36 in. (40 in., 44 in., 48 in., 52 in.); Back Length: 23 in. (23½ in., 24 in., 24½ in., 25 in.); Length to Armhole (all sizes): 14 in.; Armhole Length: 9 in. (9½ in., 10 in., 10½ in., 11 in.); Sleeve Length: 19 in. (19 in., 19 in., 19¾ in., 19¾ in.); Shoulder Width: 6½ in. (6½ in., 7 in., 7½ in., 8 in.)

Pattern Difficulty Advanced (uses steeks)

Fair Isle Gauge 8 sts = 1 in., 9 rnds = 1 in. on size 3 needles

Note *For information about stranding and steeking, see chapter 1, Fair Isle Basics, pages 8 and 10.*

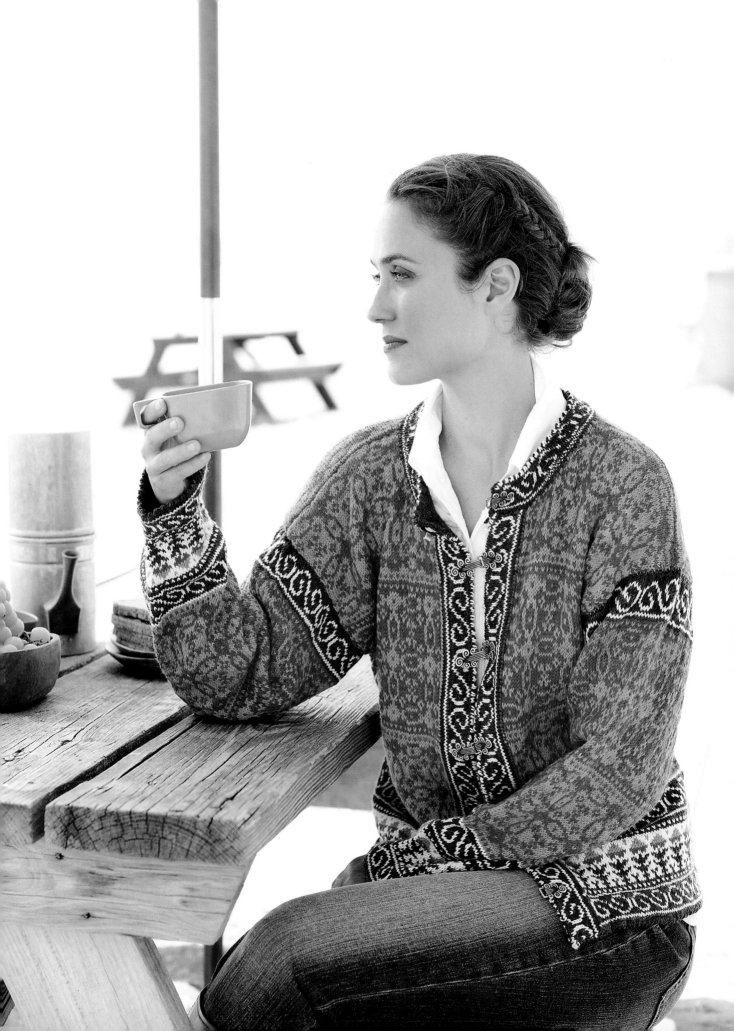

Knitting Instructions

Body Hem Facing

With 29-in. size 2 circular needle and Highland Green, CO 288 (320, 352, 384, 416) sts. Do not join.

ROWS 1–12

Work Stockinette st (K 1 row, P 1 row) back and forth, ending with a P row.

PICOT EDGE ROW 1 (RS)

YO, K2tog, rep across. Turn.

PICOT EDGE ROW 2 (WS)

P, working each YO as a st. Turn.

NEXT ROW

CO 5 sts, place marker, K to end of sts, place marker, CO 5 sts. Join. The 10 new sts are the center front opening steek. Beginning of new rnd is in center of front opening steek. (298, 330, 362, 394, 426 sts)

Body (worked in the round)

Change to 29-in. size 3 circular needle. Work **Genevieve's Graduation Charts 1, 2,** and **3** in order, repeating **Chart 2** and **Chart 3** only thereafter. K the steek sts in alternating colors on 2-color rnds. K even until body of the sweater measures 14 in. from Picot Edge Row 1.

ARMHOLE STEEK RND

K 5 steek sts, alternating colors if it is a 2-color rnd, move marker, K 67 (75, 83, 91, 99) sts according to the chart, place marker, K1, CO 8 (alternating colors if it is a 2-color rnd), K1, place marker (these 10 sts are the first armhole steek), K 150 (166, 182, 198, 214) sts, place marker, K1, CO 8 (alternating colors if it is a 2-color rnd), K1, place marker (these 10 sts are the second armhole steek), K 67 (75, 83, 91, 99) sts, move marker, K5. (314, 346, 378, 410, 442 sts)

Work even until body of sweater measures 23 in. (23½ in., 24 in., 24½ in., 25 in.).

Work 1 rnd in the background color of the current chart border.

BO all sts.

Sleeves (make 2)

With size 2 DPNs and Highland Green, CO 72 (72, 72, 80, 80) sts. Without twisting sts, join.

HEM FACING RNDS 1–12

K.

PICOT EDGE RND 1

YO, K2tog, rep around.

PICOT EDGE RND 2

K, working each YO as a st.

Change to size 3 DPNs. Work Rnds 1–12 of **Chart 1**, beginning at place indicated on chart for Small/Medium/Large sizes for first rep. Begin at Stitch 1 for X-Large/XX-Large sizes.

Work remainder of **Chart 1**, then **Chart 2** and **Chart 3**, repeating **Chart 2** and **Chart 3** as needed. Inc 1 st at beg and end of rnd, every third rnd until there are 148 (158, 166, 176, 184) sts, thereafter working even until sleeve measures 17¾ in. (17¾ in., 17¾ in., 18½ in., 18½ in.) from Picot Rnd 1. Change to 16-in. circular needle as desired.

Work Rnds 1–12 of **Chart 1**. Sleeve should measure 19 in. (19 in., 19 in., 19¾ in., 19¾ in.) from Picot Rnd 1. Work 1 rnd Highland Green.

BO all sts.

Steeks

Prepare armhole and center front steeks as described in chapter 1, Fair Isle Basics, page 10. Cut the steeks open.

Shoulder Seams

Fold the armhole steeks in and baste in place. Measure 6½ in. (6½ in., 7 in., 7½ in., 8 in.) from folded steek edge and mark at neckline. Sew shoulder seam from steek edge to mark. Rep with other shoulder.

Sleeve Assembly

Sew the hem facing up and in along Picot Edge Rnd 1. Pin the sleeve in place at the armhole opening, along the folded steek edge, and sew sleeve in place. Rep with other sleeve.

Continued on page 114

Genevieve's Graduation Cardigan Chart 1

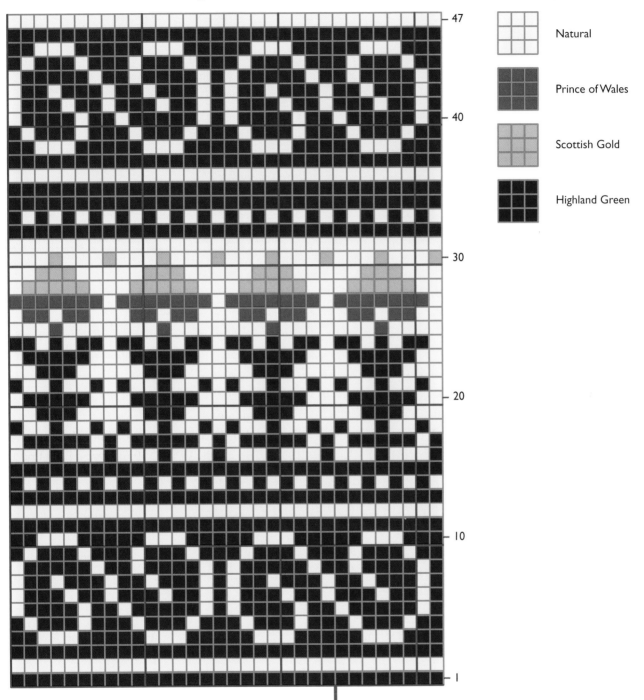

Natural

Prince of Wales

Scottish Gold

Highland Green

47

40

30

20

10

1

For S, M, L sleeve,
begin 1st sleeve here

Genevieve's Graduation Cardigan Chart 2

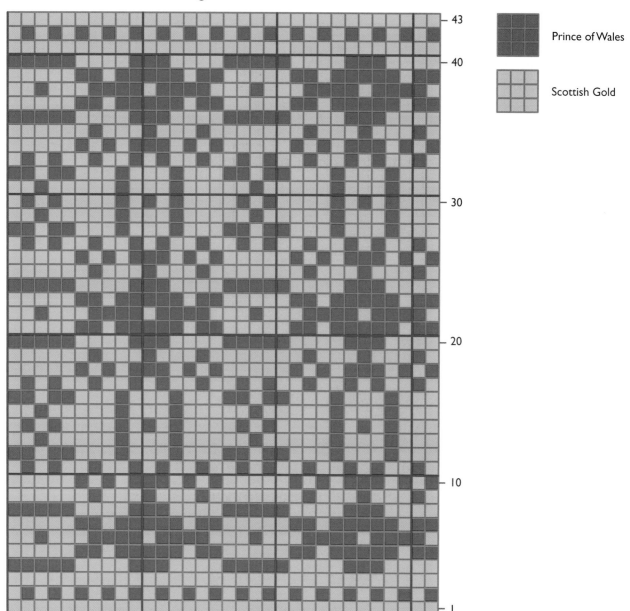

Prince of Wales

Scottish Gold

43
40
30
20
10
1

Genevieve's Graduation Cardigan Chart 3

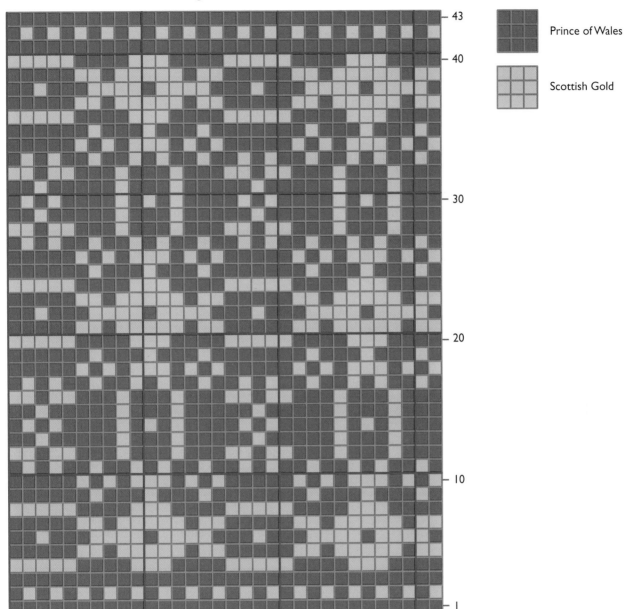

■	Prince of Wales
□	Scottish Gold

Back Neck Shaping

Measure and mark the center of the back neck opening. Fold the back neck area (between the shoulder seams) in and down 1 in. at the center back neck for a facing, making a gradual curve from the center back to the shoulder seam. Pin the facing down.

Front Neck Shaping

Do not fold the center front opening steek in. Measure 4 in. (4½ in., 4½ in., 4 in., 4½ in.) from upper edge on both sides of the front opening. Fold the front neckline down at that point, making a gradual curve from the center front to the shoulder seam. Rep with the other side, measuring to make sure that the curves match. With a highly contrasting yarn, sew a line of basting sts along the curve lines on both front necklines. By hand or machine, following the instructions in chapter 1, Fair Isle Basics, page 10, sew a steek reinforcement seam 1 in. up from the basted curved line, and trim the excess knitted fabric from the upper neck edge. Fold the new edge down along the sewn contrast stitching to form a facing. Pin the facing in place. Remove the contrasting line of sts.

Center Front Openings

Fold the steeks in along the center front openings, and pin in place.

Left Front Band

Working back and forth, not in the round, beginning at the upper left front neck edge on the right side, along the folded edge, with Highland Green and size 3 circular needle, pick up and K 160 (160, 168, 168, 172) sts along the folded steek edge. Do not join.

ROWS 1-12

Work Rows 1–12 of **Chart 1**, purling the WS rows and knitting the RS rows, carrying the floats on the WS of the work. Work from left to right on the chart for the WS rows.

ROW 13 (WS)

Work Row 13 of **Chart 1**.

PICOT EDGE ROW 1 (RS)

Change to 29-in. size 2 circular needle and Highland Green. *K2tog, YO*, rep across.

PICOT EDGE ROW 2 (WS)

P across, working each YO as a st.

FACING ROWS 1-12

Work in Stockinette st (K 1 row, P 1 row).
BO.

Right Front Band

Working back and forth, not in the round, and beginning at the lower right front corner, on the right side, with Highland Green and 29-in. size 3 circular needle, work as for Left Front Band, being sure to begin **Chart 1** at the same spot on the bottom edge as for the Left Front Band.

Neckband

Working back and forth, not in the round, and beginning at the upper right front opening, at the Picot Edge Row for the front band, with a 16-in. size 3 circular needle and Highland Green, pick up and K 130 (138, 146, 154, 162) sts evenly spaced along the neck opening, ending at the upper left front opening at the Picot Edge Row for the front band.
Work as for the front bands.

Finishing

Weave in all loose ends. Sew the body hem facing up and in. Fold the front opening steeks toward the bands, and sew the facings down to cover the steeks. Remove the pins from the neckline facings and steeks. Fold the back neckline facing and front neckline steeks up, and the neckband facing down to cover the steeks, and sew in place. Sew the armhole steeks more firmly in place, if desired. Wash and block sweater. Space the clasps evenly down the front opening, and sew in place.

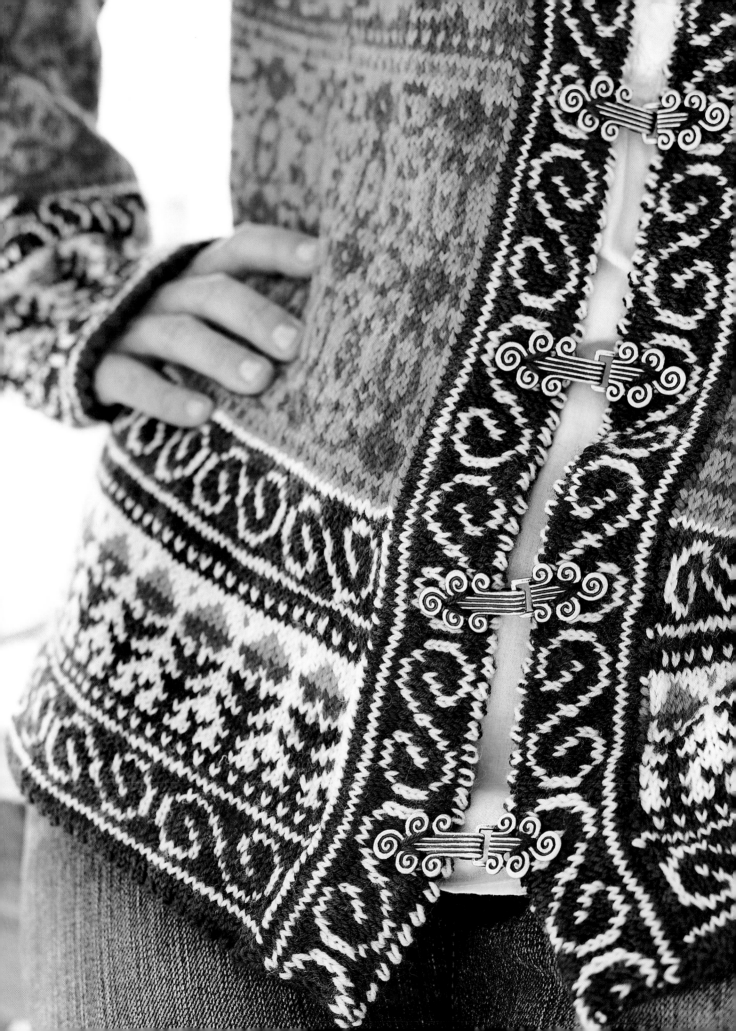

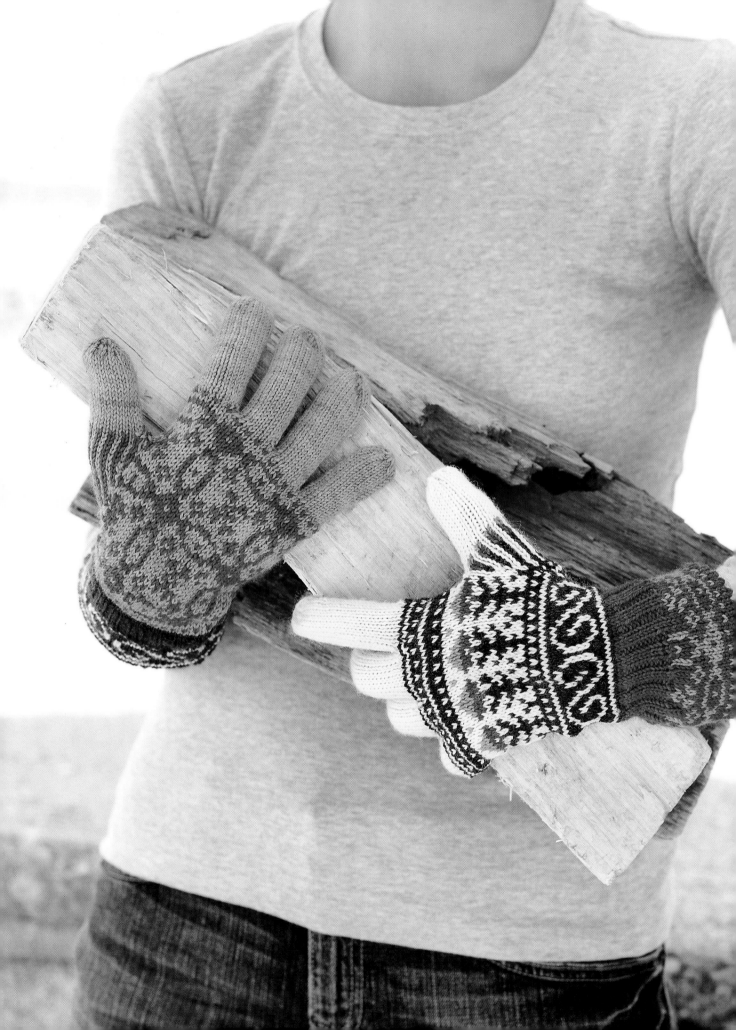

Gloves

Knit either or both of these glove variations as companions to *Genevieve's Graduation Cardigan*. Both have flared cuffs with contrasting facings and picot hems.

Yarn Decadent Fibers Savory Socks, 90% superfine superwash Merino/10% nylon, 100 g, approx 400 yd., 1 skein each of Prince of Wales (red), Highland Green, Scottish Gold, Natural undyed

Note *You may be able to knit these gloves with leftover yarn from **Genevieve's Graduation Cardigan**. A pair of gloves takes less than 70 g of yarn total, and no more than 40 g of the main color.*

Note *Hand-dyed yarns can sometimes bleed in the wash. Before knitting with them, wash hand-dyed yarns in separate batches (one for each color) with cold water and Soak, or other products made especially for washing wool fabrics, and use a Shout Color Catcher dye-catching sheet to absorb any excess color that may leach into the wash water. Wash the natural skeins separately in the same way (without the sheet) to allow the yarn to bloom.*

Yarn Weight Fingering

Needles Size 2 (U.S.)/2.75 mm DPNs, or size needed to obtain gauge

Large-eye blunt needle

Assorted stitch markers

8 safety pins

Pattern Sizes Women's Average

Measurements Cuff: 2½ in. with hem folded up and in; Hand Width: 3½ in.

Pattern Difficulty Intermediate

Fair Isle Gauge 9 sts = 1 in., 9 rnds = 1 in. on size 2 needles

Note *For more about stranding, see chapter 1, Fair Isle Basics, page 8.*

Knitting Instructions

Genevieve's Graduation Gloves 1 (make 2)

With Scottish Gold, CO 64 sts. Divide on DPNs as desired, and without twisting the sts, join.

CONTRAST FACING RNDS 1–12

K.

RND 13

Change to Highland Green, K.

RND 14 (PICOT EDGE RND)

K2tog, YO, rep around.

RND 15

K, working each YO as a st.

CUFF BAND

Work Rnds 1–15 of **Genevieve's Graduation Cardigan Chart 1**.

CUFF RIBBING RNDS 1–12

With Highland Green, work K2, P2 ribbing.

NEXT RND

K.

Begin **Genevieve's Graduation Cardigan Chart 2** at Row 1. Work 5 rnds even.

THUMB GUSSET RND 1

With Prince of Wales, pick up and K 1 st, place marker, complete rnd as charted.

THUMB GUSSET RND 2

Work st before the marker in the color of the previous rnd, move marker, complete rnd as charted.

THUMB GUSSET RND 3

With Scottish Gold, pick up and K 1 st, work next st in color of previous rnd, pick up and K 1 st in Scottish Gold.

Rep Thumb Gusset Rnds 2–3, picking up 1 st at the beginning and end of the thumb gusset, every other rnd, alternating colors of the gusset sts so that the colors make vertical stripes, until there are 19 sts before the marker.

End with Thumb Gusset Rnd 2.

Work even, following chart, continuing to work stripes on the thumb gusset sts as before, for 5 rnds.

HAND RND 1

Place the 19 sts before the marker on 2 safety pins. Work rnd as charted, join.

Finish working **Chart 2**, or work 12 rnds after Hand Rnd 1. Hand will measure 4½ in. from cuff ribbing. Cut yarns.

Divide for Fingers

Place the sts on 2 needles, divided for the glove front and back, 32 sts on each needle. Place 8 sts on a safety pin for the little finger from the front needle. Place 8 sts on a safety pin for the little finger from the back needle. Rep for the ring and middle fingers with 8 sts for each from the front and the back.

Index Finger

With Scottish Gold, and beginning at the outside edge of the hand, K 8 sts, CO 4 sts in between the front and back, K the remaining 8 sts. Divide on 3 DPNs as desired. (20 sts)

Work even in Stockinette st until the Index Finger measures 2⅝ in long, or until the finger is ¼ in. shorter than the desired length.

INDEX FINGER DECREASE RND

K2tog, rep around. (10 sts)

Cut yarn, leaving an 8-in. tail. Thread the tail in a large-eye needle and weave through the remaining loops. Tighten and tie off. Weave the end in on the inside of the finger.

Middle Finger

With Scottish Gold, and beginning at the Index Finger edge, K 8 sts from the needle, CO 2 sts in between the front and the back, K the remaining 8 sts from the needle, pick up and K 2 sts along the Index Finger edge. Divide on DPNs as desired. (20 sts)

Work as for Index Finger until Middle Finger measures 3 in, or until the finger is ¼ in. shorter than the desired length. Decrease and tie off as for the Index Finger. Use the tail to sew and tighten any gaps between the fingers.

Ring Finger

Work as for the Middle Finger until the finger measures 2⅞ in. long, or until the Ring Finger measures ¼ in.

less than the desired length. Decrease and finish as for Middle Finger.

Little Finger

Beginning at the outside hand edge, K 8 sts from the needle, pick up and K 2 sts along the Ring Finger edge, K the remaining 8 sts. Divide on DPNs as desired. (18 sts)

Work as for Index Finger until Little Finger measures 2⅛ in., or until the Little Finger measures ¼ in. shorter than the desired length. Decrease and finish as for Index Finger.

Thumb

Divide and place the 19 thumb sts on DPNs as desired. Beginning at the hand edge, pick up and K 3 sts along the hand gap, K the remaining sts. (22 sts)

Work even until the Thumb measures 1½ in.

THUMB DECREASE RND 1

K2tog, rep around. (11 sts)

THUMB DECREASE RND 2

K.

THUMB DECREASE RND 3

K2tog, rep around, end with K1. (6 sts)

Finish as for Index Finger.

Weave all loose ends in on the inside of the glove. Fold the facing up and in and stitch in place. Use matching yarn to close any gaps between the fingers. Wash and block the gloves.

Knitting Instructions

Genevieve's Graduation Gloves 2 (make 2)

Work as for **Genevieve's Graduation Gloves 1** except for the following:

CO with Highland Green for contrast facing.

Change to Prince of Wales for Picot Edge.

Work Rnds 1–15 of **Genevieve's Graduation Cardigan Chart 3** for the Cuff Band.

Work Rnds 1–12 of Cuff Ribbing in Prince of Wales.

Work 1 rnd Prince of Wales.

Work **Chart 1** for hand, increasing for the Thumb Gusset as for Glove 1, working the thumb gusset in alternating vertical stripes on 2-color rnds.

After completing the flower motif of **Chart 1**, work the next 5 charted rows twice.

End with 1 rnd Natural.

Work fingers and thumb in natural as for **Genevieve's Graduation Glove 1**. Finish as for **Genevieve's Graduation Glove 1**.

8

Prairie Earth and Sky

I DESIGNED AND KNIT THE PROTOTYPE OF this sweater with my own hand-spun yarns. I had a contest on my blog, Kathleen Taylor's Dakota Dreams (kathleen-dakotadreams .blogspot.com), to name the design, and my good friend Mary (who knitted the beautiful Genevieve's Graduation Cardigan shown on page 109) said that the colorway looked, to her, like the earth and sky of the prairie. Here, it's adapted for Knit Picks Wool of the Andes™, a worsted weight yarn. I first took the dark colors—the Earth, if you will—and worked that colorway into a lovely cardigan using browns, golds, oranges, reds, and greens. And then I gathered the Sky colors and used them to represent our beautiful cloudy and clear days with grays, blues, and purples. And while I was at it, I decided to knit one warm and comfy sock in each colorway. Make your own pair, from either Earth or Sky, or be bold and wear one of each!

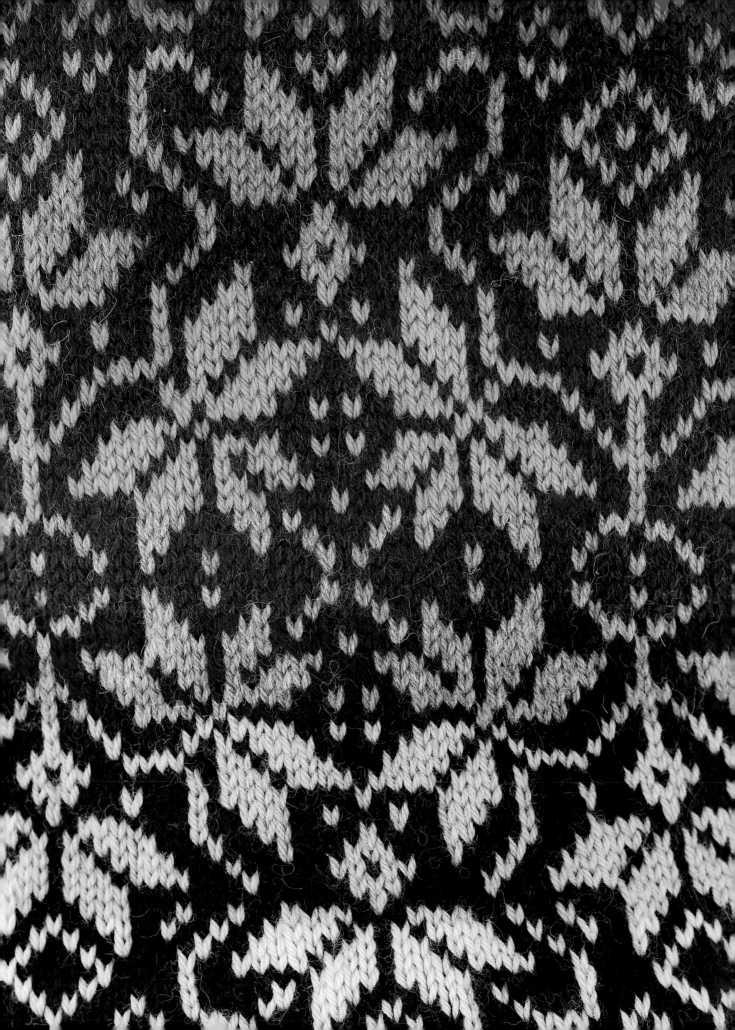

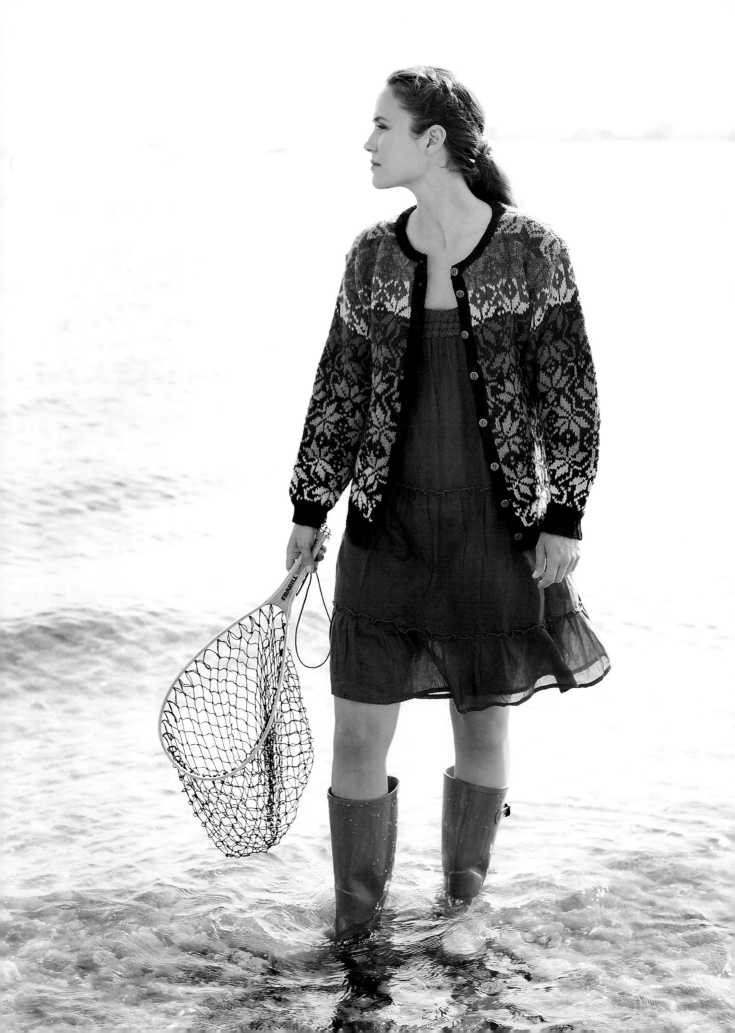

Women's Cardigan

The first version of this sweater was knit from my own hand-spun yarns. When we decided to include the design in this collection, we settled on Knit Picks Wool of the Andes, which matches the original sweater colors very well. Of course, if you can't find these colors, then experiment with your own autumnal palette.

Yarn Knit Picks Wool of the Andes, 100% Peruvian highland wool, 50 g, 110 yd., 3 (4, 4, 5, 5 balls) #23420 Coal; 4 (4, 5, 5, 5 balls) #24652 Bittersweet Heather; 2 (2, 2, 3, 3 balls) #24277 Fedora; 2 (2, 3, 3, 3 balls) #23424 Chestnut; 3 balls (all sizes) #24075 Camel Heather; 1 ball (all sizes) #23436 Daffodil; 1 (1, 1, 1, 2 balls) #23429 Snickerdoodle; 2 (2, 3, 3, 3 balls) #23430 Pumpkin; 1 (1, 2, 2, 2 balls) #24280 Persimmon Heather; 1 ball (all sizes) #24278 Painted Desert; 1 (1, 2, 2, 2 balls) #23896 Firecracker Heather; 1 (1, 2, 2, 2 balls) #24648 Green Tea Heather; 1 ball (all sizes) #23433 Fern; 1 ball (all sizes) #23427 Evergreen

Yarn Weight Worsted

Needles Size 7 (U.S.)/4.5 mm DPNs, 16-in. and 29-in. circulars; size 8 (U.S.)/5 mm DPNs, 16-in. and 29-in. circulars, or size needed to obtain gauge

Large-eye blunt needle

Stitch markers

Contrasting waste yarn

Matching sewing thread (if reinforcing steeks by sewing machine)

Notions Eight ½-in. brass buttons for all sizes

Pattern Sizes Women's Small (Medium, Large, X-Large, XX-Large)

Measurements Chest: 36 in. (40 in., 44 in., 48 in., 52 in.); Side Length to Sleeve: 14 in. for all sizes; Armhole Depth: 9 in. (9½ in., 10 in., 10½ in., 11 in.); Sleeve Length: 19 in. (19 in., 19½ in., 19¾ in., 19¾ in.); Back Length: 23 in. (23½ in., 24 in., 24½ in., 25 in.)

Pattern Difficulty Advanced (uses steeks)

Fair Isle Gauge 5 sts = 1 in., 6 rnds = 1 in. on size 8 needles

Note *For more about stranding, steek knitting, and steek preparation, see chapter 1, Fair Isle Basics, page 5.*

Knitting Instructions

Sweater Body

With 29-in. size 7 circular needle and Coal, CO 190 (210, 230, 250, 270) sts. Without twisting sts, join.

RND 1

K5, place marker, work in K2, P2 ribbing to within 5 sts of end of rnd, place marker, K5. The first and last 5 sts are the center front steek. Beginning of rnd is in center of steek.

RNDS 2–12

Work K2, P2 ribbing.

RND 13

Change to 29-in. size 8 needles. K.

Begin **Prairie Earth and Sky Women's Cardigan Chart 1** at Rnd 1 as indicated on chart. K 5 steek sts alternating colors, move marker, work the first rep beginning where indicated on chart for your size, work 4 (5, 5, 6, 6) full reps, then begin the final rep of the rnd, ending with 14 (5, 15, 6, 16) sts of the next rep, move marker, K the 5 steek sts, alternating colors.

Note Change colors in the middle of the center front steek. Work the steek in alternating colors on 2-color rnds.

Work **Prairie Earth and Sky Women's Cardigan Chart 1**, and then **Prairie Earth and Sky Women's Cardigan Chart 2**, until body measures 14 in. for all sizes.

SLEEVE STEEK RND

K 5 steek sts, alternating colors if a 2-color rnd, move marker, work 44 (49, 54, 59, 64) sts according to chart, place marker, K1, CO 8, alternating colors if a 2-color rnd, K1, place marker, work 88 (98, 108, 118, 128) sts according to chart, place marker, K1, CO 8, alternating colors if a 2-color rnd, K 1, place marker, work 44 (49, 54, 59, 64) sts according to chart, move marker, K 5 steek sts, alternating colors if a 2-color rnd. The 10 sts between the new markers are the sleeve steeks. Work as for the center front steek, alternating colors on 2-color rnds. (206, 226, 246, 266, 286 sts)

Work according to chart until armhole measures 8¾ in. (9¼ in., 9¾ in., 10¼ in., 10¾ in.).

NEXT RND

K in background color only.

BO all sts.

Sleeves (make 2)

With size 7 DPNs and Coal, CO 52 sts for all sizes. Without twisting sts, join.

RNDS 1–15

Work K2, P2 ribbing.

RND 16

Change to size 8 DPNs. K.

Work **Chart 1**, Rnd 1, beginning first rep at square indicated on chart (all sizes begin at the same square).

NEXT RND, AND EVERY THIRD RND THEREAFTER

Inc 1 st in charted patt at beg and end of rnd. Continue until there are 94 (96, 100, 102, 106) sts. Work even until Sleeve measures 18¾ in. (18¾ in., 19¼ in., 19½ in., 19½ in). Work **Chart 1** and **Chart 2**. Change to 16-in. circular needle as needed.

NEXT RND

K in current background color.

BO all sts.

Steeks

Prepare armhole and center front steeks as described in chapter 1, Fair Isle Basics, page 10. Cut the steeks open.

Shoulder Seams

From cut steek edge, sew shoulder seams 6 in. (7 in., 8 in., 8½ in., 9 in.) from cut steek edges.

Back Neckline

For all sizes, measure and mark the center of the back neck opening. Fold the upper back neck in and down 1 in. and pin in place for facing. Ease facing curve back up to the shoulder seams, and sew the facing down.

Front Neckline Shaping

For all sizes, measure 3 in. from the upper edge, at the center fronts, and mark. Measure and mark a gradual

Continued on page 127

Prairie Earth and Sky Women's Cardigan Chart 1

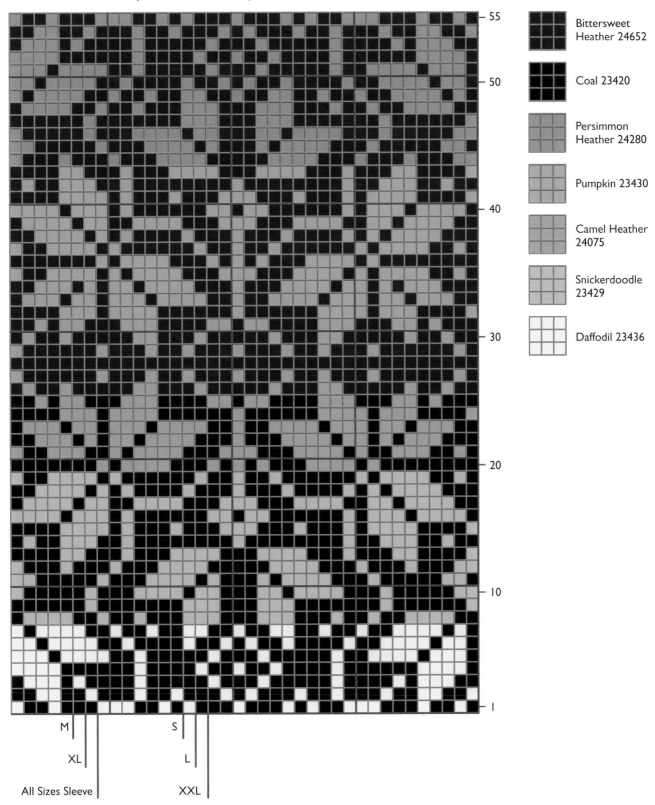

55

50

40

30

20

10

1

Bittersweet
Heather 24652

Coal 23420

Persimmon
Heather 24280

Pumpkin 23430

Camel Heather
24075

Snickerdoodle
23429

Daffodil 23436

M

XL

All Sizes Sleeve

S

L

XXL

Prairie Earth and Sky Women's Cardigan Chart 2

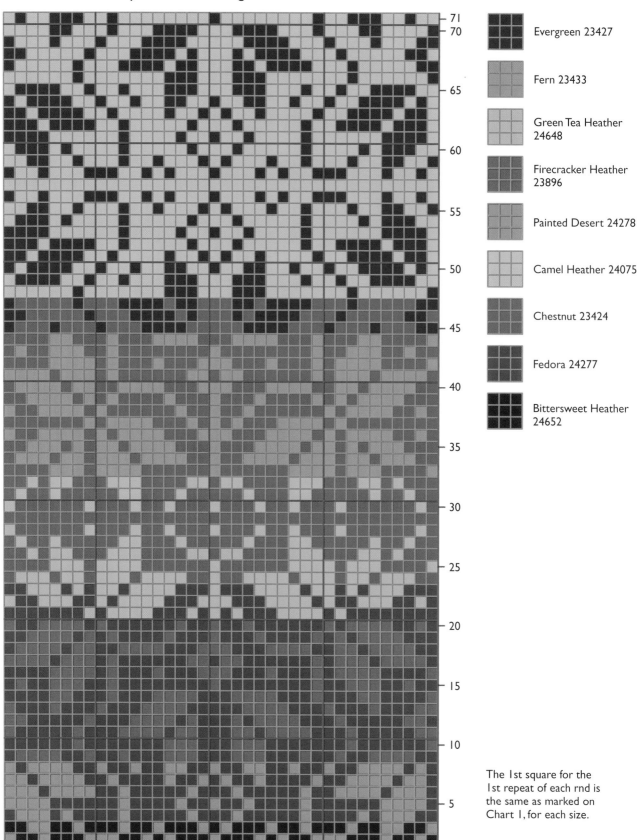

Evergreen 23427

Fern 23433

Green Tea Heather 24648

Firecracker Heather 23896

Painted Desert 24278

Camel Heather 24075

Chestnut 23424

Fedora 24277

Bittersweet Heather 24652

The 1st square for the 1st repeat of each rnd is the same as marked on Chart 1, for each size.

matching curve from the center front, up to each shoulder seam. With contrasting waste yarn, sew a line of basting sts along this curve. Measure 1 in. above the basting line, and mark. Reinforce along this line, as desired, for a neckline steek. Cut along front neckline steek reinforcement stitching. Fold neckline steek down and in along basting. Tack in place.

Left Front Band

With 29-in. size 7 circular needle and Coal, beginning on the RS, at the basting line, fold front opening steek in, pick up and K 106 (110, 112, 116, 118) sts along left front opening. Turn.

ROWS 2-8

Work K2, P2 ribbing.

BO in patt.

Right Front Band (Buttonhole Band)

Pick up and K as for Left Front Band, beginning at lower front edge. Work 3 rows K2, P2 ribbing. Turn.

BUTTONHOLE ROW, SIZE SMALL

Work 7 sts in established patt, *K2tog, YO, work 13 sts in established patt*, rep, ending with K2tog, YO, work 7 sts in established patt. Turn.

BUTTONHOLE ROW, SIZE MEDIUM

Work 9 sts in established patt, *K2tog, YO, work 13 sts in established patt*, rep, ending with K2tog, YO, work 9 sts in established patt. Turn.

BUTTONHOLE ROW, SIZE LARGE

Work 7 sts in established patt, *K2tog, YO, work 14 sts in established patt*, rep, ending with K2tog, YO, work 7 sts in established patt. Turn.

BUTTONHOLE ROW, SIZE X-LARGE

Work 9 sts in established patt, *K2tog, YO, work 14 sts in established patt*, rep, ending with K2tog, YO, work 9 sts in established patt. Turn.

BUTTONHOLE ROW, SIZE XX-LARGE

Work 7 sts in established patt, *K2 tog, YO, work 15 sts in established patt, rep, ending with K2tog, YO, work 7 sts in established patt. Turn.

NEXT RND

Work in established ribbing patt, working each YO as a st.

Work 8 rows total (including Buttonhole Row). BO in patt.

Neckband

Fold center front steeks in and neckline steek down at basting line. On RS, upper right front opening, at the outside edge of the Right Front Band, with 16-in. size 7 needle and Coal, pick up and K 94 (94, 94, 100, 106) sts. Remove basting yarn on front neck curves as you pick up the sts just below the basting line. Pick up the back neckband sts along the folded edge. Turn.

ROW 2 (WS)

K2, P2 across. Turn.

ROW 3 (RS; NECKBAND BUTTONHOLE ROW, ALL SIZES)

Work 2 sts in established patt, K2tog, YO, work remaining sts in established patt. Turn.

ROW 4 (WS)

K2, P2 across, working YO as a st. Turn.

Work 6 rows total. BO in patt.

Finishing

Fold all steeks in and/or down, and stitch in place. Weave all loose ends in on the inside of the sweater. You may trim some of the excess steek fabric at the upper front opening corners to reduce bulk. Be sure to stitch over the newly cut edges to prevent raveling. Sew sleeves in place. Sew buttons on. Wash and block sweater.

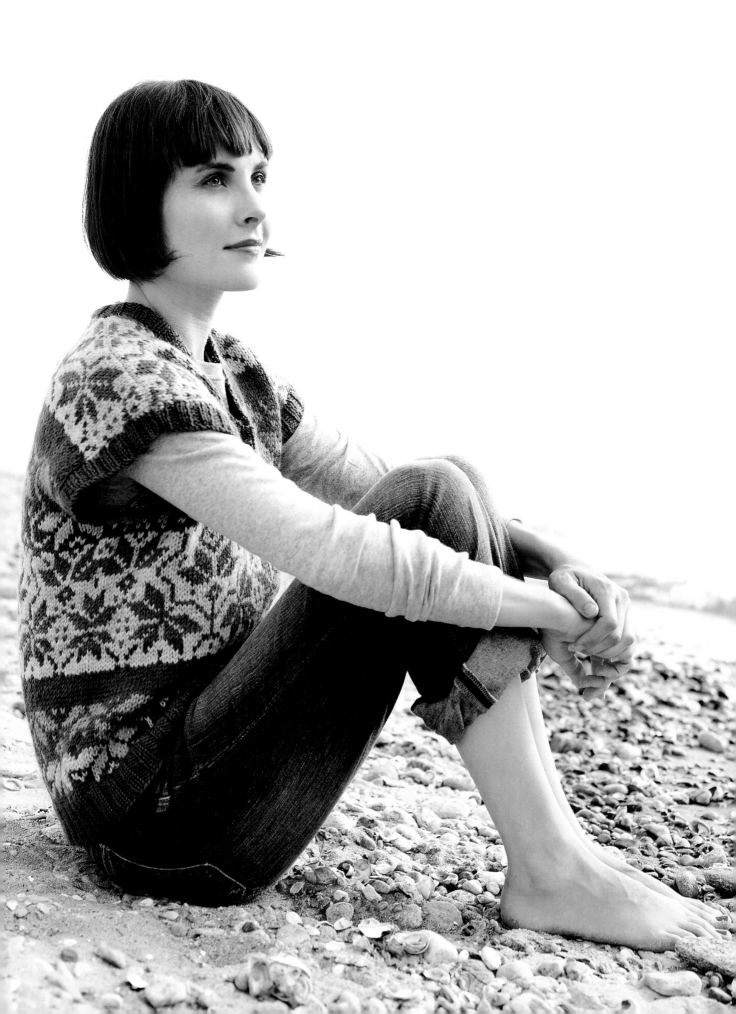

Women's Vest

Our companion vest echoes the cool colors of a winter prairie sky.

Yarn Knit Picks Wool of the Andes, 100% Peruvian highland wool, 50 g, 110 yd., 2 (2, 3, 3, 3) balls #24077 Dove Heather; 3 (3, 4, 4, 4) balls #23438 Mist; 3 (3, 4, 4, 4) balls #23898 Lake Ice Heather; 3 (3, 4, 4, 4) balls #24070 Iris Heather; 3 (3, 4, 4, 4) balls #24274 Lullaby; 3 (3, 4, 4, 4) balls #24073 Tidepool Heather; 3 (3, 4, 4, 4) balls #23894 Arctic Pool Heather

Yarn Weight Worsted

Needles Size 7 (U.S)/4.5 mm 16-in. and 29-in. circulars; size 8 (U.S.)/5 mm 16-in. and 29-in. circulars, or size needed to obtain gauge

Large-eye blunt needle

Stitch markers

Matching sewing thread (if reinforcing steeks by sewing machine)

Pattern Sizes Women's Small (Medium, Large, X-Large, XX-Large)

Measurements Chest: 36 in. (40 in., 44 in., 48 in., 52 in.); Side Length to Armhole: 14 in. for all sizes; Armhole Depth: 9 in. (9½ in., 10 in., 10½ in., 11 in.); Back Length: 23 in. (23½ in., 24 in., 24½ in., 25 in.)

Pattern Difficulty Advanced (uses steeks)

Fair Isle Gauge 5 sts = 1 in., 6 rnds = 1 in. on size 8 needles

Note *For more about stranding, steeking, and cutting, see chapter 1, Fair Isle Basics, page 5.*

Knitting Instructions

Vest Body

With 29-in. size 7 circular needle and Mist, CO 180 (200, 220, 240, 260) sts. Without twisting sts, join. Beginning of rnd is left side seam.

RNDS 1–12

Work K2, P2 ribbing.

RND 13

Change to 29-in. size 8 circular needle. K90 (100, 110, 120, 130), place marker for side seam, finish rnd.

*Begin **Prairie Earth and Sky Women's Vest Chart** at Rnd 1 at square indicated on chart for your size for the first rep, work full reps thereafter, ending with a partial rep, to side marker for vest front*, move marker, rep for vest back.

Work **Prairie Earth and Sky Women's Vest Chart** until body measures 14 in. for all sizes. Rep chart as necessary.

SLEEVE STEEK RND

Note Remove previous markers and place new ones as directed.

CO 4 sts, alternating colors if a 2-color rnd, K1, place marker, work 88 (98, 108, 118, 128) sts according to chart, place marker, K1, CO 8 sts, alternating colors if a 2-color rnd, K1, place marker, work 88 (98, 108, 118, 128) sts according to chart, place marker, K1, CO 4, alternating colors if a 2-color rnd. The 10 sts between the 2 markers are the armhole steeks. Beginning of rnd is now in the center of the left armhole steek. Work steek sts in alternating colors on 2-color rnds. (196, 216, 236, 256, 276 sts)

NEXT RND (V-NECK STEEK RND)

K 5 steek sts, alternating if a 2-color rnd, move marker, work 43 (48, 53, 58, 63) sts according to chart, place marker, K1, CO 8, alternating colors if a 2-color rnd, K1, place marker, work 43 (48, 53, 58, 63) sts to next marker, complete rnd according to chart. (204, 224, 244, 264, 284 sts)

EVERY OTHER RND

K2 tog on either side each steek every other rnd 3 times (Armhole and V-neck).

EVERY OTHER RND THEREAFTER

K2tog before and after the V-neck steek only, until 32 (36, 41, 44, 47) sts rem for the front shoulders (between the V-neck and Armhole steeks).

Work even according to chart until armhole measures 8¾ in. (9¼ in., 9¾ in., 10¼ in., 10¾ in.).

NEXT RND

K in background color only.
BO all sts.

Steeks

Prepare armhole and V-neck steeks as described in chapter 1, Fair Isle Basics, page 10. Cut the steeks open.

V-neck Shaping

Fold V-neck steeks in and tack in place.

Armhole Bands

With 16-in. size 7 circular needle and Mist, beginning at upper shoulder edge on the right side, pick up and K 1 st per st of fabric knitted along the folded steek edge, around the armhole, and back up to the upper shoulder edge. Turn.

ROWS 1–6

Work K2, P2 ribbing.
BO in patt.

Right Shoulder Seam

Sew from ribbing band to folded V-neck steek edge.

Back Neckline Shaping

For all sizes, measure and mark the center of the back neck opening between the shoulder seams (left shoulder seam will measure the same as the right shoulder). Fold the upper back neck in and down 1 in. and pin in place for facing. Ease facing curve back up to the shoulder seams, and sew the facing down.

Neckband

On RS, left front shoulder, with 16-in. size 7 circular needle and Mist, pick up and K 1 st per st of knitted fabric down to just before the center point of V along the folded steek edge, place marker, pick up and K 1 st in exact center point of V, place marker, pick up and K 1 st per st of knitted fabric up other side of V along the folded steek edge, pick up and K 1 st per st of knitted fabric along folded facing back neckline edge. Turn.

ROW 1 (WS)

Work K2, P2 ribbing to marker, move marker, P center st, move marker, work K2, P2 ribbing to end. Turn.

ROW 2 (RS)

Work K2, P2 ribbing to within 2 sts of marker, work 2 sts together in patt, move marker, K center st, move marker, work 2 sts together in patt, finish rnd in patt. Turn.

Rep Rows 1–2 three times.

BO in patt.

Left Shoulder Seam

Sew from armhole ribbing band to neckline ribbing band.

Finishing

Fold all steeks in and/or down, and stitch in place. Weave all loose ends in on the inside of the vest. Wash and block vest.

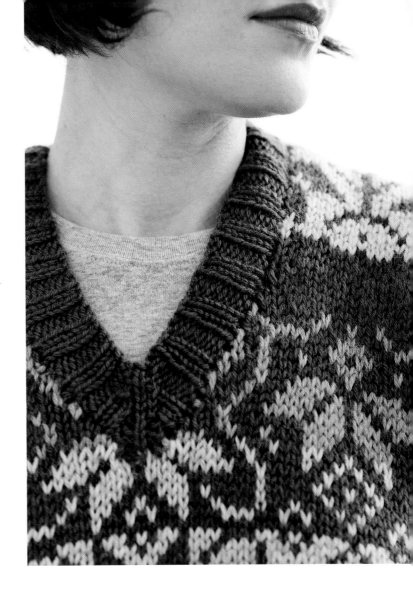

Prairie Earth and Sky Women's Vest Chart

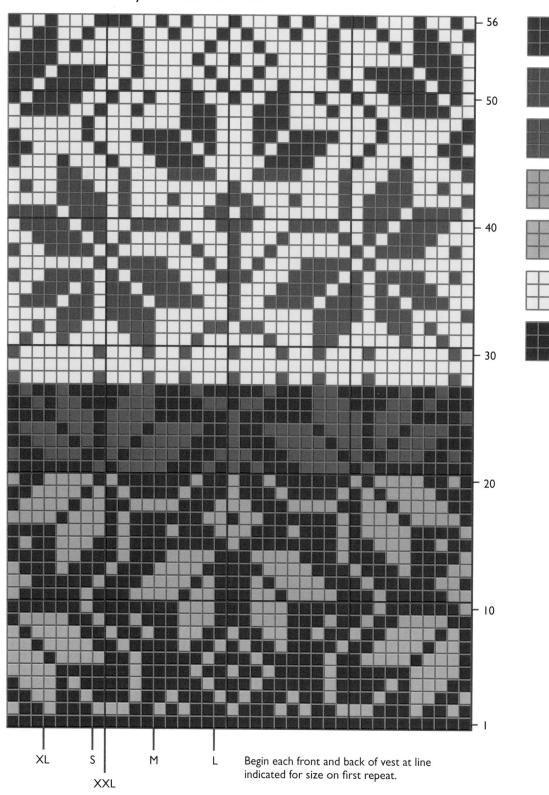

56
50
40
30
20
10
1

Arctic Pool
Heather 23894

Tidepool
Heather 24073

Lullaby 24274

Iris Heather
24070

Lake Ice
Heather 23898

Dove Heather
24077

Mist 23438

XL S M L
XXL

Begin each front and back of vest at line
indicated for size on first repeat.

Socks

You may be able to knit coordinating *Prairie Earth* or *Sky Socks* from yarns left over from the *Prairie Earth and Sky Women's Cardigan* or *Vest*.

Prairie Earth Yarn Knit Picks Wool of the Andes, 100% Peruvian highland wool, 50 g, 110 yd., 1 ball each of #23420 Coal, #24652 Bittersweet Heather, #24277 Fedora, #23424 Chestnut, #24075 Camel Heather, #23436 Daffodil, #23429 Snickerdoodle, #23430 Pumpkin, #24280 Persimmon Heather, #24278 Painted Desert, #23896 Firecracker Heather, #24648 Green Tea Heather, #23433 Fern, #23427 Evergreen

Prairie Sky Yarn Knit Picks Wool of the Andes, 100% Peruvian highland wool, 50 g, 110 yd., 1 ball each of #23438 Mist, #24077 Dove Heather, #23898 Lake Ice Heather, #24070 Iris Heather, #24274 Lullaby, #24073 Tidepool Heather, #23894 Arctic Pool Heather

Yarn Weight Worsted

Needles Size 5 (U.S.)/3.75 mm, 4 or 5 DPNs or 1 or 2 circulars as desired, or size needed to obtain gauge

Large-eye blunt needle

Stitch markers

Pattern Sizes Women's Average (Women's Wide); Shoe Size 5–6 (7–8, 9–10)

Measurements Cuff Width: Women's Average: 4 in., Women's Wide: 4¼ in.; Cuff Length (all sizes): 6 in.; Foot Length: Shoe Size 5–6: 9 in., Shoe Size 7–8: 9½ in., Shoe Size 9–10: 10 in.

Pattern Difficulty Advanced (uses short-row heel)

Fair Isle Gauge 7 sts =1 in., 7 rnds =1 in. on size 5 needles

Note *For more on stranding, see chapter 1, Fair Isle Basics, page 8.*

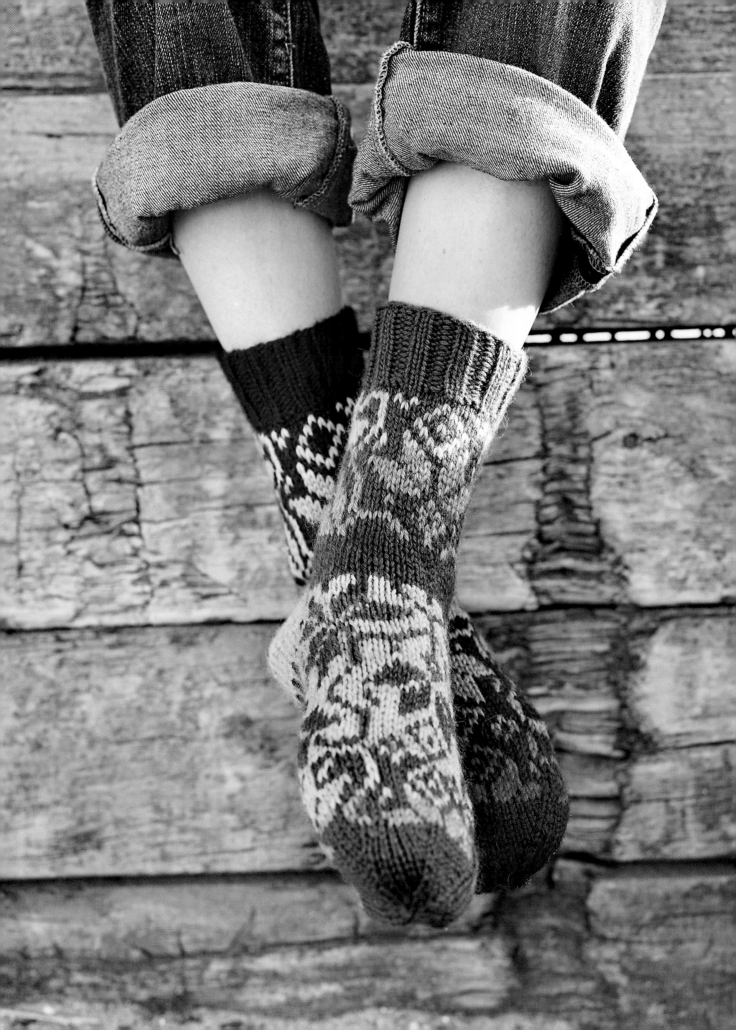

Knitting Instructions

Prairie Earth Socks (make 2)

With Coal, CO 48 (52) sts. Without twisting the sts, join.

RIBBING RNDS 1-15

Work K2, P2 ribbing.

NEXT RND

Inc 8 sts evenly spaced in rnd. (56, 60 sts)

Cuff

Beginning at Row 1 of **Prairie Earth and Sky Women's Cardigan Chart 1**, follow chart, working 9 (11) sts in alternating colors in vertical stripes on 2-color rnds, work 1 rep of the chart, ending with 9 (11) sts in alternating colors in vertical stripes on 2-color rnd. Rnd begins at the center back of the sock.

Work even, working the first and last 9 (11) sts in alternating colors on 2-color rnds, and following the chart for the middle 38 sts, until Cuff measures 6 in.

Heel Setup

Work 14 (15) sts in the established pattern, following the chart. Place the next 28 (30) sts on a separate needle or holder for the instep. Place the remaining 14 (15) sts with the first for the heel. (28, 30 heel sts)

Heel

Use the background color of the current charted border.

HEEL ROW 1 (WS)

Sl 1, P26 (28), turn.

HEEL ROW 2 (RS)

Sl 1, K25 (27), turn.

Continue in this manner, knitting or purling 1 less st on each row before turning, until 9 K sts rem after the slipped st.

HEEL TURN ROW 1 (WS, ALL SIZES)

Sl 1, P8, sl 1, pick up loop in the gap before the next st, P the sl st and the loop together (HTR 1), turn.

HEEL TURN ROW 2 (RS, ALL SIZES)

Sl 1, K8, sl 1, pick up and K 1 st in the gap before the next st, PSSO (HTR 2), turn.

Continue in this manner, thereafter working 1 more st before HTR 1 or HTR 2 on every row, until all of the heel sts have been worked. On the final HTR rows, pick up the st in the gap between the heel sts and the sts set aside for the instep. End with a WS row.

Foot Setup

Sl 1, K 13 (14) sts. Begin new rnd at center of turned heel.

Foot

Work as for cuff, continuing to follow **Prairie Earth and Sky Women's Cardigan Chart 2** as needed, until foot measures 5¼ in. (5¾ in., 6¼ in.).

TOE RND 1, WOMEN'S AVERAGE ONLY

Using the background color of the current charted border, dec 2 sts evenly spaced in rnd. (54 sts)

STAR TOE RND 1

Using the background color of the most recent charted border, *K7 (8), K2tog*, rep around. (6 sts dec)

STAR TOE RND 2

K.

STAR TOE RND 3

K6 (7), K2tog, rep around. (6 sts dec)

Continue dec every other rnd in this manner, working 1 less st before each dec on every dec rnd, until 12 sts rem.

Cut yarn, leaving an 8-in. tail. Thread the tail in a large-eye needle and pull the tail through the remaining loops. Tighten and tie off. Weave all ends in on the inside of the sock. Wash and block sock.

Knitting Instructions

Prairie Sky Socks (make 2)

Work as for Prairie Earth Socks, CO with Mist, and follow **Prairie Earth and Sky Women's Vest Chart**, repeating the chart as necessary.

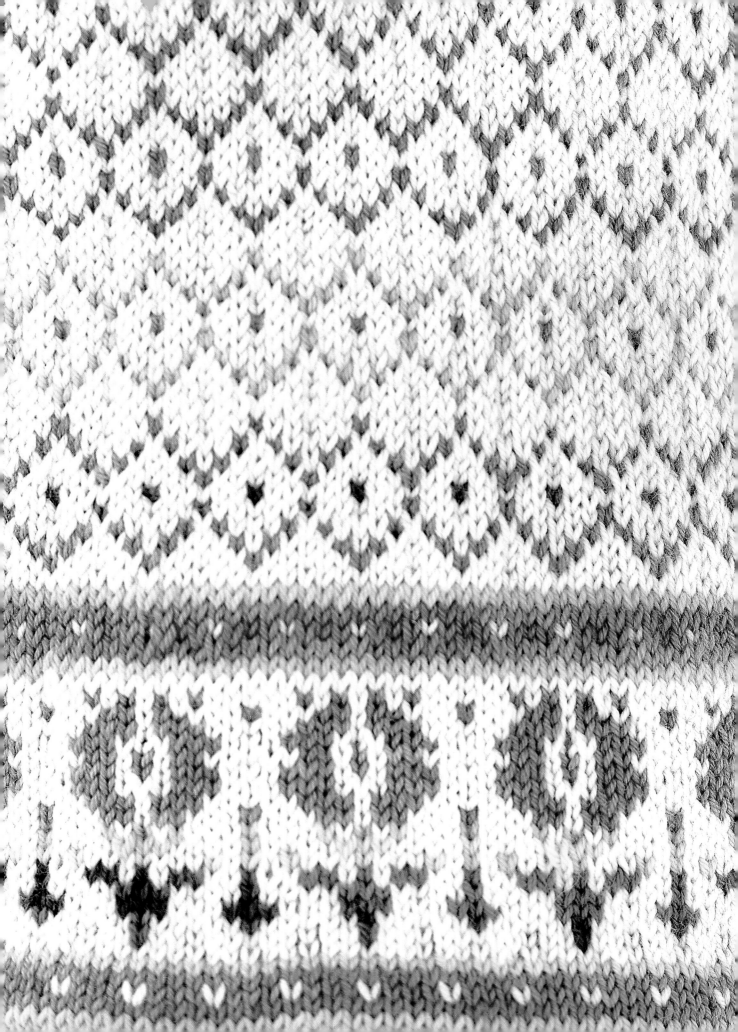

In the Flower Garden

NO BOOK OF FAIR ISLE DESIGNS WOULD BE complete without something for the little ones. These Flower Garden motifs are perfect for ushering in warm weather for the toddlers on your knitting list.

Our In the Flower Garden Children's Cardigan and Pants, worked in soft shades of blue, purple, and green with hand-dyed Savory Socks yarn from Decadent Fibers, will ward off the chill from those cool spring mornings and evenings.

Our simple sleeveless dress, with applied I-cord edging and buttonholes, and a jaunty matching tam, are also knit from Decadent Fibers' hand-dyed Savory Socks yarn. This gold, orange, and green colorway signals the long, hot days of summer.

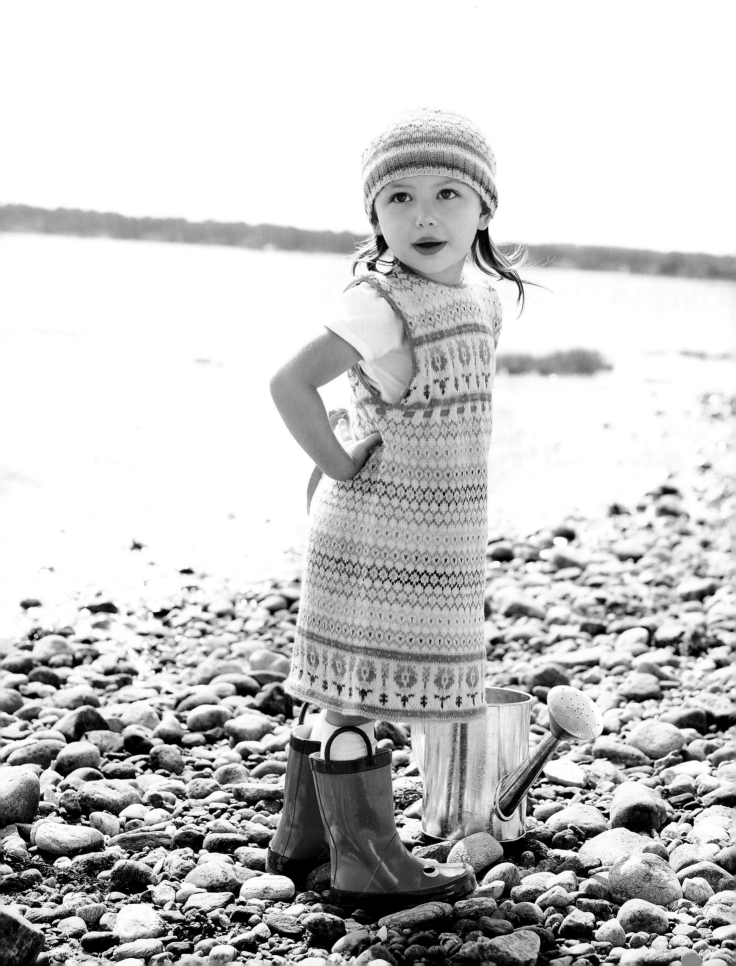

Children's Dress

Get ready for spring with this adorable sleeveless summer dress, knit in Decadent Fibers' hand-dyed, superwash sock yarn. It's simple yet elegant, with a faced hem, ribbon trim, and applied I-cord edging and buttons.

Yarn Decadent Fibers Savory Socks, 90% superfine superwash Merino/10% nylon, 100 g skein, approx 400 yd., 2 (2, 3) skeins Natural; for all sizes, 1 skein each of Bright Orange, Bright Yellow, Light Green, Dark Green

Note *Hand-dyed yarns can sometimes bleed in the wash. Before knitting with them, wash hand-dyed yarns in separate batches (one for each color) with cold water and Soak, or other products made especially for washing wool fabrics, and use a Shout Color Catcher dye-catching sheet to absorb any excess color that may leach into the wash water. Wash the natural skeins separately in the same way (without the sheet) to allow the yarn to bloom.*

Yarn Weight Fingering

Needles Size 3 (U.S.)/3.25 mm 16-in. and 24-in. circular; 2 size 2 (U.S.)/3.00 mm) DPNs, or size needed to obtain gauge

Stitch markers

Large-eye blunt needle

Notions 6 (6, 7) ½-in. yellow buttons

Matching sewing thread and needle

2 yd. ½-in.-wide orange twill tape

Pattern Sizes Small (Toddler 2–4), Medium (Child 6–8), Large (Child 10)

Measurements Skirt Width at Hem: 14 in. (16 in., 18 in.); Chest at Bodice: 24 in. (28 in., 32 in.); Length from Hem to Armhole: 14 in. (16 in., 18 in.); Armhole Length: 6½ in. (7 in., 7½ in.); Dress Length: 20½ in. (23 in., 25½ in.)

Pattern Difficulty Advanced (uses steeks)

Fair Isle Gauge 8 sts = 1 in., 8 rnds = 1 in. on size 3 needles

Note *For more about stranding, steeking, and cutting, see chapter 1, Fair Isle Basics, page 5.*

Knitting Instructions

With Light Green and 24-in. size 3 circular needle, CO 224 (256, 288) sts. Without twisting the sts, join. Beginning of rnd is the center back of the dress.

Hem Facing

Work Rnds 1–5 of **In the Flower Garden Children's Dress Chart**.

FOLD RND

With Light Green, P.

NEXT RND

K.

Dress Skirt

Work Rnds 1–61 of **In the Flower Garden Children's Dress Chart**, then rep Rnds 30–61 as needed until skirt measures 12 in. (14 in., 16 in.).

BACK OPENING STEEK

Work sts in established patt to end of rnd, place marker, CO 10, alternating colors if it is a 2-color rnd. Beginning of rnd is now in the center of the back opening steek. (234, 266, 298 sts)

Work in established patt, working steek sts in alternating colors on 2-color rnds, following chart until skirt measures 13½ in. (15½ in., 17½ in.).

SKIRT DECREASE RND

With Natural, K5, move marker, *K5 (6, 7), K2tog*, rep around. (32 sts dec; 202, 234, 266 sts)

NEXT RND

K.

EYELET RND

K5, move marker, *K2, K2tog, YO*, rep around to marker, move marker, K 5.

NEXT RND

K, working each YO as a st.

ARMHOLE STEEK RND

K5, move marker, K47 (55, 63), place marker, K1, CO 8, K1, place marker, K94 (110, 126), place marker, K1, CO 8, K1, place marker, K46 (55, 63), move marker, K5. (218, 250, 282 sts)

NEXT RND

Work Rnd 1 of **In the Flower Garden Children's Dress Chart**.

Working steeks in alternating colors on 2-color rnds, work **In the Flower Garden Children's Dress Chart** Rnds 1–61, repeating Rnds 30–61 as needed, at the same time dec 1 st on either side of the armhole steeks only, every other rnd, 6 times. (24 sts dec; 194, 226, 258 sts)

Change to 16-in. circular needle if needed.

Work even in established patt until armhole reaches 6½ in. (7 in., 7½ in.).

Work 1 rnd in Natural.

BO all sts.

Steeks

Reinforce armhole and back opening steeks in your preferred method, according to the instructions in chapter 1, Fair Isle Basics, page 10. Cut the steeks open. Fold the steeks in, and baste in place.

Shoulder Seams

Measure 3½ in. (3¾ in., 4 in.) from the folded armhole steek edge, along the upper edge, and mark. Sew the shoulder seams.

Back Neck Shaping

Measure down 1 in. from the upper edge in the center back on either side of the steek opening. Fold the upper edge down and in and pin in place, angling the fold up to the shoulder seam. Baste in place.

Front Neck Shaping

Measure down 2¼ in. from the center front upper edge and mark. Measure and mark an angled line from the center mark up to the shoulder seam. Sew a line of contrasting basting sts along this line. Sew a line of steek reinforcement sts ¾ in. up from the basted line, and cut the excess fabric away. Fold the neckline in and down along the basted line, and baste in place. Remove the basting.

In the Flower Garden Children's Dress Chart

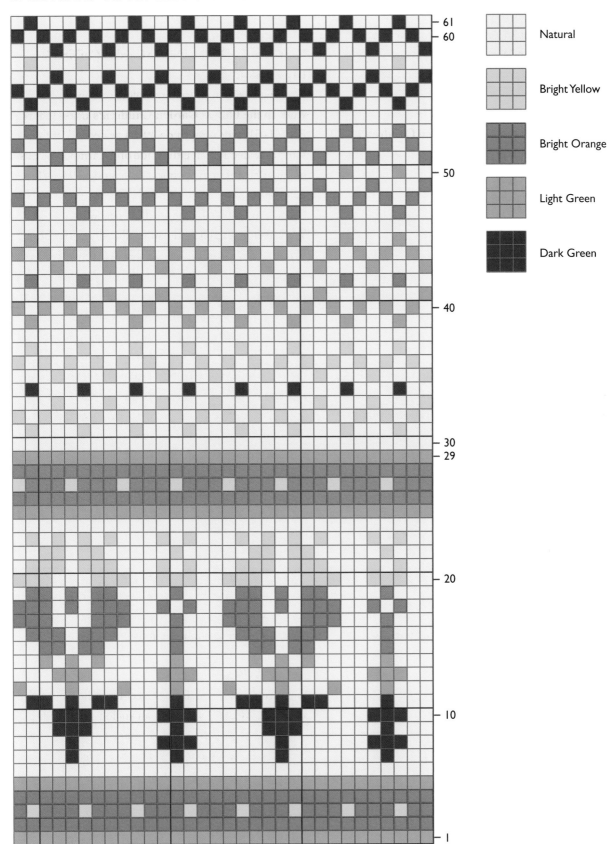

— 61	
— 60	
— 50	
— 40	
— 30	
— 29	
— 20	
— 10	
— 1	

Natural

Bright Yellow

Bright Orange

Light Green

Dark Green

Armhole Edging (Applied I-Cord)

With Bright Orange and size 3 DPNs, CO 3.

Work from wrong side of lower armhole edge.

APPLIED I-CORD EDGING RND 1

Slide sts to right of needle, bring yarn around from behind the sts, K2, Sl 1 as if to knit, pick up and K 1 st from the folded armhole edge, PSSO.

Rep Rnd 1 around armhole opening, picking up each st in succession around the armhole opening, along the folded steek edge.

LAST RND

Slide the sts to the right, bring the yarn around from behind. Sl 1 as if to knit, K2tog, PSSO. Cut yarn, leaving an 8-in. tail. Pull the tail through the remaining loop and tighten.

Sew the ends of the Applied I-Cord Edging together. Weave the ends in. Rep with other armhole opening.

Neckline, Back Opening, and Buttonholes

Working from the wrong side, beginning at the top right back opening, and with Bright Orange, work an Applied I-Cord edging around neckline along the fold line, as for Armhole opening, until you get to the upper left neckline corner.

TOP BUTTONHOLE

Without cutting or tying the yarn off, slide the sts to the right, bring the yarn around from behind, and K across. Rep 6 more times, skip 2 sts along the folded back opening steek edge, and then work the Applied I-Cord Edging Row 1 as for the Armhole openings. Rep 9 times.

REMAINING BUTTONHOLES

Continue the buttonhole process of 7 rows of plain I-cord, skip 2 sts along the folded back opening steek edge, then work Applied I-Cord Edging for 10 sts, until 6 (6, 7) buttonholes have been worked. Work Applied I-Cord Edging to the bottom of the back opening. Finish and tie off as for the Armhole Edging.

Finishing

Weave all loose ends in on the inside of the dress. Sew the hem up and in along the purl fold line. Wash and block dress to proper measurements, and allow dress to dry. With matching sewing thread, sew the buttons in place along the back opening. Beginning at the back opening, using a large-eye needle, thread the twill tape through the eyelet openings, around to the back opening. Tie tape in a bow, and trim ends to desired length.

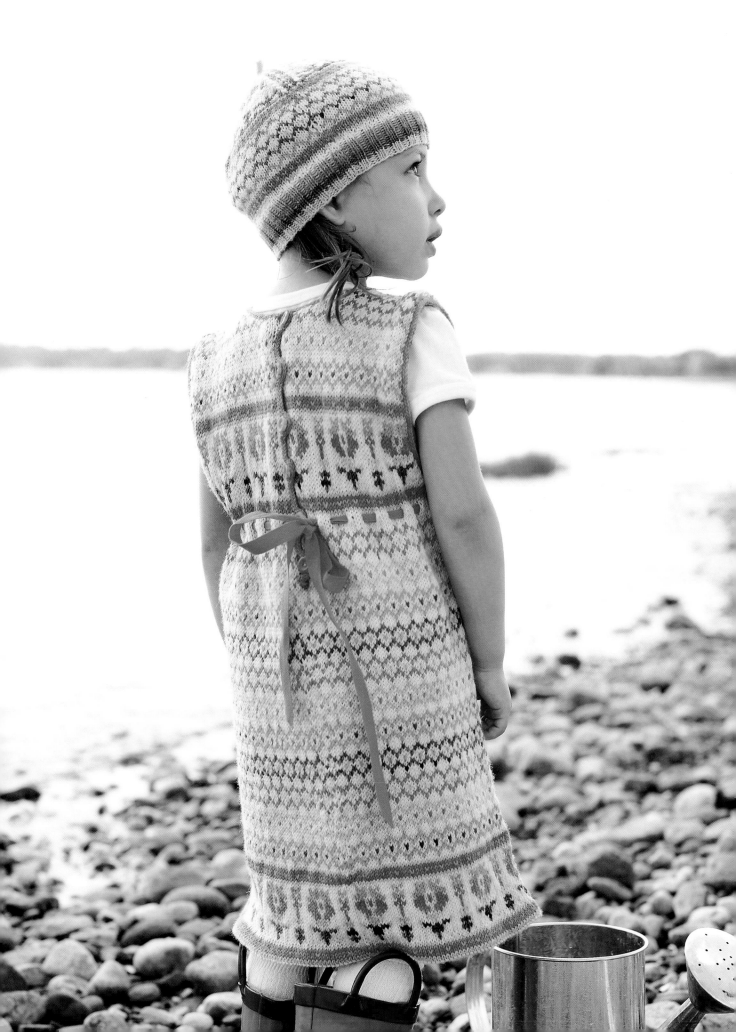

Tam

You should have enough yarn left from the *In the Flower Garden Children's Dress* to knit this adorable matching tam.

Yarn Decadent Fibers Savory Socks, 90% superfine superwash Merino/10% Nylon, 100 g, approx. 400 yd., (for all sizes)1 skein each of Natural, Bright Orange, Bright Yellow, Light Green, Dark Green

Note *Hand-dyed yarns can sometimes bleed in the wash. Before knitting with them, wash hand-dyed yarns in separate batches (one for each color) with cold water and Soak, or other products made especially for washing wool fabrics, and use a Shout Color Catcher dye-catching sheet to absorb any excess color that may leach into the wash water. Wash the natural skeins separately in the same way (without the sheet) to allow the yarn to bloom.*

Yarn Weight Fingering

Needles Size 2 (U.S.)/3.0 mm 16-in. circular; size 3 (U.S.)/3.25 mm 16-in. circular and DPNs, or size needed to obtain gauge

Stitch markers

Large-eye blunt needle

Dessert plate or saucer for blocking

Pattern Sizes Small (Toddler 2–4), Large (Child 6–10)

Measurements 8 in. (9¼ in.) across the top of the hat, lying flat and blocked

Note *Tam can be blocked either larger or smaller than listed above, depending on the plate used for blocking.*

Pattern Difficulty Beginner

Fair Isle Gauge 8 sts = 1 in., 8 rnds = 1 in. on size 3 needles

Note *For more about stranding, see chapter 1, Fair Isle Basics, page 8.*

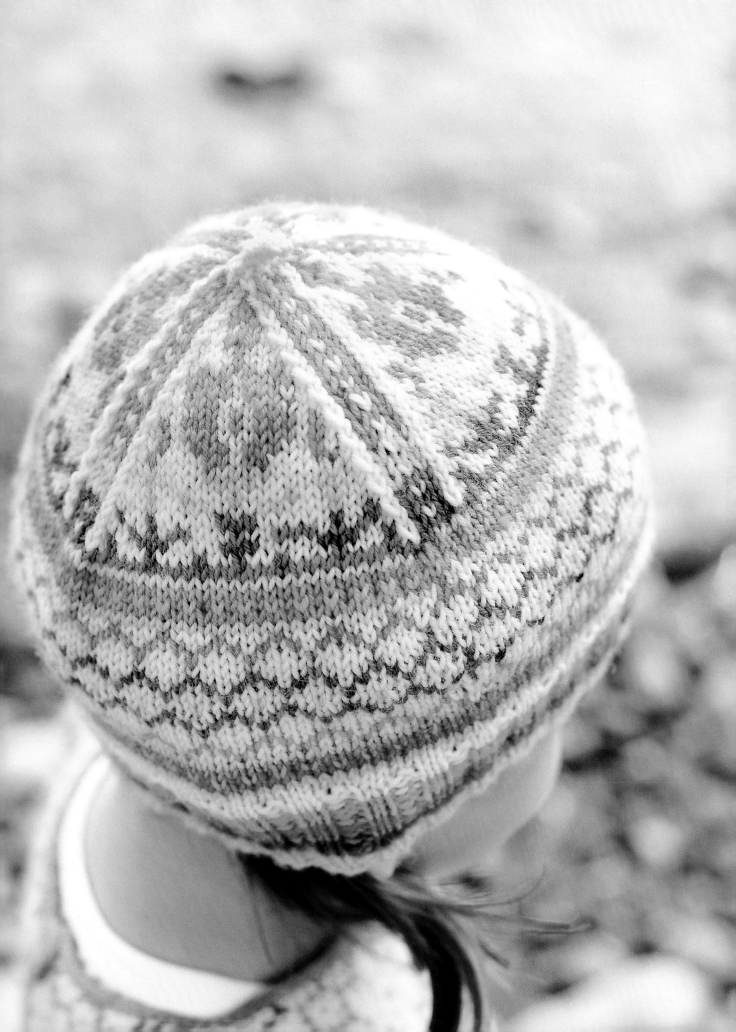

Knitting Instructions

Note *Small size will have 4 flower reps on the top of the tam, Large will have 5 flower reps.*

With Light Green and 16-in. size 2 circular needle, CO 116 (140) sts. Without twisting the sts, join.

Ribbing

Work K2, P2 ribbing, 3 rnds each, in this order: Light Green, Dark Green, Bright Orange, Bright Yellow, Natural.

NEXT RND

Change to 16-in. size 3 circular needle. K with Natural, inc 12 (20) sts evenly spaced in rnd. (128, 160 sts)

Work **In the Flower Garden Tam Chart 1**.

Work **In the Flower Garden Tam Chart 2**, working the decs where shown on the chart. Work K2tog decs on the left side of the chart, and K2tog TBL on the right side of the chart.

Change to DPNs as needed.

RND 29

Sl 1, K2tog, PSSO, rep around. (8, 10 sts)

RND 30

K2tog, rep around. (4, 5 sts)

RND 31, LARGE SIZE ONLY

K2tog, K around.

Place all sts on one DPN.

I-CORD TOP ROW 1

Slide sts to the right side of the needle, bring the yarn around behind the work, and K across.

Rep I-Cord Top Row 1 four times.

LAST ROW

K2tog twice.

Cut yarn, leaving a 6-in. tail. Pull tail through remaining loops, tighten, and tie off on the inside of the tam. Weave all ends in on the inside of the tam.

Blocking

Soak tam and then squeeze or spin the excess moisture from the tam. Place the tam over a saucer (dessert plate), and pull so that the motifs are centered and even. Note that the tam can be blocked to either a larger or smaller size than listed in the pattern, depending on the plate used for blocking. Allow tam to dry, and then remove the plate.

In the Flower Garden Tam Chart 1

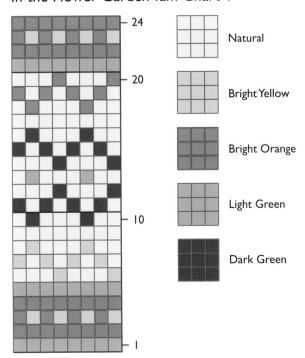

Natural

Bright Yellow

Bright Orange

Light Green

Dark Green

In the Flower Garden Tam Chart 2

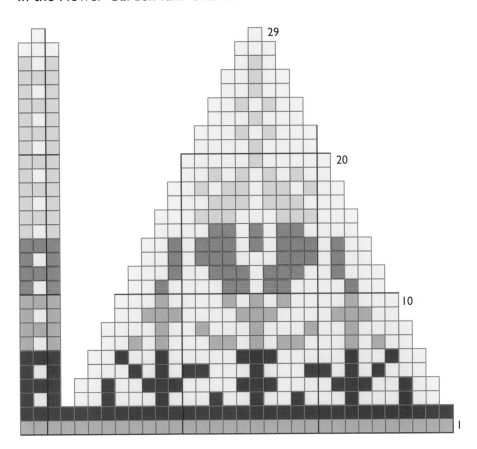

Children's Cardigan

Stroll through the flower garden with this lovely children's cardigan, worked in soft, hand-dyed blues and purples.

Yarn Decadent Fibers Savory Socks, 90% superfine superwash Merino/10% nylon, 100 g, approx 400 yd., (for all sizes) 2 skeins Natural, 1 skein each of Dark Green, Light Green, Blue, Purple

Note *Hand-dyed yarns can sometimes bleed in the wash. Before knitting with them, wash hand-dyed yarns in separate batches (one for each color) with cold water and Soak, or other products made especially for washing wool fabrics, and use a Shout Color Catcher dye-catching sheet to absorb any excess color that may leach into the wash water. Wash the natural skeins separately in the same way (without the sheet) to allow the yarn to bloom.*

Note *There will be enough Light Green, Dark Green, Blue, and Purple left to complete the **In the Flower Garden Children's Pants**.*

Yarn Weight Fingering

Needles Size 2 (U.S.)/3 mm 16-in. circular needle, size 3 (U.S.)/3.25 mm DPNs and circulars in desired lengths, or size needed to obtain gauge

Stitch markers

Large-eye blunt needle

Notions Nine ½-in. buttons

Pattern Sizes Small (Toddler 2–4), Medium (Child 6–8), Large (Child 10)

Measurements Chest: 24 in. (28 in., 32 in.); Length to Sleeve: 8 in. (9 in., 10 in.); Cardigan Length: 14½ in. (16 in., 18 in.); Sleeve Length: 11 in. (12 in., 13 in.)

Pattern Difficulty Advanced (uses steeks)

Fair Isle Gauge 8 sts = 1 in., 9 rnds = 1 in. on size 3 needles

Note *For more about stranding, steeking, and cutting, see chapter 1, Fair Isle Basics, page 5.*

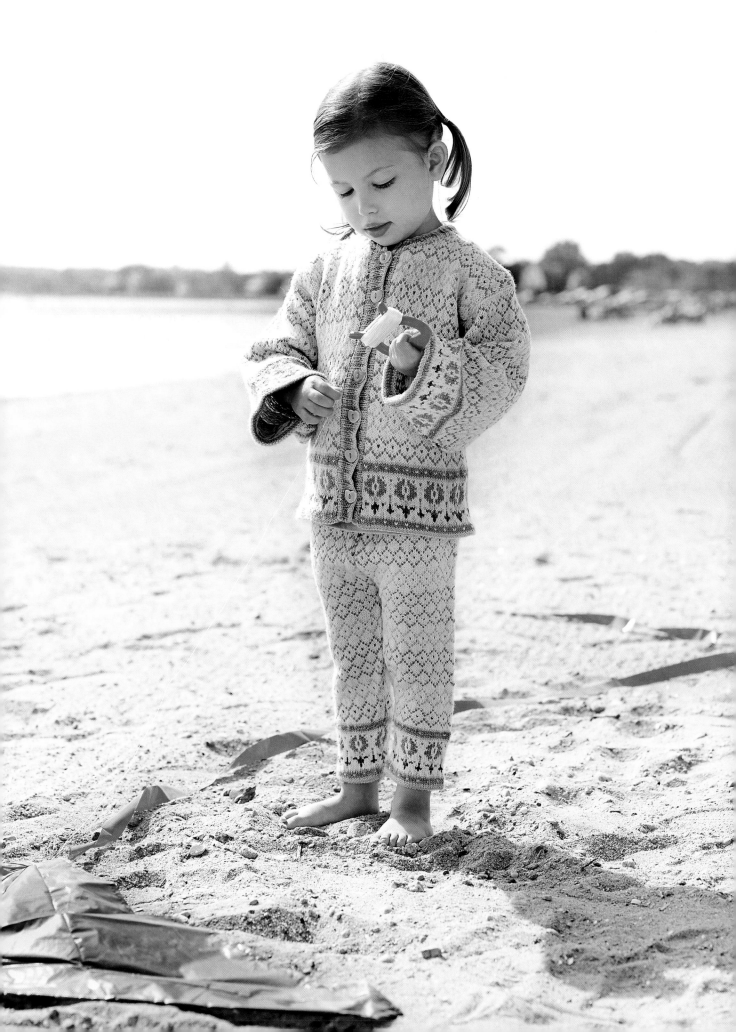

Knitting Instructions

With size 3 circular needle and Light Green, CO 192 (224, 256) sts. Do not join. Turn.

HEM FACING RND 1 (RS)

K with Light Green, turn.

HEM FACING RND 2 (WS)

P with Purple, turn.

HEM FACING RND 3

K, turn.

HEM FACING RND 4

P, turn.

HEM FACING RND 5

K with Light Green, turn.

Fold Rnd 6 (WS)

K, turn.

SWEATER BODY RND 1

With Light Green, CO 5 sts, place marker, work Rnd 1 of **In the Flower Garden Children's Cardigan Chart**, place marker, CO 5, join. New rnd begins in center of center front steek. (202, 224, 256 sts)

Work steek sts in alternating colors on 2-color rnds.

Work Rows 2–61 of **In the Flower Garden Children's Cardigan Chart**, and then repeat Rows 30–59 as needed, until sweater body measures 8 in. (9 in., 10 in.).

ARMHOLE STEEK RND

K 5 steek sts, alternating colors if a 2-color rnd, move marker, work 47 (55, 63) sts according to chart, place marker, K1, CO 8, alternating colors if a 2-color rnd, K1, place marker, work 94 (110,126) sts according to chart, place marker, K1, CO 8, alternating colors if a 2-color rnd, K1, place marker, work 47 (55, 63) sts, move marker, K5. (218, 250, 282 sts)

The sts between the new markers are the armhole steeks.

Continue working according to chart, working the steek sts in alternating colors on 2-color rnds, until armhole measures 6½ in. (7 in., 8 in.).

Work 1 rnd in Natural. BO all sts.

Sleeves (make 2)

With size 3 DPNs and Light Green, CO 66 sts for all sizes. Divide as desired, and without twisting sts, join.

HEM FACING

Work Rnds 1–5 of **In the Flower Garden Children's Cardigan Chart**.

FOLD RND

With Light Green, P.

SLEEVE

Work Rnds 1–5 of **In the Flower Garden Children's Cardigan Chart**.

NEXT RND

Inc 10 sts evenly spaced in Row 6 of **In the Flower Garden Children's Cardigan Chart**. (76 sts, all sizes)

NEXT RND

Begin Rnd 7, starting first patt rep at line indicated on chart for all sizes, work full reps after that, ending with a partial rep.

EVERY OTHER RND THEREAFTER

Inc 1 st at beg and end of rnd, until there are 108 (112, 128) sts while working chart, and then rep Rows 30–61 as needed. Change to circular needle as needed.

Work even, following chart, until sleeve measures 11 in. (12 in., 13 in.).

NEXT RND

K with Natural.

BO all sts.

Steeks

Prepare sleeve and center front opening steeks as described in chapter 1, Fair Isle Basics, page 10. Cut the steeks open.

Shoulder Seams

Measure in 4½ in. (5¼ in., 5¾ in.) from cut sleeve steek edge and sew shoulder seams.

Back Neck Shaping

Measure and mark the center back neck opening. Fold the back neck edge in and down ¾ in. for all sizes, for

Continued on page 153

In the Flower Garden Children's Cardigan Chart

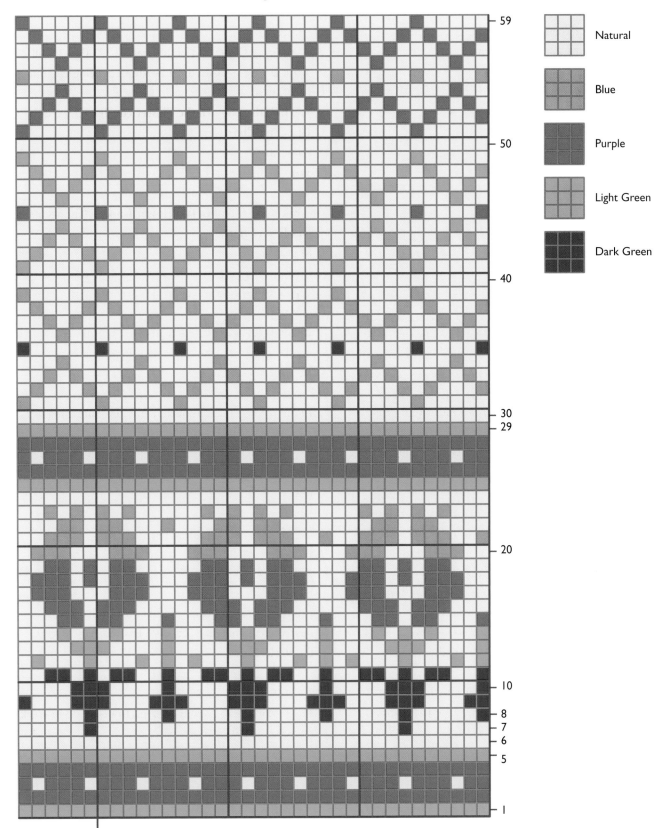

59

50

40

30
29

20

10
8
7
6
5

1

Natural

Blue

Purple

Light Green

Dark Green

All Sizes Sleeve: On Rnd 8 begin 1st repeat here, work full repeats thereafter, ending with a partial repeat

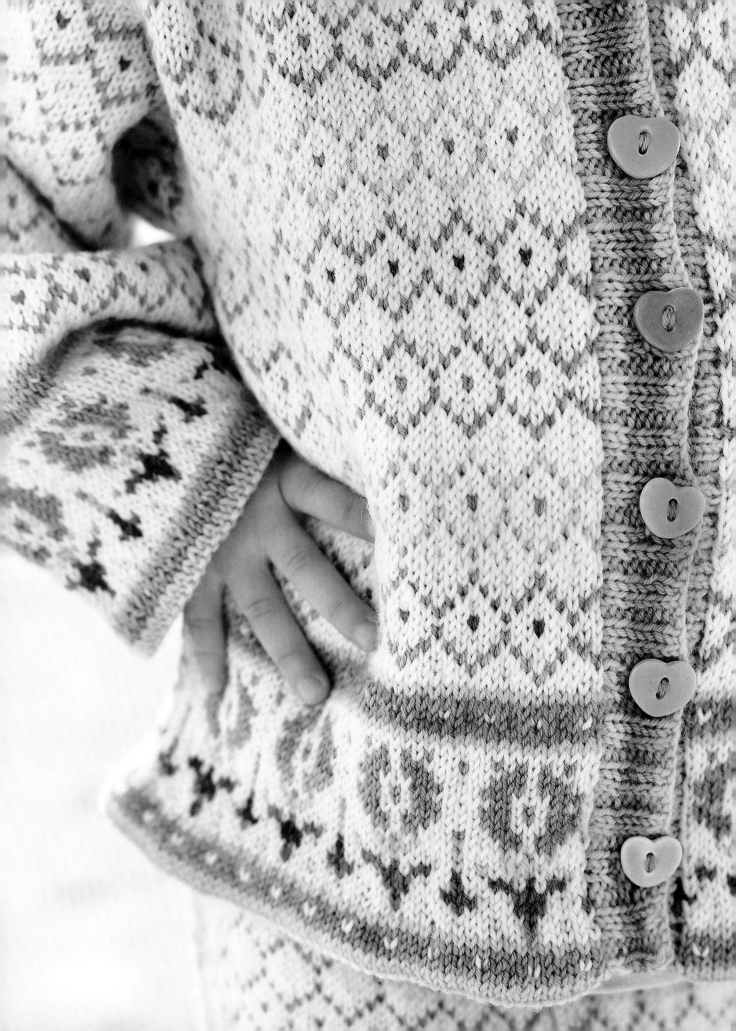

back neck facing. Gradually ease curve of facing up to shoulder seam. Tack in place.

Front Neckline Shaping (all sizes)

Measure 2 in. down from the upper edge, at the center fronts, and mark. Measure and mark a gradual matching curve from the center front up to each shoulder seam. With contrasting waste yarn, sew a line of basting sts along this curve. Measure 1 in. above the basting line, and mark. Reinforce along this line, as desired, for a neckline steek. Cut along front neckline steek reinforcement stitching. Fold neckline steek down and in along basting. Tack in place.

Left Front Band

Fold steek in. Beginning at top right side of right cardigan front at basting line, with size 2 circular needle and Light Green, pick up and K 104 (118, 136) sts evenly spaced to fold line. Turn.

ROW 1 (WS)

Work K2, P2 ribbing. Turn.

ROW 2 (RS)

Work K2, P2 ribbing. Turn.

ROWS 3-6

Change to Purple. Work K2, P2 ribbing. Turn.

ROWS 7-8

Change to Light Green. Work K2, P2 ribbing. Turn. BO in patt.

Right Front Band (Buttonhole Band)

Fold steek in. Beginning at bottom right front opening fold line, RS, with Light Green and size 2 circular needle, pick up and K sts as for Left Front Band. Work Rows 1–4 as for Left Front Band.

BUTTONHOLE ROW

Working as for Left Front Band, work 3 (6, 7) sts in established ribbing patt, *work 2 sts tog, YO, work 10 (11, 12) sts in the established ribbing patt*, rep, end with: work 2 sts tog, YO, work 3 (6, 7) sts in established ribbing patt.

NEXT ROW

Work as for Left Front Band, working each YO as a st. Finish as for Left Front Band.

Neckband

With size 2 circular needle and Light Green, pick up and K 100 (118, 134) sts along neckline folded edges, removing basting yarn as you pick up sts just below that line on the fronts. Turn.

Work and finish as for Left Front Band.

Fold all steeks in, and sew in place. Sew sleeves in place. Fold hem facings up and in and sew in place. Sew buttons in place. Weave all ends in on the inside of the sweater. Wash and block sweater.

Children's Pants

Knit these matching pull-on pants for younger children.

Yarn Decadent Fibers Savory Socks, 90% superfine superwash Merino/10% nylon, 100 g, approx 400 yd., 1 skein each of Natural, Dark Green, Light Green, Blue, Purple

Note *Hand-dyed yarns can sometimes bleed in the wash. Before knitting with them, wash hand-dyed yarns in separate batches (one for each color) with cold water and Soak, or other products made especially for washing wool fabrics, and use a Shout Color Catcher dye-catching sheet to absorb any excess color that may leach into the wash water. Wash the natural skeins separately in the same way (without the sheet) to allow the yarn to bloom.*

Note *There will be enough of the Light Green, Dark Green, Blue, and Purple left from the* **In the Flower Garden Children's Cardigan** *yarn requirements to complete the pants. You will need a whole skein of Natural to complete the pants.*

Yarn Weight Fingering

Needles Size 3 (U.S.)/3.25 mm 16-in. circular needle and DPNs, or size needed to obtain gauge

Stitch markers

Large-eye blunt needle

Notions ¾ yd. ½-in.-wide elastic

Pattern Sizes Toddler's 2 (4)

Measurements Waist: 24 in.; Leg Length to Crotch: 10 in. (12 in.); Length from Crotch to Waist: 8½ in. (9½ in.); Pants Length from Waist to Leg Hem: 18½ in. (21½ in.)

Pattern Difficulty Advanced (uses steeks)

Fair Isle Gauge 8 sts = 1 in., 9 rnds = 1 in. on size 3 needles

Note *For more on stranding, steeking, and cutting, see chapter 1, Fair Isle Basics, page 5.*

Knitting Instructions (make 2)

Note Size 2 and 4 are knit with the same number of sts; the size difference is in the leg and waist length.

With size 3 DPNs and Light Green, CO 64 sts. Making sure the sts aren't twisted, join.

LEG CASING RNDS 1–5
K with Light Green.

LEG FOLD RND 6
P.

NEXT RND
K.

Leg

Work Rnds 1–5 of the **In the Flower Garden Children's Cardigan Chart**.

RND 6 OF CHART
Inc 8 sts evenly in rnd. (72 sts)

RNDS 7–29 OF CHART
Work according to chart.

LEG INCREASE RND 1
Continuing with chart, inc 1 st at the beg and end of the rnd. (2 sts inc)

LEG INCREASE RND 2
Follow chart.
Rep Leg Increase Rnds 1–2 until there are 96 sts. Change to circular needles as needed.
Work even, following chart, repeating Rows 30–61 as needed, until leg measures 10 in. (12 in.) from the Leg Fold Rnd.

Steek

Work to end of rnd in the established patt, following chart, place marker, CO 10 sts, alternating colors if it is a 2-color rnd.

New rnd begins in center of the newly cast-on steek sts. Work the 10 steek sts in alternating colors on 2-color rnds. Steek will be the center front and center back pants seams.
Work even in established patt, following chart, until the piece measures 8½ in. (9½ in.) from the beginning of the steek.

Waist Casing

FOLD RND
With Natural, P.

WAIST CASING
K. Work 1 in. even with Natural.
BO all sts. Weave all loose ends in on the wrong side of the fabric.

Pants Assembly

Prepare steeks as described in chapter 1, Fair Isle Basics, page 10. Cut the steeks open.
Fold the steeks in and baste in place. Sew the pants sections together along the center front and back steeks.

Leg Finishing

Fold the leg casings up and in along the P fold line, and sew in place.

Waistline Finishing

Fold the waist casing in and down along the P fold line and sew in place, leaving a 1-in. opening. Thread elastic through the casing, tightening as desired. Cut and sew the elastic together. Sew the 1-in. opening closed.
Wash and block pants.

10

The Dragon Ride

I SAVED THE KNITTING OF THIS AMAZING shawl until all of the other projects in the book had been finished. I was a bit daunted by the chart and the size of the finished project.

I needn't have been intimidated. While this large dragon chart is the most complicated in the book, with more long floats than any other design, it's still simple to follow. And the absolutely fantastic Classic Elite Chesapeake yarn made the knitting pure pleasure.

The construction is unusual. The body of the shawl is knit in the round with a center steek, which is cut open. The end bands are then picked up along either edge and also worked in the round, then cut open as well. Silk ribbon, sewn around the shawl on the wrong side after blocking, helps to stabilize the edges.

This stunning shawl ended up being one of the easiest projects in the book to knit. And it's certainly one of the most beautiful.

Shawl

This showstopper shawl, with its beautiful dragon motif, inspired by an old book of cross-stitch designs, knits up more quickly than you can imagine on large needles with Classic Elite's wonderful Chesapeake yarn. The shawl and the end borders are knit in the round, so there is no back-and-forth Fair Isle knitting necessary.

Yarn	Classic Elite Chesapeake, 50% organic cotton/50% Merino wool, 50 g, 103 yd., 3 balls each of #5938 Bracken, #5925 Tokyo Rose, #5985 Mandarin Orange; 2 balls #5904 Scuba Blue; 1 ball each of #5981 Tendril Green, #5997 Metro Green, #5955 Shanghai Red, #5949 Arabian Night, #5903 Mephisto
Yarn Weight	DK
Needles	Size 8 (U.S.)/5 mm 16-in. and 40-in. circulars, or size needed to obtain gauge
	Stitch markers
	Large-eye blunt needle
Notions	7 yd. 13-mm-wide black silk ribbon
	Matching sewing thread
	Sewing needle

Pattern Size	One size fits all
Measurements	Unblocked: 19 in. x 78 in.; Blocked: approx 20 in. x 91 in.
Pattern Difficulty	Advanced (uses steeks)
Fair Isle Gauge	Approx 5 sts = 1 in., approx 5 rnds = 1 in. on size 8 needles
Note	*For more about stranding, steeking, and cutting, see chapter 1, Fair Isle Basics, page 5.*
Note	*Test-wash the silk ribbon for color bleeding and shrinkage. If either occurs, wash, dry and press the entire length of the silk ribbon prior to sewing it to the shawl.*

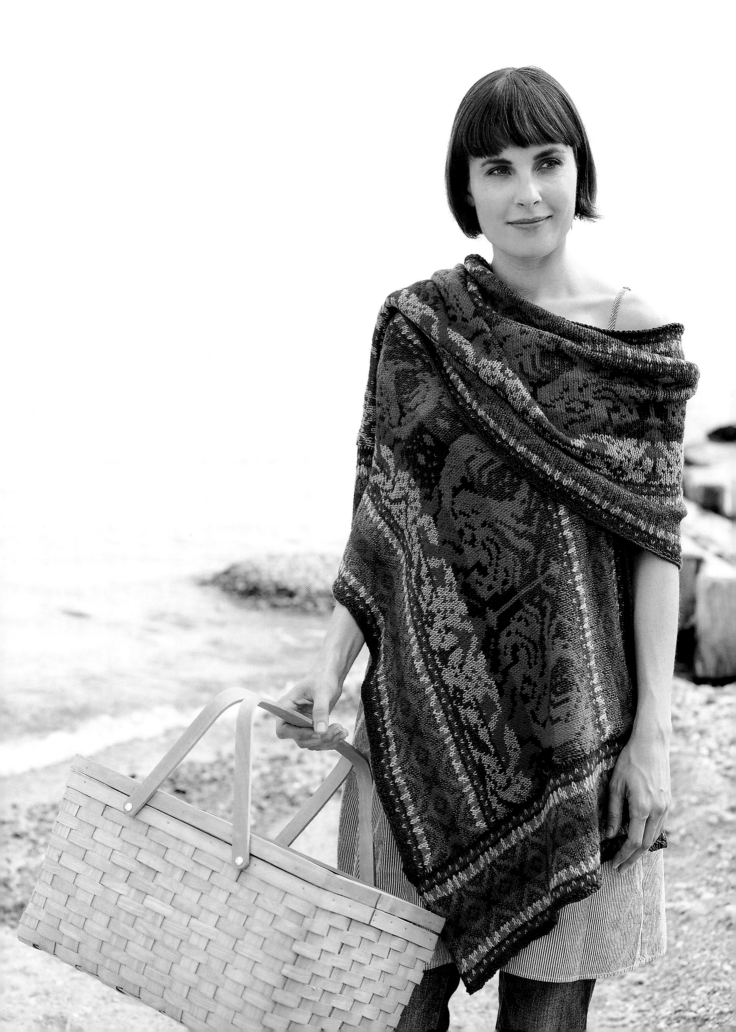

Knitting Instructions

Shawl Body

With 40-in. size 8 circular needle and Bracken, CO 5, place marker, CO 324, place marker, CO 5. Without twisting the sts, join. The 10 sts between the markers are the shawl steek. New rnd begins in the middle of the steek. (334 sts)

RND 1

K5, move marker, *K2, P2* around to marker, move marker, K5.

RND 2

K5, move marker, *P2, K2* around to marker, move marker, K5.

RND 3

K.

Work **Dragon Ride Shawl Chart 1**, working the steek sts in alternate colors on 2-color rnds.

Work **Dragon Ride Chart 2**, working the steek sts in alternate colors on 2-color rnds.

Work **Chart 1**, working the steek sts in alternate colors on 2-color rnds.

Work Rnds 1–2 with Bracken.

BO all sts in K.

Shawl End Borders

Prepare the shawl body steek with your desired method, and cut the steek open. If you have hand-sewn or crocheted the steek reinforcement, fold the steeks in and sew in place on the wrong side of the shawl. If you have machine-sewn the steek reinforcement, fold the raw edges under and stitch in place on the wrong side of the shawl.

With a 16-in. size 8 circular needle and Bracken, CO 5, place marker, pick up and K 1 st for each st across one end of the shawl along the folded steek edge, place marker, CO 5, join. The 10 sts between the markers are the steek. New rnd begins in the middle of the steek. Work the steek in alternate colors on 2-color rnds.

Work **Chart 1**. Note that the final rep will probably not be complete.

Work Shawl Body Rnds 1–2. BO all sts in K.

Rep for other shawl end border.

Prepare the new shawl end steeks, cut them open, and stitch them down as for the Shawl Body.

Wash and pin-block the shawl to the listed measurements. Allow it to dry.

Finishing

After the blocked shawl is dry, weave in any loose ends as necessary. Sew black silk ribbon around the outside edges of the shawl, except for the folded steek edge of the end border sections, on the wrong side for stability.

Dragon Ride Shawl Chart 1

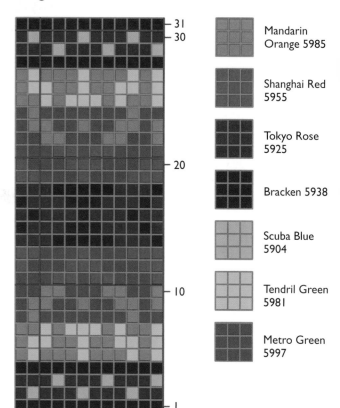

Mandarin Orange 5985

Shanghai Red 5955

Tokyo Rose 5925

Bracken 5938

Scuba Blue 5904

Tendril Green 5981

Metro Green 5997

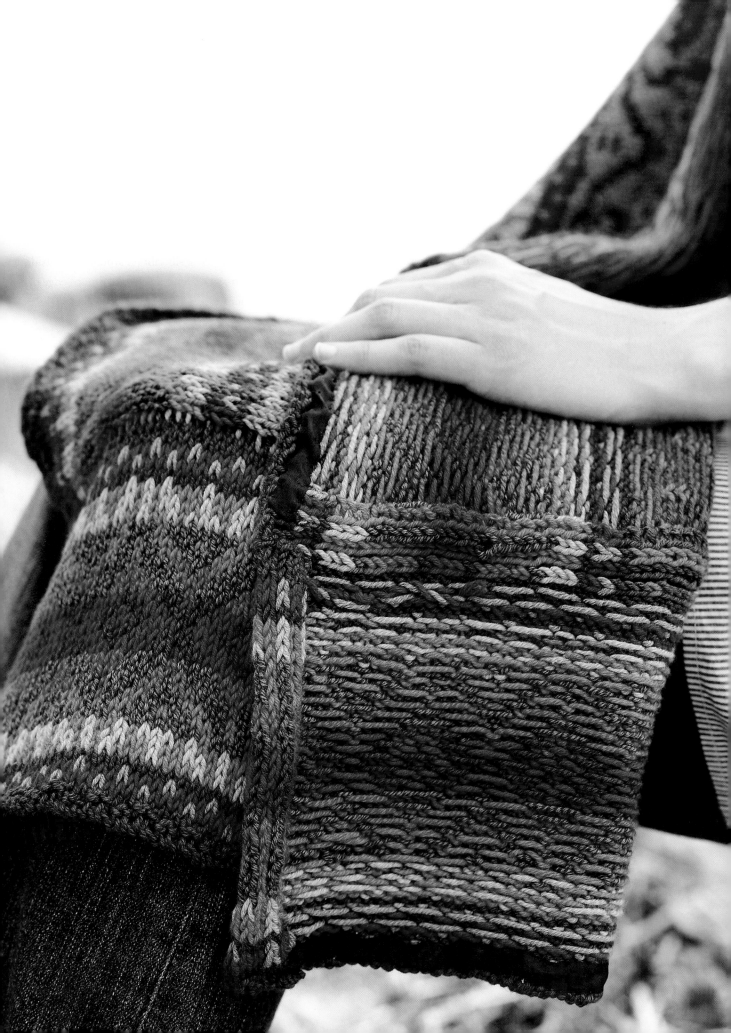

Dragon Ride Shawl Chart 2

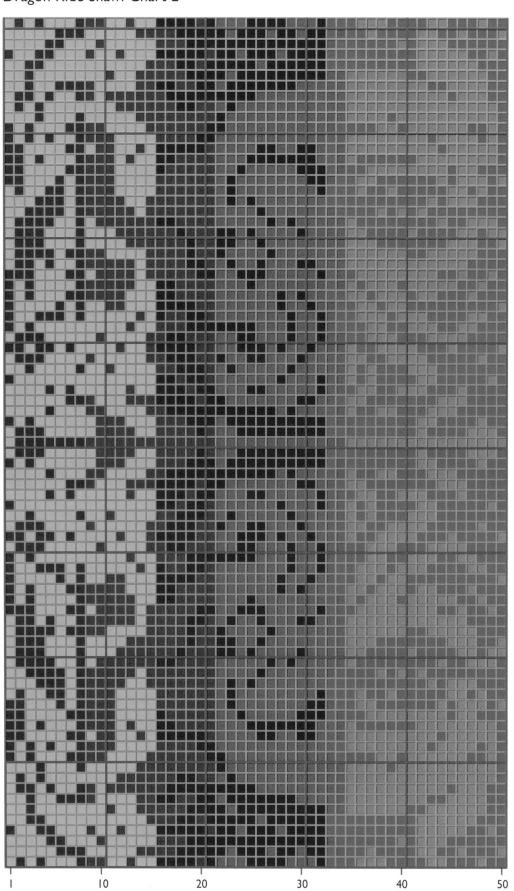

 Mephisto 5903

 Arabian Night 5949

 Scuba Blue 5904

 Bracken 5938

 Tokyo Rose 5925

 Shanghai Red 5955

Mandarin Orange 5985

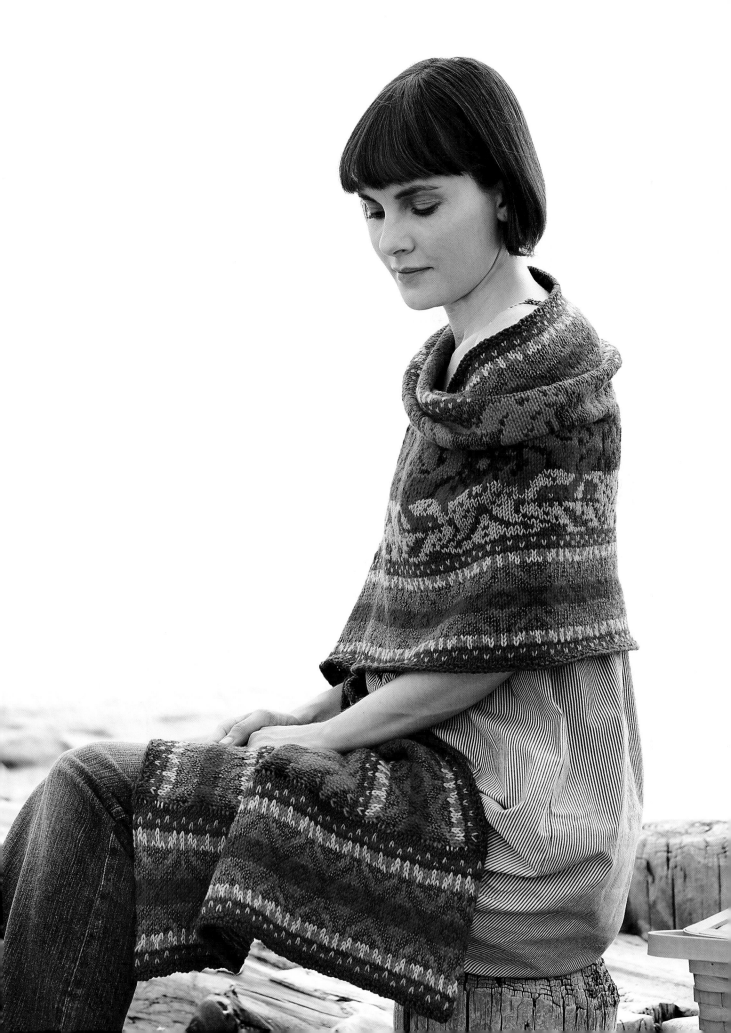

Standard Yarn Weights

ACTUAL YARN	NUMBERED BALL	DESCRIPTION	STS/4 IN.	NEEDLE SIZE
Superfine	1	Sock, baby, fingering	27-32	27-32 2.25-3.25 mm (U.S. 1-3)
Fine	2	Sport, baby	23-26	3.25-3.75 mm (U.S. 3-5)
Light	3	Dk, light worsted	21-24	3.75-4.5 mm (U.S. 5-7)
Medium	4	Worsted afghan, Aran	16-20	4.5-5.5 mm (U.S. 7-9)
Bulky	5	Chunky, craft, rug	12-15	5.5-8.0 mm (U.S. 9-11)
Super bulky	6	Bulky, roving	6-11	8 mm and larger (U.S. 11 and larger)

Resources

Yarns

Classic Elite Yarns
www.classiceliteyarns.com

Crystal Palace Yarns
www.straw.com

Decadent Fibers
www.decadentfibers.com

Knit Picks
www.knitpicks.com

Notions

The Button Drawer (buttons and clasps)
www.buttondrawer.com

ThreadArt (silk ribbon)
www.threadart.com

Index

Note: **Bold** page numbers indicate a photo, and *italicized* page numbers indicate a pattern. (When only one number of a page range is bold or italicized, a photo or pattern appears on one or more of the pages.)